W9-ACC-858

The Photograph

Oxford History of Art

Graham Clarke is Reader in Literary & Image
Studies, University of Kent, Canterbury. His
publications include *Walt Whitman: The Poem
as Private History* (St Martin's Press, 1991),
and he has edited a wide range of volumes
including *The American City: Literary &
Cultural Perspectives* (St Martin's Press, 1988),
The Portrait in Photography (Reaktion Books,
1992), *The New American Writing*, and
The Art of Landscape, as well as editions of
Edgar Allan Poe, T. S. Eliot, Henry James,
and Thomas Hardy.

Oxford History of Art

The Photograph

Graham Clarke

Oxford NewYork

OXFORD UNIVERSITY PRESS

1997

For Thomas and Harriet

Oxford University Press, Great Clarendon Street, Oxford OX2 6DP
Oxford New York
Athens Auckland Bangkok Bogota Bombay Buenos Aires
Calcutta Cape Town Dar es Salaam Delhi
Florence Hong Kong Istanbul Karachi
Kuala Lumpur Madras Madrid Melbourne
Mexico City Nairobi Paris Singapore
Taipei Tokyo Toronto
and associated companies in Berlin Ibadan

Oxford is a trade mark of Oxford University Press

First published 1997 by Oxford University Press

British Library Cataloguing in Publication Data
Data available

Library of Congress Cataloging in Publication Data
Data available

0-19-284200-5 Pbk
0-19-284248-X Hb

10 9 8 7 6 5 4 3 2 1

Picture Research by Elisabeth Agate
Designed by Esterson Lackersteen
Printed in Hong Kong
on acid-free paper by C&C Offset Printing Co., Ltd

Contents

Introduction

In attempting to write any kind of history one is mindful of the way in which one edits and ignores, and, due to the demands of space, pushes to the margins those aspects which in a different context might be given a central position. The photograph is a primary example of this problem. As Peter Turner, in the introduction to his *History of Photography*, noted, he 'was told once that more photographs exist than bricks'; an observation made potent by the fact that in the United Kingdom in 1971 alone, some 325 million colour prints were produced. In contrast to such a mass of prints (and if only we could know the world-wide number of total photographic images for that year and since), I have some 130 photographs—less than the number of images in my daily newspaper. I am, of course, aware of the irony, but I am also aware of the questions that might be raised concerning the basis on which I have selected those images. Inevitably many of them have been chosen for their historical significance; in many cases they are there because they pose important questions about the nature of the photograph and photography in a wider context. Above all, however, they are there because of the critical issues they raise in relation to what the photograph means and the kinds of status we give to it. They are thus, to my mind, exemplary—but equally they remain the representatives of all those millions of images that push against them as part of a limitless tradition. My approach has been to view them as examples of larger questions; seeing them as simultaneously characteristic and individual; the site, effectively, of a series of wider questions that this book, albeit in a limited way, attempts to address. Ian Jeffrey, whose *The Photograph: A Concise History* remains a central text for any understanding of the medium, noted that it would be possible to write a history of the photograph 'in which individuals rarely appear'. Just so; and indeed, many recent studies of the photograph have moved away from a concentration on specific photographers to a focus on larger questions viewed very much within the context of contemporary critical developments and cultural issues. In that sense any photograph, by implication, involves a set of questions and ambiguities endemic to its nature as an act of representation. But any study of this kind must engage with a series of

Detail of 79

individual photographers as well as with individual images, and it would be perverse to imagine that the understanding of the photograph, and certainly its history, has not been dependent upon a series of individual photographers who have been central to its development, and who have produced what remain its definitive images.

Beyond questions of the photographer and the photograph, though, I have attempted to engage a series of pervasive questions in relation to the larger cultural and social meanings of the photograph as an image. Indeed, in many ways this has been my overriding concern. I have attempted to raise a series of questions which point to larger issues and wider problems beyond the scope of this text. I would hope that they suggest something of the underlying ambiguity and complexity of the photograph itself: something which, as part of our everyday lives, seems so obvious and simple, and yet is endlessly complex. In that sense, this book is not so much a history as a series of essays which seek to probe the photograph within a series of historical and critical contexts. I have attempted a process of *reading* in which any photographic image can be placed, and in which the reader is alerted to the terms of that reading and its place within a larger context. The medium is so large, so pervasive, and so complex, that to offer a linear narrative of its development and its significance would be limiting, to say the least. What we can do, however, is try to understand its methods and its practice; how and why it sanctions meaning, and how and why, in turn, we read it thus.

In my work on the photograph many individuals and institutions have provided help, advice, and inspiration, and it is impossible to name all of those to whom I owe a debt of gratitude. However, I would like to thank, from that number, the following: from my university, my colleagues Malcolm Andrews, Stephen Bann, and Roger Cardinal, for their general help and advice; Mike Weaver and Annie Hammond, Mick Gidley, Mark Haworth-Booth, Peter Bunnel, Alan Trachtenberg, Pam Roberts (and the Royal Photographic Society), Peter Turner, Ian Jeffrey, the British Academy, the University of Kent, the Bieneke Library (Yale University), the Library of Congress, and the Bibliothèque Nationale. I would also like to thank my editor, Simon Mason, for his encouragement and patience, and Jim Styles (The University of Kent) for help with the illustrations as well as my picture editor, Elizabeth Agate, for all her help and perseverance. Above all, I would like to thank my wife and partner, Jan, and my children, Thomas Price and Harriet Price, who, in their own ways, have always taught me to see and, in other ways, have never failed to point out those things that I couldn't see.

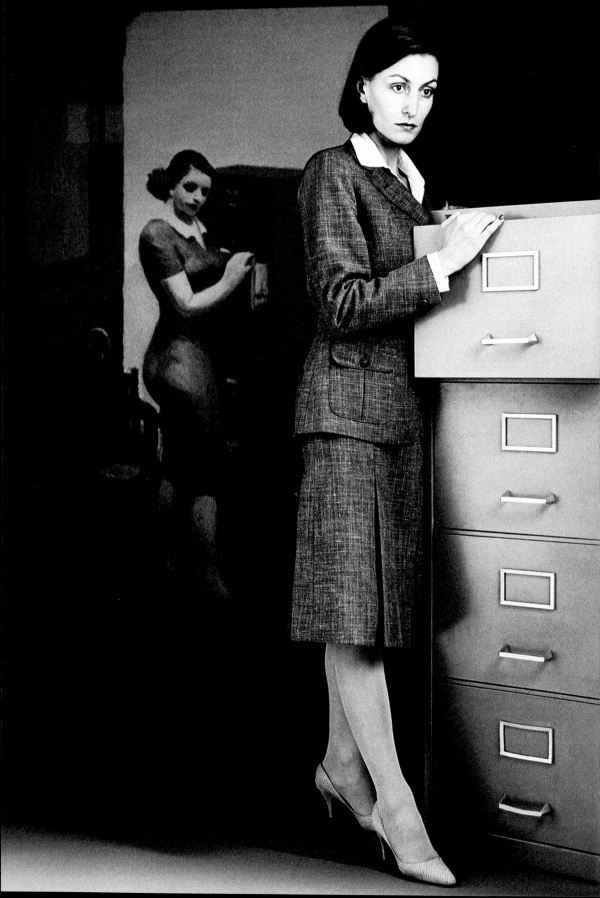

What is a Photograph?

1

In a world dominated by visual images the photograph has become almost invisible. We take photographs, look at them endlessly, and carry them around with us so that their *currency* (to use John Tagg's term)[1] is pervasive. They are one of the most common of objects that change hands on a daily basis. And yet such a common status belies their underlying complexity and difficulty; for we are always left with the primary and shifting question: what precisely *is* a photograph? We have inherited an entire structure of codes and conventions which not only invests the photograph with status (as a means of representation), but does so in relation to its availability and access. It is, in that sense, a doorway on to a world waiting to be recorded; but, like the world through which we move, it seems almost neutral in its structures of meaning.

Strange then, that in 1760 a French writer, François Tiphaigne de la Roche, in his novel *Giphante*, predicted with a sense of wonder the possibility of fixing an image when his narrator, looking at a scene, is amazed that 'a picture should have caused such an illusion'. 'Illusion' is appropriate, for it recalls to us the extent to which the attempt to record and fix a permanent image was seen as almost magical in its effect and suggestiveness: an alchemical process of transformation akin to revelation. Although, as Beaumont Newhall declared, 'what we know as photography is the combined application of optical and chemical phenomena long known to man'[2], this does not take away the essential element of surprise and fascination that any photograph engenders in a viewer who, for the first time, finds himself able to record, rather than paint, trace, or draw, an image of what he sees before him. No wonder, then, that the daguerreotype was called a 'mirror image'.

In one sense, of course, this emphasizes its dependence on light. Indeed, the word 'photograph' means 'light-writing'. But it also speaks to an underlying concern to control light and time. The photograph not only signals a different relationship to and over nature, it speaks very much to a sense of power in the way we seek to order and construct the world around us. Like so much of its meaning, this dual aspect (the scientific and the cultural) is basic to its mode of representation. The

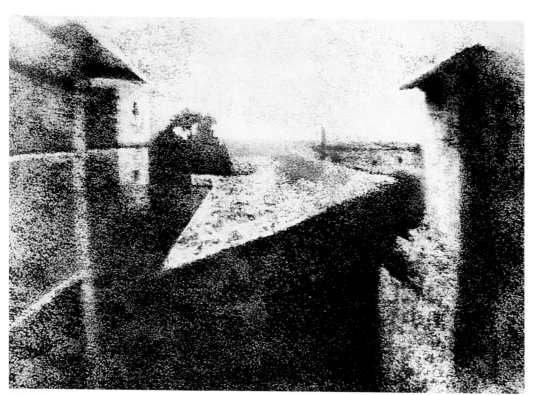

act of taking a photograph fixes time, but it also steals time, establishes a hold on the past in which history is sealed, so to speak, in a continuous present.

Exact images of the real world had been available for some time before the photograph proper. The camera obscura, and later the camera lucida, had been in use since the Renaissance. Indeed, Leonardo da Vinci outlined a theory of the photograph, although the first published account is taken to be *Natural Magic* by Giovanni Battista della Porta in 1558. The camera obscura, however, was an aid to artists. It offered them an inverted image which could then be traced; an accurate rendition of the reflection of light.

Minor developments were achieved by such figures as Thomas Wedgwood and Sir Humphry Davy in Britain who, in 1802, used 'white paper . . . moistened with solution of nitrate of silver' to 'capture' small objects, but once again, such images were not permanent. It was the Frenchman Joseph Nicéphore Niépce (1765-1833) who first fixed a photographic image [1], a view taken from his attic window at Chalon-sur-Saône in 1826, achieved after some eight hours exposure. Named a 'heliograph', it is accepted as the first 'photograph' and Niépce's image retains the presence, even ambiguity, appropriate to its status: its crude format and poor quality declare it not so much an image as an archaeological fragment.

But it was precisely such poor quality which led Niépce to team up

with another Frenchman, the Parisian dioramist Louis-Jacques-Mandé Daguerre (1787-1851). Indeed, Daguerre's interest in the diorama (and panorama), is a significant but often overlooked fact, and emphasizes his concern with producing views and prospects of cities and landscapes. Although Niépce died in 1833, it was not until 1839 that Daguerre published his new photographic process—the *daguerreotype*. Niépce had defined heliography as 'the automatic reproduction, by the action of light, with their gradations of tones from black to white, of the images obtained in the camera obscura', a definition echoed by Daguerre for his own process. A daguerreotype was 'the spontaneous reproduction of the images of nature received in the camera obscura', a 'chemical and physical process' which allowed nature 'to reproduce herself'. The sense of wonder implied in the notion of a 'spontaneous' method of reproduction was echoed in the sensational response to it at the time. *La Gazette de France*, in 1839, declared the 'invention' to be so significant that it 'upsets all scientific theories on light and optics, and it will revolutionise the art of drawing'. Nothing less was being made possible than 'a way to fix images'. Daguerre had made available a 'fixed and everlasting impress which . . . can be taken away from the presence of the objects'. No wonder that Delacroix lamented, that 'from this day, painting is dead'.[3]

One of the outstanding attributes of the daguerreotype was its capacity to record detail. *The Photographer's Studio* (or *Intérieur d'un Cabinet Curiosité*) [2], taken in 1837, has a clarity and detail wholly missing from the Niépce; what *La Gazette* called an 'extraordinary minuteness'. This was an 'exact transcript' which, whether of objects, or architecture or, increasingly of people, made what it saw a palpable presence in time and space. Daguerre's *Boulevard du Temple, Paris*

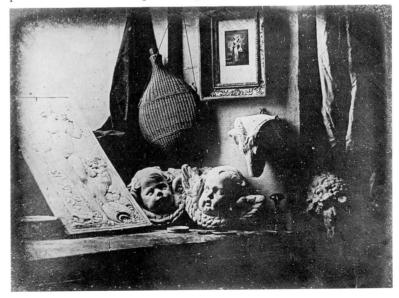

(c.1838) is an early urban scene characterized by a range of tone and a capacity for detail which does, indeed suggest the photograph as a 'cabinet of infinite curiosities'. One can understand why the American writer, Edgar Allan Poe, declared this invention as 'the most important, and perhaps the most extraordinary triumph of modern science', and the literalness of Daguerre's images was commented upon again and again in the United States, most famously by Oliver Wendell Holmes and Nathaniel Hawthorne.[4] But the daguerreotype suffered from a series of basic disadvantages which, despite its popularity in France and the United States, led to its rapid decline as a means of photographic representation.

To begin with, the daguerreotype required long exposure times. Although within a relatively short period after its invention this was reduced to minutes rather than hours, it still placed limitations on the choice of subject. The slightest movement resulted in a blurred image; an obvious limitation for the recording of urban images, people, and documentary scenes. The world had to render itself static in front of the camera. In portrait photography (and the daguerreotype became a major form for a new kind of domestic portraiture) the subject had to be 'held' still, sometimes with special rests to aid posture. The result was often a stylized series of positions and attitudes in which the *act* of being photographed superseded the experience of being photographed. Portraits reflected the method not the medium. The daguerreotype, in its concern with static objects, suggests an underlying aspect of all photography: a fascination with the accurate recording of things as part of a larger act of classification and possession. Above all, however, each daguerreotype was a unique image. There was no negative/positive process. Although a 'mirror image' of the original, it could not be reproduced and its delicate surface, easily scratched, had to be carefully protected, often by a leather case covered in velvet. It became as much an object of attention as it was an image of information, thus declaring, from the beginning, the photograph's dual status as simultaneously both object and image.

The basis of the modern photograph, however, was developed by the English scientist and artist Henry Fox Talbot (1800-77), who produced the first negative/positive photographic process, thus allowing multiple copies to be made from a single negative—clearly of fundamental significance to the future cultural status of the photograph. As Walter Benjamin suggested, the photograph is a prime example of 'the work of art in the age of mechanical reproduction'—an image based on both a chemical and industrial process of production.[5]

Talbot started experimenting with photographs in 1833 whilst in Italy, after using a camera lucida to help him draw more accurately (see Chapter 3). By 1834 he was working with what he termed a 'photogenic

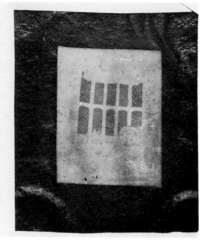

Latticed Window
(with the Camera Obscura)
August 1835

When first made, the squares
of glass about 200 in number
could be counted, with help
of a lens.

4 William Henry Fox Talbot

Latticed Window, 1835

Taken from inside Talbot's country house, Lacock Abbey, the minuscule size of the negative belies its importance. This is, as it were, the first negative and allowed, for the first time, a potentially infinite number of positive prints to be reproduced from it. The photograph, in terms of this single artefact, had come of age.

drawing', involving nitrates of silver on paper—one of the most basic forms of photograph possible. Using ferns, lace, or flowers, Talbot reproduced images of the object by simply placing it on to the sensitized paper and exposing the paper to light—equivalent to wearing a wrist-watch when sunbathing. Once again the terms in which he spoke of his discovery were typical of the period. The images, he said, had 'the utmost truth and fidelity' and were part of a 'natural magic' and 'natural chemistry' which could do 'in the space of a few seconds' what it would otherwise take 'days or weeks of labour to trace or to copy'. Although possessing an attraction of their own [3], photogenic drawings were of more significance in what they suggested about the possibilities of the photograph. As a process, it was clearly limited in its capacity to record more than a narrow range of objects.

Talbot kept his researches a secret, but in 1839, in response to Daguerre's public announcement in France, he too (believing Daguerre to have developed a similar process) announced his 'invention', and by 1840 had produced the *calotype* (significantly, based on the Greek for 'beautiful picture'; in 1839 Sir John Herschel had already used the word 'photograph' at a Royal Academy lecture). The calotype, however, was the first true negative/positive photographic process and remains the basis of all photographic methods today. Although it lacked the detail of the daguerreotype, its great asset was that, for the first time, an infinite number of positive prints could be taken from a single negative image. The photograph proper had arrived. It is appropriate, then, that Talbot's first negative, like Niépce's first image, should be equally ambiguous. The *Latticed Window* [4], a small and fragile ghost of the original, portrays a window at Talbot's country home, Lacock Abbey. Its minuscule size (one inch square) belies its historical significance. Symbolically it speaks to the act of photographing and to the photograph itself, for we look at (and through) a window which suggests an almost mysterious play of

presence and absence. It remains an *ur*-image for both the history and the understanding of the photograph. Talbot printed his first calotypes in 1840, and it was this process that laid the foundation for the illustrations in *The Pencil of Nature* which Talbot started to publish in 1844.

Despite such revolutionary breakthroughs on the part of these early figures, the history of the photograph in the nineteenth century shows a series of fundamental contradictions, which remain endemic to the photograph as an image and as a means of representation. An aspect underlined by the way the technology of the photograph rapidly changes and develops. Daguerre and Talbot had put into place the means to record. But the rapid development in the technology of recording which followed in the nineteenth century not only reflected the industrialization of photography, in the cultural and ideological context, but also, integral to the very nature of the photographic image, a belief that there could be a perfect means of reproducing the perfect image; a hyper-reality, as it were. The camera was no longer concerned with a literal record but with something beyond the objective. Technology, in this way, has always been wedded to the 'magic' of what the photographic image promises.

This sense of 'perpetual' technological change is endemic from the beginning. By 1851, for example, Scott Archer, a sculptor (1813–57), had produced what was known as the *collodion* process: a system based on wet glass plates which superseded Talbot's calotype. Its major drawback, however, was that developing had to take place immediately after the image had been captured; a basic but crucial factor in the way the technology limited the photographer as to how and where he or she could photograph. By 1870 the wet plate, in turn, was made obsolete, and by 1871 Richard Leach Maddox, an English physician, had developed the first plates to use gelatin which, by 1877 had become the *gelatin dry plate*.

Throughout the nineteenth century, then, we can plot this continuing (if uneven) process of change which produced a veritable mosaic of photographic forms and processes; all part of the establishment of the structures and institutions of the photograph on which this most common of objects is based. And the camera, too, changed rapidly. The hand-crafted wooden and brass cameras used by Talbot were simple affairs: essentially *objets d'art* rather than technical tools. Their major drawback was in the fixed lens although as early as 1840 Voigtländer had constructed the Petzval lens, which reduced exposure time by some 90 per cent. Indeed camera design underlines one of the most obvious and yet problematic aspects of the development and reception of photography as a cultural practice. On the one hand the beautifully made but highly expensive cameras of Talbot, on the other the availability, as early as 1884 (and significantly in the United States) of the first flexible negative film, produced by

George Eastman, and, by 1888, the first Kodak camera, a name he chose because it 'could be pronounced anywhere in the world'. This was a small camera with a single speed of 1/25 second and a fixed focus. It significance was twofold. It was relatively cheap (it sold for five guineas) and easy to use. Thus the Kodak slogan: 'You press the button, we do the rest.' By 1895 the pocket Kodak had been reduced in price to one guinea and, with the arrival of the Brownie in 1900, the camera was offered for sale at five shillings (or one dollar). As the photographer Alvin Langdon Coburn commented, 'Now every *nipper* has a *Brownie*', and 'a photograph is as common as a box of matches'. Photography was, potentially, open to everyone; it had become the most mobile and the most available of visual forms. Photographs and cameras could, literally, be carried around in the pocket.

In less than sixty years, then, the photograph had changed from being the privileged domain of its early progenitors to being one of the most accessible and accepted means of visual representation. It was the ultimate democratic art form, at once sanctioning everything and everyone with potential significance—for everything and everyone could now be photographed and given status—and allowing everyone to produce photographs and construct an individual view of their world and particular histories.

And yet underlying this universalizing tendency is the complex (and shifting) distinction between the amateur and professional photographer—between photography as an 'art' (with the stress on individual creativity and expertise), and the photograph as a mass-produced object. Each domain retains its own mythology (see Chapter 9) and each involves, once again, a complex series of relationships. Talbot, for example, established a 'workshop' (at Reading) for the mass production of calotypes, while on the other hand, by 1853 in New York City there were some eighty-three portrait galleries producing daguerreotypes. Even so the distinction between the amateur and the professional reflects the extremes of photographic practice and production and is reflected in the mass of institutions, assumptions, and secondary aspects of photography's cultural status. The professional photographer still remains central and, inevitably, has dominated both the history of photography and the meaning of the photograph. Indeed, one of the many paradoxes at the centre of the medium is the extent to which an infinite number of photographs and of photographers has been dominated by a limited canon of images and practitioners; as few as 200 photographers have determined the terms of reference and the frame of meaning for the history of the photograph. Their work, and the assumptions it reflects, are basic to what we mean by a photograph. Despite its acutely populist base the photograph, for all its capacity to reproduce the literal, retains the values and hierarchies so much associated with what might be viewed as its opposite: academic painting.

What, then, *is* a photograph? It is, at its most basic level, 'a picture, likeness, or facsimile obtained by photography'. But, as we have seen, even in the nineteenth century this definition had to cover the daguerreotype, the heliotype, calotype, albumen print, gelatin-silver print, photogravure, and photogenic drawing, while in the twentieth century we could add the polaroid, electronic scanner, digital processes, and so on. The differences recall to us the inherent complexity and shifting nature of what constitutes a photograph. Any photograph is dependent on a series of historical, cultural, social, and technical contexts which establish its meanings as an image and an object. The meaning of a photograph, its efficacy as an image, and its value as an object, are always dependent on the contexts within which we 'read' it. We need to view the photograph in relation to what Roland Barthes called it: a 'transparent envelope', a potent phrase which suggests its underlying ambiguity as an artefact and a means of representation.

On a functional level, then, the photograph is dependent on its context. The 'fixed' image it offers is subject to a continuous state of transformation and metamorphosis. We forget, for example, how crucial are such obvious factors as the differences between black-and-white photographs and colour, or between small and large images, or square, rectangular, or even circular images. We might see a photograph in a newspaper, magazine (on glossy or matt, thick or thin paper), album, frame, on a wall, taken from a wallet, on a document or in a gallery, in a box or locket, or as a negative or a contact print. Each change of context changes it as an object and alters its terms of reference and value, influencing our understanding of its 'meaning' and 'status'. A passport photograph in a passport has a fixed function as an official mark of identity (itself reflecting a complex underlying series of relationships), but the same image in a gallery might attract an entirely different kudos relative to its declared status as a singular example of individual photographic practice.

And this alerts us to a further problem in the way we understand a photograph; the shifting distinction between its function as an image and its assumed value. In many ways those photographs deemed to have the most value are the least functional, and vice versa. Photographs are placed in categories (or genres) which further codify their terms of reference and status. An 'art' photograph involves an entirely different set of assumptions from a 'documentary' photograph; all part of the complex web of interrelationships within which any photograph is suspended. The extent to which so much photographic practice has been haunted in its development by what has been termed 'the ghost of painting' is crucial, for photography established, from the outset, genres and hierarchies of significance related to painting. It institutionalized the artistic and professional aspects of its meaning in

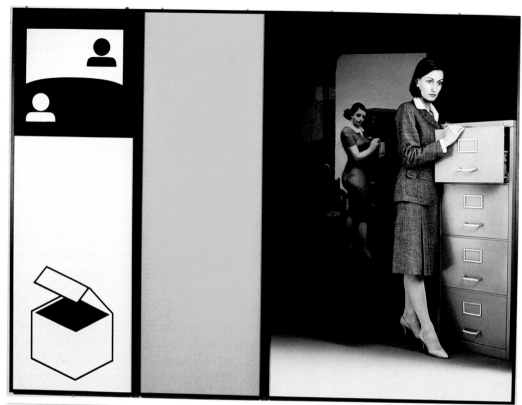

terms of an academic tradition. For example, the Photographic Society (later the *Royal* Photographic Society) was founded as early as 1853 in London, dedicated to promoting the idea of photography as a fine art.

It is a basic aspect of the photograph, however, that it 'comes of age' in a period when the whole technology of sight is undergoing fundamental change. When John Berger notes that, 'In twentieth century terms, photographs are records of things seen', he underscores the way in which the photographic image has been sanctioned as an analogue of the 'real'.[6] As a medium it has an infinite capacity to reproduce the world of its attention, for there is no end to its appetite. If every thing is, potentially a photograph, then so is every moment. What Delacroix called 'the dictionary of nature' suggests the photograph as not so much a 'mirror' up to nature as a veritable catalogue of the world.

But against this sense of the actual and the literal has always existed a powerful vocabulary, most associated with 'art photography', which insists on the medium's capacity to express something beyond the surface appearance of things. The photograph mirrors back not a literal but a super- or spiritual reality. In this mythology of creative sight the photograph allows us to see what we would otherwise not see. The camera becomes an artificial eye which, through the creative 'lens' of the photographer, probes the world in an act of revelation. A

literal record is transformed into a metaphysical moment of fixed transcendence. The history of photography is full of such attempts, and the language of photographers littered with such terms of reference. Paul Strand, for example, a supporter of Alfred Stieglitz (who was called a 'seer'), spoke of the camera's 'intensity of vision', while Edward Weston talked of its capacity for 'looking deeply into the nature of things'. Perhaps Siegfried Kracauer defined this comprehensively when he declared that 'the power of the medium' lay in its ability 'to open up new, hitherto unsuspected dimensions of reality'. Thus, 'photographs do not just copy nature but metamorphose it . . .'—the use of the word 'metamorphose' is fundamental, for the photograph, in this sense, is the very opposite of a literal record. Rather than endorse Baudelaire's disparaging remarks about its limited capacity for reflecting no more than the superficial aspect of things, this Wordsworthian (even Ruskinian) perspective mythicizes the notion of insight over sight. A language of depth replaces that of surface. The photographer, like the poet, 'sees into the life of things'.

These two extremes—of surface and depth—add to the way in which the photograph exists amidst paradox, and qualifies, once again, its status as image and object as well as the way its meaning is sanctioned within complicating aesthetic, cultural, and ideological contexts. The photograph has a multiple existence which informs its multiple meanings. Its seeming simplicity of form and function belies an implicit problematic of sight and representation. I want to look briefly at six aspects related to this problematic which, although basic, remain part of what we might call the hidden structure of photographic definition and discourse.

First, we need to be aware that both the efficacy and effect of a photograph is very much dependent upon its size. Any negative image has the potential to be enlarged as far as technology will allow, so that the image is only relative, in its immediate form, to its other spatial representation. Size is thus part of a changing and ambiguous function and status, but it is also an aspect of the medium's history within a larger aesthetics of representation, especially in relation to painting. In the first decade after the 'invention' of the photograph the painting of portrait miniatures virtually disappeared as an art form, displaced by the new technology. At the other extreme we have something like Victor Burgin's (1941–) *Office at Night, No. 1* (1986) [5], which measures 183 × 244 cm. It is an enormous photograph and clearly uses its size to establish parallels with the grand tradition of European painting, suggesting the grandiose and the epic. And yet, as a subject, what could be more banal than an office at night? Its iconography and painterly parallels (especially with Edward Hopper), however, alert us to the way we should read it, as a visual essay on the meaning of contemporary urban life. In a similar way, the 'snapshot' has a standard mass-

produced size, redolent, perhaps, of its assumed 'everyday' signi-
ficance. When we go on to select particular photographs to be
enlarged, we thus underscore their difference and value.

The size of a photograph, moreover, alerts us to the way in which
the photograph, in itself, frames space. We might frame a photograph,
but equally we use the photograph to control and order what is before
the eye. And much of this, once again, relates to the language of
painting. The two dominant terms for the frame of photographs, for
example, are 'portrait' (vertical) and 'landscape' (horizontal): the space
of a photograph has been divided between two painterly genres; both
emblematic of the way we situate ourselves *in* space and organize that
space according to aesthetic and cultural principles. However, the
polaroid camera produces a square format, with a very different
effect—the American photographer Diane Arbus was to use such a
frame as central to her portraits of New York individuals. The square
format of her images suggested a voyeurism and immediacy often
associated with the polaroid format, as well as making the entire space
of the photograph of equal significance. Of course professional
photographers will crop and enlarge at will, but we need to remember
how standardized the act of framing is and how it represents a cultural
(and ideological) way of shaping the world. Even when, in the
nineteenth century, a variety of shapes of prints were used (the
stereoscope, for example, or the circular Kodak print), photography
did not deviate from the principles of Renaissance perspective and
centring embedded in the history of painting.

The size and shape of the photograph, then, reflects a larger
structure of aesthetics and sight, and of the way we order our world.
The very act of focusing implies an element of choice, a hierarchy of
significance itself reflecting other assumptions and other values: the
conventions of the dominant ideology. And yet, if the photograph
gives credence to one frame of reference, so it makes invisible, indeed
discards, everything which surrounds the chosen subject at the
moment of taking the image. We can, as it were, never go outside the
frame of the photograph. In that, at least, it has absolute control. And
just as the photograph cuts into the space of the subject, so it alters the
scale of that which it records. Invariably it reflects the world it observes
according to the principles of one-point perspective, but it does so in
terms of the world in *miniature*. The photograph is always reductive. If
Burgin's image is virtually life-size, it self-consciously draws attention
to the very question of size, and the problematics of representation.
Any sense of a photograph's 'realism' has to be qualified in terms of the
size of the image at which we look. Entire cities are reduced to an
image of 6 × 4 inches: part of the medium's alchemy of power and
possession. We can go no further than what the photograph allows us
to 'see'. It thus reflects a continuous process of selection, editing, and

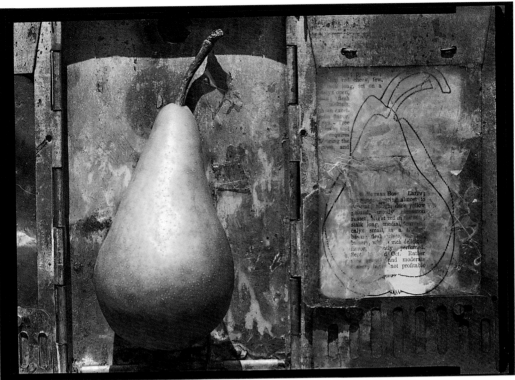

6 Olivia Parker

Bosc, 1977

Bosc, a relatively small image, is a wonderful example of the way a photograph can establish a play of possible meanings in terms of both the eye and the intellect. The image is full of visual puns, conundrums, and ambiguity. It saturates itself with questions concerning the real, the abstract, and the conceptual. Its surface complexity is akin to the cubist still-lifes of Braque and Picasso.

control; the replication, not so much of an objective reality, as of a subject framed by a set of ideological assumptions and values.

The surface of a photograph might be matt or glossy, but it is always *flat*. The obvious nature of the point belies the implications for the photograph as a form of representation. The three-dimensional illusion it offers is based on the uninterrupted expansion of a flat surface which, unlike a painting, does not draw attention to itself. Indeed, the photograph 'buries' its surface appearance, in favour of the illusion of depth and the promise of the actual. We assume that we can look into a photographic space, but we only look over and across it. We can never enter a photograph's 'depth'. Roland Barthes rightly complained about the frustration involved in the misplaced assumption that the closer we look at a photograph, the more we see.

The traditional *canon* of photography largely eschews colour, so that we are faced with the paradox of photography's 'realism' being communicated in black and white. It drains the world of colour, representing another way in which the 'realism' of photography is part of a structure of illusion to which we accede. The most obvious aspect of this remains the traditional 'documentary' image, where the presence of colour actually lessens the sense of the photograph's veracity as an image and witness. We equate black-and-white photographs with 'realism' and the authentic. Colour remains suspect. There were colour (and tinting) processes available as early as the

nineteenth century, but colour failed to establish itself as a viable alternative to black and white until the introduction of Kodacolor film in 1942. Colour photographs remain problematic. They are central to the snapshot, but are still invariably rejected by the professional and art photographer who will use colour only in a deliberate and self-conscious way: either to draw attention to the medium, or to imply a statement about the subject. Thus, rather than adding to a photograph's 'realism', colour invariably detracts from it and reflects the act of interpretation rather than of recording. Since the 1970s, certainly, the use of colour has formed part of a critical, not a representational vocabulary.

Finally, and perhaps most significantly, a photograph fixes a moment in *time*. Although, as we have seen, the exposure of the image has varied historically from hours down to fractions of a second, so the assumed speed of a camera has added to the mythology of the photograph's 'truthfulness': the record of what happened *at that moment*. But the language of capturing (most obviously reflected in Eadweard Muybridge's visual experiments for the recording of motion) must equally be placed in a cultural context. Although, as Hubert Damisch states, the photograph offers 'the trace of an object or a scene from the real world', it does so only in so far as 'it isolates, preserves and presents a moment taken from a continuum'.[7] Thus another paradox, for we look at a photograph as recording time, as a historical record, whereas invariably it stops time and, in turn, takes its subject *out* of history. Every photograph, in that sense, has no before or after: it represents only the moment of its own making.

I want to look briefly at one image by a contemporary American photographer, Olivia Parker (1941–) for it suggests how the aspects I have isolated conspire, as it were, to resist definition. Originally a painter, Parker approaches her work very much in the context of painterly representation. Thus, she is as much concerned with the act of seeing as with what is seen. 'Knowing', in this sense, is basic. And *Bosc* (1977) is an exemplary image in this context [6]. A pear has been photographed against a series of what one assumes to be small wooden structures. There is a 'pear' on the left, while on the right there is part of a written text and, over this, the outline of what we take to be a 'pear' (or 'pair of pears'). The overall surface effect is of different areas of light and texture, of depth and contrast, so that there is a wonderfully rich surface texture which promises other meanings and possibilities. Again, each area of the image is of equal significance. The eye has no point of rest, even though, ironically, we might describe this as a 'still life'. The dense resonance (a thickness of meaning rather than of surface) means that any reading of the image is relative to where the eye comes to rest within the photographic space.

But this is also an image about photographic meaning, an essay on

the capacity of the photograph to both reveal and conceal its meanings. It asks, in one sense, not only what we look at and how we look, but how a photograph encodes the 'real'. In other words, it asks what a photograph *is*. Thus, the pear is reconstituted, and referred to other contexts and meanings. The obvious subject-matter is rendered problematic, and the question of definition becomes basic. In essence, what Parker's image suggests is that the photograph, far from being a literal or mirror image of the world, is an endlessly deceptive form of representation. As an object it announces its presence, but resists definition. It is, in the end, a sealed world to which we *bring* meaning; a complex play of presence and absence. But it is also part of a dead world. Again, as Barthes insisted, whenever we look at a photograph we look at something which no longer exists.[8] The moment has passed. It replicates what we have lost, and in one sense suggests a deep psychological need to record, retain, and to classify the world of our actions. If the photograph is 'light-writing', it is also our signature on that world. It is not so much photography 'that evades us' as the world we would capture on film. Hence photography's power and fascination, and hence too its complexity. For if the photograph depends on light, it also depends on dark, and what falls between, as T. S. Eliot reminded us is, of course, the shadow. The photograph is a distinctive cultural product which reflects a culture's way with the world. As a means of possession it may be no accident that its rise and popularity was related to particular cultures. As a means of representation, it says as much about the world it 'mirrors' as it does about the world which produced the images in the first place.

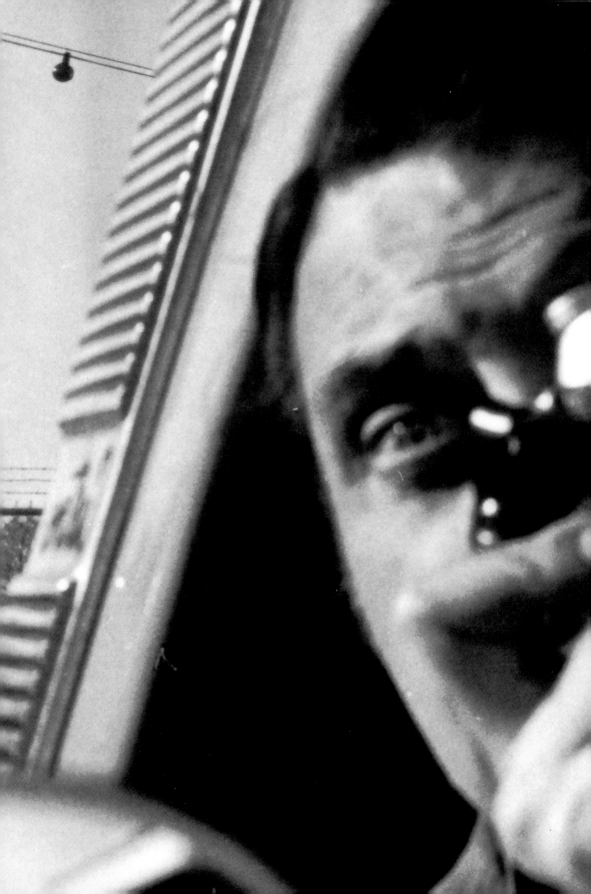

How Do We Read
a Photograph?

2

Whenever we look at a photographic image we engage in a series of complex readings which relate as much to the expectations and assumptions that we bring to the image as to the photographic subject itself. Indeed, rather than the notion of looking, which suggests a passive act of recognition, we need to insist that we *read* a photograph, not as an image but as a *text*. That reading (*any* reading) involves a series of problematic, ambiguous, and often contradictory meanings and relationships between the reader and the image. The photograph achieves meaning through what has been called a 'photographic discourse': a language of codes which involves its own grammar and syntax. It is, in its own way, as complex and as rich as any written language and, as I suggested in Chapter 1, involves its own conventions and histories. As Victor Burgin insists:

The intelligibility of the photograph is no simple thing; photographs are texts inscribed in terms of what we may call 'photographic discourse', but this discourse, like any other, engages discourses beyond itself, the 'photographic text', like any other, is the site of a complex intertextuality, an overlapping series of previous texts 'taken for granted' at a particular cultural and historical conjuncture.[1]

This is a central statement as to how we 'read' the photograph as a text and underlines the problematic nature of the photographic image as both arbiter of meaning and trace of the 'real'. And in a crucial way it lays clear the extent to which any photograph is part of a larger language of meaning which we bring to our experience of the photograph. Much of Burgin's understanding of this discourse was, consciously at least, quite alien to 'readers' of the photograph in the nineteenth century, although we can claim with some confidence that much photography was 'read' in relation to the accepted language of painting and literature of the time, especially in terms of symbolism and narrative structure. Early commentators like Poe, as much as Hawthorne, Holmes, and Baudelaire, noted the literal rather than symbolic aspects of the photograph, ignoring the extent to which it replicated cultural meaning rather than actual things.

The photograph both mirrors and creates a discourse with the

Detail of 11

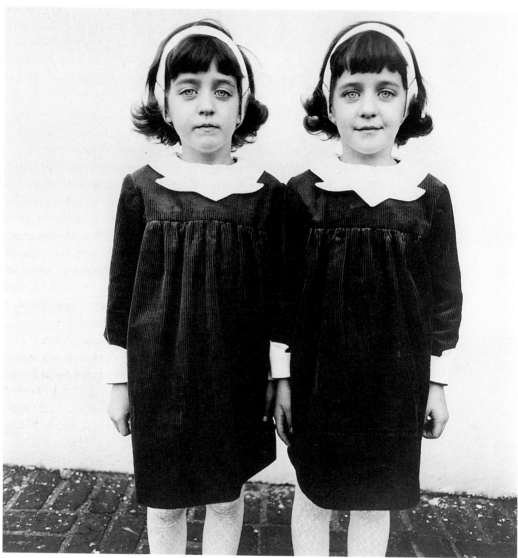

7 Diane Arbus

Identical Twins, 1967

Arbus's image is deceptively simple and belies its implicit complexity. On one level it is an exemplary Arbus photograph and reflects her concern with identity. But it is also about *difference*, and the act of looking (and judgement). In many ways it can be viewed as a visual essay on the nature of photographic meaning.

world, and is never, despite its often passive way with things, a neutral representation. Indeed, we might argue that at every level the photograph involves a saturated ideological context. Full of meanings, it is a dense text in which is written the terms of reference by which an ideology both constructs meaning and reflects that meaning as a stamp of power and authority. We need to read it as the site of a series of simultaneous complexities and ambiguities, in which is situated not so much a mirror of the world as our way with that world; what Diane Arbus called 'the endlessly seductive puzzle of sight'. The photographic image contains a 'photographic message' as part of a 'practice of signification' which reflects the codes, values, and beliefs of the culture as a whole. Its literalness, as such, reflects the *re*-presentation of our way with the world—the site (and sight) of a series

of other codes and texts, of values and hierarchies which engage other discourses and other frames of reference; hence, its deceptive simplicity, its obtuse *thereness*. Far from being a 'mirror', the photograph is one of the most complex and most problematic forms of representation. Its ordinariness belies its ambivalence and implicit difficulty as a means of representation.

To read a photograph, then, is to enter into a series of relationships which are 'hidden', so to speak, by the illusory power of the image before our eyes. We need not only to see the image, but also to read it as the active play of a visual language. In this respect two aspects are basic. First, we must remember that the photograph is itself the product of a *photographer*. It is always the reflection of a specific point of view, be it aesthetic, polemical, political, or ideological. One never 'takes' a photograph in any passive sense. To 'take' is active. The photographer imposes, steals, re-creates the scene/seen according to a cultural discourse. Secondly, however, the photograph encodes the terms of reference by which we shape and understand a three-dimensional world. It thus exists within a wider body of reference and relates to a series of wider histories, at once aesthetic, cultural, and social.

Take, for example, *Identical Twins* (1967) [7] by Diane Arbus (1923-71). This is one of her least contentious images, and on the surface at least appears to be quite straightforward. It is, so to speak, what it says it is: an image of identical twins. But as we look at it and begin to read it, so the assumed certainty of its subject-matter gives way before an increasing series of quizzical aspects which, in the end, make this an image exemplary of the difficult nature of photographic meaning.

To begin with, the notion of identical twins suggests the very mirror-like resemblance granted to the daguerreotype in the nineteenth century, and underscores the idea of a photograph as a literal record. Each twin is a reflection of the other. But 'identical' infers 'identity', and the portrayal of a self limited to the surface presence of a single image. The two aspects open up a critical gap between what we 'see' in the photograph and what we are asked to 'view'. The questions raised are made more insistent by the way in which both figures are framed within a photographic space which denies them any obvious historical or social context. We cannot *place* them in time or space, and there are few clues as to their social or personal background. Arbus has effectively neutralized their terms of existence. The background is white: a painted wall and a path run across the bottom of the image. And yet the path, as a presence, establishes the terms by which we can establish, both literally and symbolically, the basis of our reading of the image. The path runs at a slight angle, and that 'angle' reflects precisely Arbus's approach to her subject-matter. This photograph does not meet its subject in a parallel sense, but looks at it askew, even askance. Thus, what the image begins

to reflect is that, like a language, its meanings work not through similarity but through *difference*. The more we look at the image, moving over its space in time, so the more the merest detail assumes a larger resonance as an agent of identity. And yet we are left with such a pervasive sense of difference as to belie the certainty of the title. Even on a basic level such difference is vital. One twin is 'happy' and one is 'sad'; the noses are different, the faces are different; their collars are a different shape, the folds of the dresses are different, the length of the arms different, their stockings are different. All, it seems is similar but equally all is different. Eyebrows, fringes, hair, and hairbands are different. The more we continue to look, the more the merest detail resonates as part of a larger enigmatic presence and tension as to what, exactly, we are being asked to look at. Far from identical, these are individuals in their own right. They are, as it were, very *different twins*.

Identical Twins, then, recalls us to a consideration of the implicit complexity of the photographic message. But it also underlines the extent to which we must be aware of the photographer as arbiter of meaning, and namer of significance. Every photograph is not only surrounded by a historical, aesthetic, and cultural frame of reference but also by an entire invisible set of relationships and meanings relating to the photographer and the point at which the image was made. Part of any reading of this image would involve a knowledge of the work of Arbus and, in turn, her photographic philosophy. We could place it in relation to her *œuvre* as a whole, allowing its difference and similarity to other images to determine the terms by which we read it. We might note specific influences upon Arbus (for example, the work of Weegee and Lisette Model), as well as a penchant for particular kinds of subject-matter. Photographs by major photographers might be said to elicit a particular style in the same way that any author exhibits a style of writing that we come to recognize. In this sense we can view the photographer as an *auteur*, and the work as the summation of a visual style in which content and form are the visual reflection of a photographic discourse and grammar, as much as they are in writing and film. Although this is to the fore in relation to the photographer as artist, literally signing, so to speak, each image with the mark of creative authenticity, it equally recalls to us the extent to which every image is part of a self-conscious and determining act of reference to give meaning to things. The image is as much a reflection of the 'I' of the photographer as it is of the 'eye' of the camera.

In any image, however, the primary frame of reference remains the subject of the photograph (although this in itself can be problematic). Roland Barthes has suggested an important distinction here between the relative meaning of different elements within the photographic frame, distinguishing between what has been termed the *denotative* and the *connotative*.[2] By 'denotative' is meant the literal meaning and

8 Diane Arbus

A Family on Their Lawn One
Sunday in Westchester,
New York, 1969

Another archetypal Arbus
image which, highly symbolic
in its language, presents what
might be seen as a general
image of American culture.
It remains an example of the
way a single photograph can
represent a larger condition,
at once cultural, social, and,
in this instance, psychological.

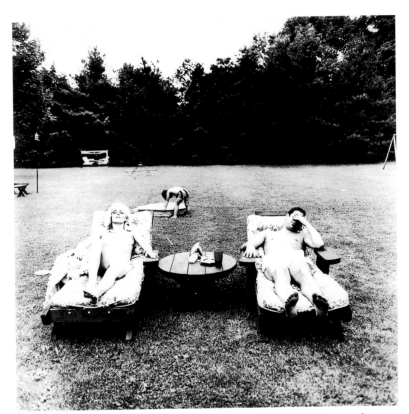

significance of any element in the image. A gesture, an expression, an object remains just that—a literal detail of the overall image. Meaning thus operates at the most basic of levels, a simple recognition of what we look at: *a* smile, *a* table, *a* street, *a* person. But beyond this moment of recognition the reader moves to a second level of meaning, that of the 'connotative' aspects of the elements of the scene. Thus connotation is 'the imposition of second meaning on the photographic message proper' ... 'its signs are gestures, attitudes, expressions, colours, and effects endowed with certain meanings by virtue of the practice of a certain society'. In other words, series of visual languages or codes which are themselves the reflection of a wider, underlying process of signification within the culture.

As we shall see, this distinction underlies the meaning of the photograph at every level, and draws into our reading of the image every detail, for everything, potentially, is of significance. On a wider level it informs the terms by which we classify and understand a photograph; for as in painting and literature, each genre has its own conventions and terms of reference. Landscape, portraiture, documentary, art photography—all imply a series of assumptions, of meanings, accepted (and sometimes questioned) as part of the signifying process: a photograph (via the photographer) can reaffirm or question the world it supposedly mirrors. In relation to this critical

context, Barthes (in *Camera Lucida*) has established a further distinction in the way we read the photograph. In discussing the photographic message, he identifies two distinct factors in our relationships to the image. The first, what he calls the *studium*, is 'a kind of general, enthusiastic commitment', while the second, the *punctum*, is a 'sting, speck, cut, little hole'. The difference is basic, for *studium* suggests a passive response to a photograph's appeal; but *punctum* allows for the formation of a critical reading. A detail within the photograph will disturb the surface unity and stability, and, like a cut, begin the process of opening up that space to critical analysis. Once we have discovered our *punctum* we become, irredeemably, active readers of the scene.[3]

Look at a second Diane Arbus image, *A Family on their Lawn One Sunday in Westchester, New York* (1969) [8]. On the surface this is an image of an average New York suburban middle-class American family, but once again, the more we look at it the more its meaning changes, until it emerges not just as a definitive Arbus image, but as an almost iconic statement on the nature of suburban America. Spatially, for example, the geometry of the image is crucial. The lawn takes up two-thirds of the photographic space and indicates precisely the sense of emptiness, sterility, and dislocation that pervades the image. Equally, the trees at the back have a looming presence that suggests a haunting otherness. Even at this level the atmosphere seems gloomy, empty, and depressing. A literal, physical configuration has given way to the beginnings of a compelling connotative register suggestive of a psychological and emotional inner space.

This is the setting for the figures in the image. The parents are separate and alone, and every detail of their figures and bearing adds to this sense of difference. The man is tense (rather than relaxed, as we might expect) and holds his head in his hand. His right hand looks to touch and make contact with his wife, but remains inert and separate. The mother also 'relaxes' but in a seemingly 'fixed' mode, just as she is dressed in a stereotypical bikini and wears make-up. Their separation is made obvious by the way in which their lounge chairs are presented formally to the camera, with the round table between them: a circular reminder of unity and wholeness, although the slatted lines imply a rigid familial and psychological geometry—a connotation further suggested by the solitary child who stares into a circular bathing pool. The boy plays alone and is turned away from his parents. The title itself 'frames' our terms of reference and guides us into the symbolic structure of the photographic message. *Punctum* follows *punctum*, so that each aspect resonates as part of a larger map of meaning, especially in relation to the associations implied by 'family', 'Sunday', and 'lawn'. An image of family relaxation seems to have been inverted and emerges as a psychological study of estrangement and loneliness

which, in its compulsive effect, speaks about a whole culture's condition. Look, for example, how obvious items of play and pleasure have been pushed to the borders of the image. On the left is a picnic table, in the background a swinging seat and see-saw, and on the right a swing; all abandoned and ignored. We could continue such a reading, noting (and explaining) the significance of the cigarettes, the glass, the portable radio, the washed-out sky, the father's dangling feet, the abandoned plate to the left of the mother, and the way the child is closer to his mother than his father: all compounded by the square format of the photograph and the way the family seems unaware of the photographer's presence.

Arbus's image, which is typical of her photography, both plays with and questions codes of meaning. It inculcates a dense play of the denotative and connotative in relation to its subject, and compounds its textual reference within a geometry of the straight and the circular. It is a static image which resonates with multiple meanings and ultimately retains a complexity which resists paraphrase and description.

Photographs have always had this capacity to probe and suggest larger conditions, which underlies the notion of an image's potential 'universal' appeal and international language. Such, for example, were the terms of reference for *The Family of Man Exhibition* in New York in 1955. Curated by Edward Steichen, its 503 photographs were divided into distinct general categories: 'creation, birth, love, work, death, justice . . . democracy, peace . . .' and so on. The exhibition thus suggested 'universal' themes which mitigated against the argument for a photographic language rooted in the culture as the ideology within which the photograph established its meaning. We can, then, speak of a language of photography, in which every aspect of the photographic space has a potential meaning beyond its literal presence in the picture.

Thus we can read a photograph within its own terms of reference, seeing it not so much as the reflection of a 'real' world as an interpretation of that world. The *punctum* allows us then to deconstruct, so to speak, those same terms of reference, and alerts us to the fact that a photograph reflects the way we view the world in cultural terms. Photographic practice, though, has in many ways made invisible its strategies and that language, so that we tend to look at the photograph as a reflection—once again, the simple mirror—but on the other hand much photography does seek to make us aware of how and why a photograph has 'meaning'; and in the twentieth century, certainly, many photographers have questioned not just the terms of reference we take for granted but also the codes and conventions of photography itself (e.g. the photographer's status, photographic genres, style, etc.).

In part, of course, such codes are central to the photograph's power

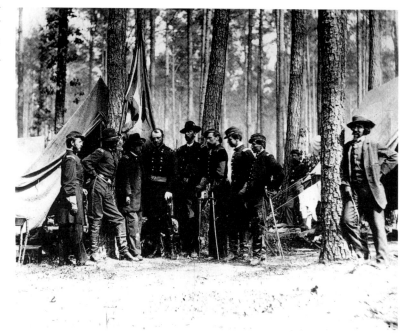

9 Matthew Brady

General Robert Potter and
Staff. Matthew Brady Standing
by Tree, 1865

A characteristic portrait
from the American Civil War.
The central aspect of this
photograph is the presence
of the photographer, Matthew
Brady, to the right of the
official military group. Brady's
presence not only questions
the terms of photographic
meaning, but the values of
the system and the subjects
photographed. Compare, for
example, Brady's stance to
that of General Potter.
Note also the insistence
on the vertical as part of a
larger symbolic military and
male code.

as an image. Its surface, flat and 'sealed' beneath its gloss coating, presents the image as part of a sealed and continuous world, so that the context in which it was taken remains invisible and outside the frame of the image. A painting, in contrast, has a surface we can identify in terms of paint and brushstrokes. It always reflects the way it was made. Photography, as a medium, is deceptively invisible, leaving us with a seamless act of representation, an insistent thereness in which only the contents of the photograph, its message, are offered to the eye.

War photography is a case in point, especially in the nineteenth century. The American Civil War was the most photographed war of its time, with thousands of images documenting its progress in extraordinary detail. This suggests that the camera is a 'witness to events', and yet even at this 'documentary' level the most seemingly neutral of images is subject to the problematic of representation. Look, for example, at Matthew Brady's (1823-96) *General Robert Potter and Staff. Matthew Brady Standing by Tree* (1865) [**9**]. Brady was one of the foremost of the official photographers of the war, and his images offer a sustained record of events. This one is typical, one of a large number of group photographs in which the Union army's hierarchy pose before the camera. So what makes this image so significant? I think the answer is twofold. First, *as* a formal picture it takes its place within a larger body of portraiture whose parallel, of course, is in painting. Secondly, the photographer himself is *in* the image (although many of Brady's images were taken by his assistants). What emerges is two different photographs with two distinct messages. Brady has made himself visible to us and, in so doing, has made photography, as much

10 Matthew Brady

John Henry, A Well-Remembered Servant, 1865
Another Civil War image the reverse of the official portrait. On its own it remains ordinary, but in the context of other images (especially Fig. 9) it takes its place within a hierarchy of representation. Thus it questions the terms of reference advertised in Fig. 9 and draws attention to the position of the black figure within the Union army. The figure's position is compounded by the way in which the smallest object (rubbish, cans, a fence, his clothes) reflects his social position. Every detail signifies something beyond its literal meaning.

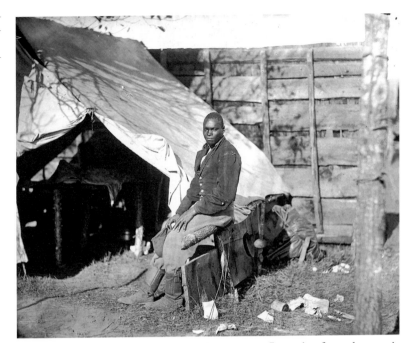

as the military group, the subject of the image. In such a formal portrait meaning is established though strict codes of significance based on a traditional (military) hierarchy of rank and significance in a male world. If we cut Brady out, then Potter, as the general, becomes the centre of attention and is placed in the middle of the photographic space. His position is reinforced by the way the rest of the group defer to him. They look at him, as do we. Potter, at the centre of the group, is also identified as the symbol of a military code based on honour, courage, and strength. His hairstyle and stance are reminiscent of the way Napoleon was pictured (or painted). Potter seems to offer himself as a representative icon of the military world he controls and of the values for which he stands. But his position is also part of his place *in* history. This is then, in one sense, a definitive portrait, akin to an oil-painting. But as with the Arbus, what begins to emerge on closer scrutiny is a highly stylized and dense register of meaning reflecting the world of the image. The vertical structure reinforces the obvious codes of authority and distinction, merging the straightness of the trees behind with the presence of the figures as they stand before us. Potter is the only figure who does not wear a hat, further distinguishing him from the group and increasing his singular status. His significance is given added 'weight' by the dense frieze-like arrangement of the group, reminiscent of a monumental sculpture. The regalia and insignia complete the impression of power and authority, as distinct symbolic languages in their own right.

As such, then, this is a conventional portrait and confirms the values of a military world and the significance of distinguished individuals as

they confirm their place in history. But what happens when we include the figure of Brady in the image? Allow Brady's presence on the right to be the object of our attention and immediately Potter is *de*-centred. The compositional balance of the 'first' photograph is completely broken. What emerges is a double structure: an official group portrait which advertises and celebrates a white military world, and a second which, through the simple presence of the photographer, questions the terms of reference of the first. Brady has established a critical distance between himself, the group, and the way the group has been photographed; an aspect further underlined by the way his own pose, nonchalant and casual, is in direct contrast to the others. In terms of Barthes's reading of photographs Brady's presence creates a *punctum* which begins a process of questioning. Brady, along with such figures as Timothy O'Sullivan and Alexander Gardner, is among the most celebrated of the 'official' war photographers of the period, but once we begin to question the context, the terms of imaging, the treatment of subject, and so on, a very different image of the war emerges, and a very different sense of war photography as an historical account. What such images show us is not so much a history as an ideology, and in their accretion as a composite image they create a sustained photographic essay on that ideology. Collectively they build towards a critical questioning and, far from 'official', they suggest the contradictions and myths at the centre of the culture. Thus, in relation to the General Potter photograph an image like [**10**] takes its place within a very different tradition of portraiture and history, as a fundamental inversion of the 'official' portrait. This is, literally, the underside of the formal advertising and reveals the Potter image as both propagandist and mythologized. The single figure is isolated, at the margins of the world depicted and at the bottom of the hierarchy. Most obviously he is black, and just as his presence was missing from the white world of Potter's image, so here he is restrained within a domestic context. He is named as a servant, passive, and surrounded by rubbish. His uniform confirms his condition.[4]

Such a critical and self-conscious use of the medium is most often associated with radical twentieth-century photography, especially since the 1950s, when there has emerged a sustained questioning of the terms of representation and the structures of meaning very much influenced by critical theories associated with modernism, and in the postmodern period, by structuralism and semiotics. But in many ways we need to see all photographs in the same terms and be alert to the extent that photographers have always been concerned with the context of both the photograph and the act of taking it. The illusion of a photograph's veracity is always open to a *punctum* which allows us to read it critically and to claim it as not so much a token of the real, but as part of a process of signification and representation.

The extent to which many contemporary photographers have questioned the idea of a single representational space and made the reading of the photograph their subject helps to place all photography within the context of postmodern practice. The irony that photography achieved its ascendency as a visual medium confirming a real world just at the point when literature and painting were rejecting the aims and assumptions of realism, is tempered once we agree to a theory of photographic meaning as being as problematic as anything we find in such works as *The Waste Land*, *Ulysses*, or *Les Demoiselles d'Avignon*. Just as Wallace Stevens declared that in modern poetry the subject was 'poetry itself', so in painting the act of representation itself became central. Photography has followed a similar development, creating the terms for a critical reading of its meaning and status as a mode of representation.

One such photographer is the American Lee Friedlander (1934–). Friedlander's photographs are deliberately difficult to read, indeed, they make difficulty basic to their meaning as part of a larger critical process. The question of the terms by which we read a photograph, and the status of the world it 'reflects' are central to his whole enterprise. His eye roams the United States not as a Walker Evans intent on a vision of a particular cultural order, but as the recorder of a series of random events and images which, once questioned, fail to cohere. What emerges is a disparate world of chaotic images and signs, signifying processes in which everything hovers about meaning but finally only declares itself as part of a larger problematic structure. And within this process the photograph directly implicates us in the act of reading. It neither draws us into its assumed space, nor mirrors back a world which affirms our own terms of reference. Instead, it purposefully distorts the world we take for granted and makes the photographic act part of a larger way of seeing and constructing meaning. His images are not so much a record of what is, as visual essays on cultural representation. Highly self-conscious, they work through paradox, the play of absence and presence, radical perspectives, and the breaking up of the photographic surface to create new and difficult relation-ships.

Thus Friedlander makes the act of reading basic. One of his most famous images, for example, *Route 9W New York* (1969) [11], includes a reflection of the photographer in the wing-mirror of his car as he takes a photograph at the scene on which we look. It is definitive Friedlander territory—a visual space in which the theoretical is central to the scene/seen. The very act of looking is displaced as part of a larger process of construction. The mirror establishes a self-reflexive term of reference, and opens up the image to a complex and ambivalent photographic and cultural discourse. The mirror is, in fact, basic to Friedlander's effect, for he will not just, Brady-like, include himself in

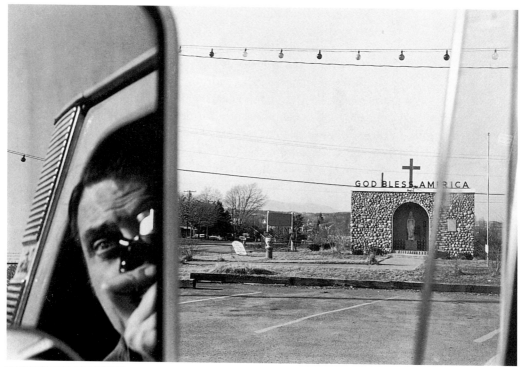

the scene/seen, but makes reflections, shadows, part of a radical symbolic presence.

The process is similar in another exemplary Friedlander image, *Albuquerque* (1972) [**12**]. One of a number of images of America, this could be anywhere and nowhere. At first glance it appears as a bland and nondescript image, but then begins to resonate with a rich and profuse meaning. In characteristic manner Friedlander has broken up the surface of the photograph so that an ordered, three-dimensional space is simultaneously questioned and altered. We look not at Alberquerque but at a photograph. It resists any single focal point, so that our eye moves over and over the image without any point of rest, any settled or final sense of unity (and unitary space and meaning). It photographs the most obvious of urban things: a block of flats, a dog, a fire-hydrant, a car, a road, and yet fuses them into an enigmatic series of connections. Friedlander makes the familiar unfamiliar, and the obvious strange. In this image, for example, there is no sense of depth, so that everything exists in a two-dimensional rather than three-dimensional perceptual space. Any 'depth' exists in relation to the conceptual density of the image. In a connotative context, we note how the image is saturated with signs of communication. A sterile scene is glutted with the process of possible connections: the car, the road, the telegraph wires, and the traffic-lights. And of course the act of communicating, the lines of meaning, are part of the photograph's subject. Friedlander thus creates a photographic space which makes

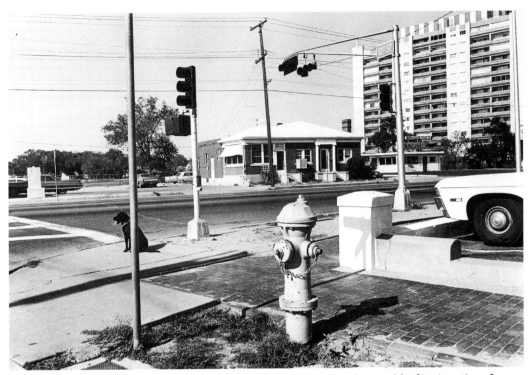

12 Lee Friedlander

Albuquerque, 1972

Although a somewhat banal image, this is deceptively complex and almost gluts the eye with images of implied communication. All the elements of the image remain on the *edge* of meaning. The atmosphere is one of emptiness. The photograph is a distinctive statement about contemporary America.

critical analysis and cultural meaning the world of its imaging. Just as his discontinuous and deceptive images make central the language and syntax of the photograph, so they often exhaust the subject in order to reduce it to little more than a marginal and banal presence. The most obvious and marginal subject often resonates as part of an on-going ambiguity and difficulty. In short, they offer us exemplary images for how we read a photograph and how the photograph constructs meaning.

Friedlander's images change the history of the photograph and give us a critical vocabulary by which to read its development. They return to the basic distinctions between the denotative and connotative so insisted upon by Barthes and Umberto Eco,[5] and make clear that, as much as in painting and literature, the meaning and practice of photography takes place within its own series of codes and frames of reference. When Barthes declared that photography 'evades us' and is 'unclassifiable', he alerted us to the paradox of something seemingly so obvious and yet so problematic. The following chapters take up that paradox and suggest a reading which celebrates the photograph in all its ambivalence and strangeness as a mode of representation.

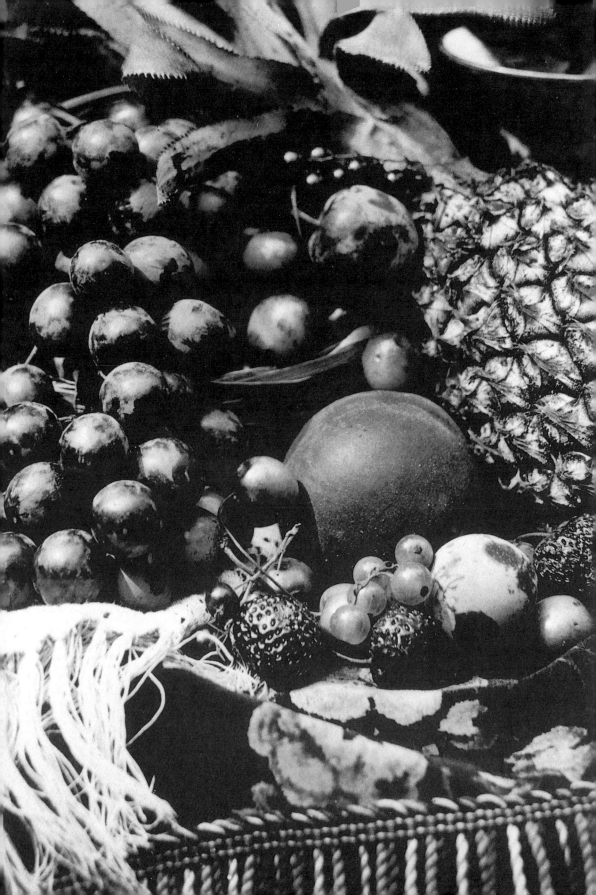

Photography and the Nineteenth Century

3

Five years after the announcement of the 'invention' of photography, Henry Fox Talbot issued (in instalments) one of the most momentous photographic publications ever. *The Pencil of Nature* (1844) has been called a 'classic'. Its significance lies not so much in the fact that it is the first book to contain photographic images (twenty-four pasted-in calotypes), nor even that it was mass-produced (Talbot's Reading 'factory' produced some 2,475 prints), but that it both predicted and set the terms of reference for the way photography was to be viewed for much of the nineteenth century.[1]

And yet although in the text Talbot is concerned to give an account of the way he developed his photographic technique, he does so very much in terms of painting. Indeed, one of the primary points of reference throughout the nineteenth century is the extent to which photography continues to be understood in relation to painting. Thus we read that the 'new art of photogenic drawing' is achieved 'without any aid whatsoever from the artist's pencil'. Photography is, by implication, an 'art' and is judged accordingly. The camera will, thus, 'make a picture of whatever it sees'. The very title of the book, *The Pencil of Nature*, underlines the analogy with drawing. The word 'art' appears continually throughout the text, underscoring the extent to which Talbot understands the photograph in terms of painting.

Despite the insistence on the literal and the minute the emphasis is on the aesthetics of beauty. (Talbot's term 'Calotype' was derived from the Greek *kalos*, 'beauty'.) The description of its literal and aesthetic qualities underscores its status. Indeed, the implied combination of aims is reflected further in the hierarchy of subjects that Talbot declared as appropriate for the photographer. Thus, cultural 'types' such as sculpture, architecture, landscapes, and 'facsimiles' (portraits) were set alongside both natural and man-made 'objects': insects, plants, lace, cotton, and 'microscopia'. Again there is a mix of the traditional fine arts with the scientific; one half associating the photograph with the academy and the *beau ideal* as propounded by Sir Joshua Reynolds in *The Discourses*, and the other relating it to the newer concern with detailed observation: a literal rendering of the thing seen dependent upon its accurate recording by the eye. In

Detail of 18

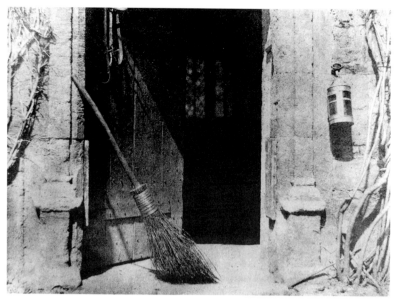

Talbot's own work there is a similar tension: images of specific objects,
bonnets, books, bottles, a breakfast table, all vie for attention with such
formal compositional pieces as *The Open Door*, *The Haystack*, and *The
Ladder*.

The Open Door (1843) [13], for example, is one of the book's set
pieces and (as has been argued) approaches the status of a painting.[2]
Talbot wrote of it, 'we have sufficient authority in the Dutch school of
art for taking as subjects of representation scenes of daily and familiar
occurrence. A painter's eye will often be arrested when ordinary people
see nothing remarkable.' He justifies the choice of subject in relation to
painterly tradition. Even here the 'painter's eye' is sought out for
approbation, a synecdoche for the photographer's sense of both choice
and composition. Certainly the sense of composition is crucial: *The
Open Door* is not a candid or passing shot. It is as calculated and as
composed as any painting, with a clear reference back to seventeenth-
century Dutch art, as much as to a higher connotative vocabulary
which unites its composition. A highly formal structure binds together
a series of carefully chosen symbolic elements: the open door, the
broom, the lamp. As we 'read' it, the formal geometry of light and
pattern binds the symbolic references of the foregrounded objects, so
that a series of symbolic and narrative levels emerges which moves it
beyond the simple delineation of literal or found objects.[3]

Consistently in Talbot's work there is a tension between the
denotative and the connotative, as if things are justified as photographs
only in so far as they relate to painting. It both suggests a dialectic
between denotation and connotation, between realism and idealism,
so to speak, and, of more significance, between those who can read the
photograph, and those who cannot. And certainly within the British

nineteenth-century tradition Talbot's approach underpins one of the central tensions in coming to terms with the 'new art'. It recalls to us how much, from its inception, the meaning of the photograph has been encoded within the language and values of academic art. Even most of its basic genres, the portrait, the landscape, still life, and so on, develop from a painterly basis and establish many of their own terms of reference through their painterly equivalents.

In 1861 C. Jabez Hughes (writing on 'art' photography) distinguished between three main levels of the photograph. *Mechanical photography* consisted of those photographs 'which aim at a simple representation of the objects to which the camera is pointed . . .' In these, everything is to be depicted exactly as it is. This is called 'literal photography'. As distinct from such basic recording there is *Art-photography*, where the photographer (as artist) 'determines to diffuse his mind into [objects] by arranging, modifying, or otherwise disposing them, so that they may appear in a more appropriate or beautiful manner'. And thirdly, *high-art photography*, consists of 'certain pictures which aim at a higher purpose than the majority of art-photographs, and whose purpose is not merely to amuse but to instruct, purify, and ennoble'. Here, then, are three distinct categories, a hierarchy as closed as Reynolds's, with a status dependent on a meaning and assumed effect characteristic of nineteenth-century British culture.[4] For the Victorian, such high-art photography was to be found in the work of Henry Peach Robinson (1830–1901) and Oscar Gustave Rejlander (1813–75). Both developed what were known as *composite photographs*, a process based on combination printing which used a series of negatives to construct the photographic image proper. The photographs are distinguished by their false appearance, for they are made up out of separate scenes and demand for much of their effect

14 Gustave O. Rejlander

The Two Ways of Life, 1857
A photograph which apes the 'grand style' of painting. This is a definitive combination print which, in its heavily plotted moral symbolism, reads like a Victorian narrative painting.

15 Henry Peach Robinson

Fading Away, 1858

Robinson's image reflects the Victorian penchant for the sentimental and melancholic. Its significance rests in the issues it raised about the real and the faked. As a documentary image (supposedly) it looks forward to current debates on documentary photography and advertising. It is, of course, a fake scene, and at the time caused a minor scandal.

a high degree of the theatrical and the parodic. Their significance is twofold, first, as aligning the photograph with Victorian narrative painting, and secondly, as stressing the moral context of the image. Two of the most famous, Rejlander's *The Two Ways of Life* (1857) [**14**] and Robinson's *Fading Away* (1858) [**15**], remain distinctive period pieces. To the modern eye they seem peculiarly dated and moralistic. *Fading Away* caused a furore when it was first published because it was assumed to be an actual (*sic*) photograph of an actual (*sic*) scene. It is a telling irony that it was acceptable to the public only as a fabrication, not as a literal image. The subject was accepted as part of Victorian conventions; but a photographic intrusion into private family space was not. *The Two Ways of Life* is based on a series of obvious oppositions between the moral and the immoral. On the right are images of thrift and industry; on the left images of the profligate and degenerate. Its size, and the scope of its moral tale, equate it with the grand style in painting, and its period quality borrows directly from earlier painterly tradition and iconography. Both pictures are staged with the purpose of telling a visual story. Like Talbot's images, they depend upon a known visual language and convention, as found in the work of contemporary painters like Millais and Holman Hunt. They are, as much as Talbot's work, examples of the photograph as a painting.

The other extreme in the period is that 'mechanical' photography looked down upon by Jabez. In this area we find significant differences in the approaches of photographers working in the three main nineteenth-century photographic traditions: British, French, and

American. The work of Roger Fenton (1819–69), for example, is central to any understanding of the nineteenth century[5]. He produced images in all the (then) accepted forms: landscapes, cityscapes, still lifes, and portraits, and as much as Talbot, he views the world according to a strict hierarchy of values, very much associated with the landed upper classes he photographed. His images do not question cultural assumptions, but rather they reinforce them in a way that eighteenth-century painting did for its wealthy patrons. They are painterly to a high degree. Even the famous Crimean War images ignore the brutality of war, instead creating set pieces of an army at leisure and bound by the strict codes of behaviour and hierarchy of nineteenth-century England. There is no democratic or questioning frame of reference in Fenton. His quintessential image of the 'valley of death' with the ground strewn with cannonballs, is an empty scene, as if the reality of what had happened could not be photographed. We see the same selective eye at work in his landscapes, and even when he photographs London it is the central London of Westminster and Hyde Park that he chooses: a highly selective imagery which celebrates public buildings and monuments as symbols of power and order. The sprawling and chaotic London of Charles Dickens and such photographers as John Thompson is absent.

This selectivity is nowhere more obvious than in Fenton's photographs of still-life objects. The photographing of objects is of the essence to early photography, such mechanical recording supposedly reproducing the actual without intervention from the photographer. What we looked upon was 'real'. There was, though, a clear distinction between still life and objects. A still life, like the portrait, was to be understood through terms of reference drawn from painting. The imaging of objects for their own sake, though, is part of an unstructured probing of the external world. The camera is an eye which seeks out things, rather than a frame of reference which reads things according to a predetermined hierarchy of significance.

This attitude is part of a larger cultural and scientific revolution, and develops differently within the three traditions I have noted. It is clearly of significance, for example, that the 'founder' of sociology, Auguste Comte, developed his ideas in the same period as Daguerre. The drive to collect and classify the world of objects and structures, developed through the work of such figures as Buffon, Lamarck, and Cuvier, is reflected in such images as Daguerre's famous *Shells and Fossils* [16] of 1839, suggestive of an entire tradition and placing photographs in the context of this larger process of classification. It reflects both the developing museum culture, and the way in which the photograph was seen as an analogue of the real. The objects in such photographs display a fierce insistence on their own authenticity, much as things do in a museum cabinet. We look at them not because of any

16 Louis-Jacques-Mandé Daguerre

Shells and Fossils, 1839

An image which reflects both the museum culture of the nineteenth century and the urge to classify and collect. The act of photography is suggested as a parallel process.

secondary meaning they might have, but as *objets trouvés*. A similar condition is achieved in the work of another pioneer of French photography, Hippolyte Bayard (1801–87) who, amongst other subjects, photographed garden implements as things in themselves, underscoring a continuing empiricism as a basic aspect of the French tradition. (See, for example, *The Overturned Pot* or *The Hat*.) Phenomenologically, there is a primary concern with the thingness of things, whereas even when Talbot photographed shelves of books [17], it was as a library, with all that implies about his own position, his academic knowledge, and the cultural traditions within which he worked and wished his images to be read.

Like Talbot, and in contrast to the French tradition, Fenton's still lifes are painterly in their formal, compositional qualities. Nor does he choose to depict everyday or common objects: falling into two groups, his subjects are either dead game or fruit [18]. While Fenton's photographs are wonderfully alert to texture and light, with a remarkable play of surface detail, it is the subjects themselves that are distinctive, for they reflect wealth and privilege to a high degree: the bounty from the landed estate, the walled garden, and the Victorian greenhouse. The luxurious and exotic nature of the images are as much a celebration of the countryhouse as are Fenton's landscape and London images. Compare this with Calvert Jones's *Garden Implements*

(1847?) [**19**]: here the implements are not only displayed in terms of their functions—they seem to speak to the very world of labour which produced the fruit for Fenton's images in the first place.

Debates over the relationship between the photographic image and its painterly equivalents continued throughout the century. Naturalism, it was felt, was to be avoided. An article by Lady Elizabeth Eastlake in the *Quarterly Review* in 1857 announced that 'fifteen years ago . . . specimens of a new and mysterious art were first exhibited to our wondering gaze', since when, 'photography has become a household word and a household want'. She went on to say, though, that the more precise the photographic image was, the less would be its 'aesthetic significance'. What was wanted was a *general image* to suggest the effect, not the thing itself. In 1853 Sir William Newton, speaking to the Photographic Society, had argued against 'minute detail' and favoured a 'broad and general effect'. Thus, 'the object is better obtained by the whole subject being a little out of focus . . .' The effect would be 'more suggestive of the true character of nature', and would be found to be 'more artistically beautiful'. It is an argument that hovers between the language of Talbot and that of the later pictorialists, suggesting once again elements of the Reynoldsian *beau ideal*, and arguing for a general nature against the very specific language of detail that the image could produce.[6]

Much nineteenth-century photographic practice, then, was conducted within the language of painting and academic notions of beauty. Indeed, in relation to the work of Julia Margaret Cameron (see Chapter 6), the relationship is extended to literature, for in her association with Alfred Lord Tennyson the attempt to suggest a general effect and ideal beauty is given qualities associated with poetry.

17 William Henry Fox Talbot

The Library, 1845

This image is similar to Talbot's image of Victorian bonnets in a shop window and confirms the nineteenth century's obsession with *things*. However, it also confirms the context within which Talbot photographed, for this is his library and reflects the literary context through which he read his world.

18 Roger Fenton

Fruit, 1860

A Victorian image which has clear parallels with painting. This is a photographic 'still-life' and looks towards the later studio studies of shells, fruit, and vegetables by such photographers as Edward Weston. Fenton's image has a remarkable tangible quality about it but it equally reflects the highly privileged life-style of those to whom such exotic foods were available.

As Tennyson wrote in his poem 'On a Portrait', the painter had to seek 'rare harmonies' in order to achieve the 'mystery of beauty'. In that sense, many Victorians were as much painters as they were photographers.

Other developments, however, raised different questions. The nineteenth century also saw the establishment of a major tradition of travel photography. This was the great age of European empire, and in the work of such photographers as Francis Frith (1822–98), John Thompson (1837–1921), Samuel Bourne (1834–1912), Maxime Du Camp (1822–94), John Murry, and Félice Beato (active 1860s–1890s) we can see foreign (non-European) cultures viewed through western eyes and western assumptions. One could add the name of Herbert G. Ponting (1871–1935), who published photographs taken on visits to Japan, India, and Antarctica. Books such as Frith's *Visits to the Middle East* underscored the interest in and demand for scenes 'foreign'. In these images the photographer is 'cultural interpreter and witness to the world', but only because his assumptions place him at the centre of the geographies through which he moves. Many of these images have a valuable ethnographic and anthropological significance, imaging in

detail the artefacts and values of other cultures and civilizations, and in the process making the world they photograph part of a museum culture. In a period when many western archaeologists were physically carrying away the artefacts of the cultures they viewed, photographers were able to 'capture' entire monuments as a way of possessing that world for European eyes. Francis Frith's *Entrance to the Great Temple, Luxor* (1857) [20] is characteristic of the period, focusing on a significant building from the position of an outsider, placing the scene and its figures in a picturesque frame of reference. These lands exist, as it were, for the benefit of the western camera. In a period of limited travel and communication, photographs offered wondrous images of otherwise only imagined cultures. They point to the international terms of reference that a visual culture beginning to establish itself would offer; and the basis of that new culture would be the photograph.

19 Calvert Richard Jones

Garden Implements, 1847?

Jones's image might be compared to Talbot's *The Open Door* as well as to images by Hippolyte Bayard. Unlike Talbot, however, Jones has 'arranged' rather than structured the implements so that they retain their literal meaning.

20 Francis Frith

Entrance to the Grand Temple, Luxor, 1857

Frith's image is one of many travel photographs in the period. Indeed, such images established 'tourism' as a genre in its own right. They reflect the new freedom of the photographer to record other cultures as well as to impose (via the camera) his or her own cultural view upon the scene. Such photographs reflected western assumptions about 'foreign' lands and were intended for European consumption.

In other contexts the camera started to concentrate on specific, even limited, locales in order to image acute analyses of the life lived in them. Such is the work of Lady Clementina Hawarden (1822–65). An amateur photographer, she made her central subject the depiction of women in closed and constricted privileged environments. Although to some extent influenced by the Pre-Raphaelites, there is in her work a highly charged analytical approach to her subjects which avoids documentary and edges towards portraiture. It is the individual self that is so significant. The long dresses almost imprison their wearers, and the interior spaces are more like cells than domestic rooms. Figures are isolated, alone, or are looking and being looked at—as if there is a continuing presence of surveillance. The effect is not unlike the inner turmoil of Lucy Snowe in Charlotte Brontë's *Villette*, (1853) who struggles against social restriction and the limitations placed on women's lives. *Clementina Maude* (1863–4) [**21**] is exemplary Hawarden. The mirror sets up the terms of inner reflection as well as the woman's image as a surface reflection and social construct. The figure on the bed is photographed as herself, with a suggestion of inner distress intensified by the way the window, the door, and the mirror all exhibit a restrictive and overpowering presence. Such an image might be contrasted with Camille Silvy's (1835–?) full-length portraits of the great and the good in the same period. A French aristocrat, and a producer of the then-popular *cartes-de-visite*, Silvy was a renowned

portraitist. But he effectively renders back a surface figure clothed in the symbols of power and privilege. There is no critical distance between himself and the subject, such as Hawarden achieves. Like the *carte-de-visite*, these are images which advertise a public self, not a private condition. Along with Anna Atkins (1799–1871), the 'first' woman photographer, Julia Cameron, and Anne Brigman, Hawarden constitutes part of a powerful and central female tradition within the period.

Hawarden responded to a cultural condition, but another central figure in the period responded both to the condition of photography and his chosen subject-matter. Peter Henry Emerson (1856–1936) was a central figure in what is understood as 'pictorialism'. He denounced Robinson as 'the quintessence of literary fallacies and art anachronisms'. The statement is characteristic of his approach. Emerson sought a new understanding of the photograph, based on its own terms of reference and its own possibilities as a medium. He thus discounted the continuing comparison with and dependency upon the painting as the primary point of reference. He was, of course, influenced by painting, but his tradition is that of Constable, Corot, and the Barbizon School: those painters dedicated to a literal, realistic rendering of the thing seen rather than to a carrying on of received convention. He (mistakenly) argued for a photography based on the science of sight and renounced comparisons with painting, insisting instead on the possibilities of the photograph itself as an art in its own right, with its own distinctive features. In Emerson's approach detail,

21 Lady Hawarden

Clementina Maude, 1863–4
An image which suggests the closed and restrictive environment of the Victorian woman. Although ostensibly portraits, Hawarden's photographs reflect a psychological condition similar to that expressed in the writing of the period, most notably by the Brontës and George Eliot.

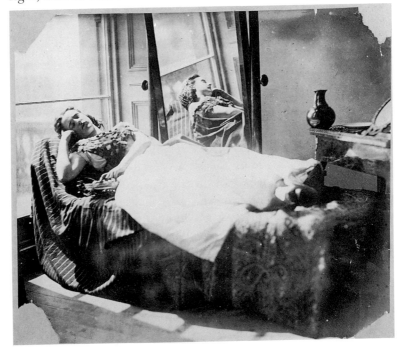

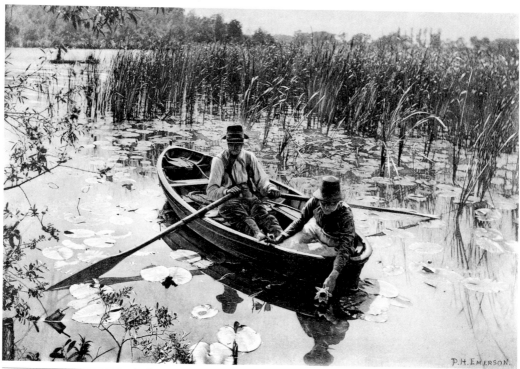

22 Peter Henry Emerson

Gathering Water Lilies, 1886

A representative image from Emerson's extensive and detailed study of life on the Norfolk Broads in the nineteenth century. The photographs have about them a pervasive melancholy which suggests the passing of a way of life.

light, and the formal composition of the scene are central, but it was the *seen* rather than the scene that remained crucial. The potential for a photograph lay in what was before the camera. This was pictorialism at its most pure, and we can understand why it was Emerson who awarded Stieglitz first prize in a photographic competition in the 1880s. He argued against retouching,[7] soft focus, and combination printing, just as he rejected photographs with an allegorical or narrative structure. His aims are reflected in his use of the platinotype (and photogravure), for these were considered more permanent and delicate in their ability to reproduce tonal variation, and palpable in terms of the atmosphere they suggested.

Emerson was individual in a number of ways, but his essential concern was to photograph a particular area. Just as Thomas Hardy had focused on Wessex as his imaginary geography, through acute attention to the detailed depiction of a specific area, so Emerson's record of East Anglia and the Norfolk Broads constitutes one of the most sustained photographic studies of a single area and community in the history of the photograph. The depiction of everyday life from the point of view of an outsider is both acute and detailed. His *Life and Landscape on the Norfolk Broads* (1886) and *Naturalistic Photography* (1889) reflect his underlying philosophy which, although he was to reject it shortly afterwards, nevertheless remains central to the development of the medium. In image after image Emerson achieves a remarkable degree of presence [**22**]. Everything within the frame of the

image is, seemingly, given equal attention—a 'democratic' approach, quite distinct from what we find in Fenton, for example. Indeed one of the extraordinary things about Emerson's images is their modernity. Emerson has stripped the image of its associations with painting. In his photographs we receive an image of a specific community as it was. Where Fenton might have referred it to another context, so Emerson claims them for his own camera. Yet these are not literal, much less documentary images. They have, in their own way, a poetic resonance, such is the acute attention to the individual terms of reference. In brief, they look at what they see, and do so in terms of what is there rather than what is assumed to be there. They bring a needful humility to both the scene and the seen.

The strength of this whole period, however, is astonishing. The portraits of Hill and Adam (see Chapter 6), the detailed accounting of the area of Whitby (in Yorkshire) by Frank Meadow Sutcliffe (1853–1941), and the extraordinary architectural studies of Sir Frederick Evans (1852–1943) or the work of George Davison, whose *The Onion Field, Mersea Island, Essex* (1890), made with a pinhole camera, underscores his involvement with the Linked Ring, all point to the variety of the age. Lewis Carroll (Charles Dodgson, 1832–98) is another significant photographer (as well as the author of *Alice in Wonderland*), although his images of children have raised questions regarding his depiction of the body; Sutcliffe's images are detailed excursions into a particular environment, almost Atget on a small scale. They offer an acute record of place in the most understated of ways. Likewise Evans, whose forte was architecture, especially cathedrals and (French) chateaux. A member of the Linked Ring, Evans wanted a 'pure' photography which, like Emerson, sought an image based on the possibilities of the medium itself. His interior images stress surface and texture as much as light and space—an environment of constant change and subtle delineations. They belong to the photograph as a fine-art tradition.

The century gave very much a mixed response to the question of what the photograph means. Indeed, Lady Eastlake's essay remains appropriate as an estimation of the whole period. It announces the photograph as belonging to 'a kind of republic' in the way it unites 'the tradesman' and 'the nobleman' in a single enterprise; it also stresses the immediacy of the medium. Thus, to photograph 'is to give evidence to facts'. This is its unique role, but in turn, this is also the very ambiguity that is to be carried forward into its status as a medium for the twentieth century. The modern photograph as such, drags its nineteenth-century past into every image.

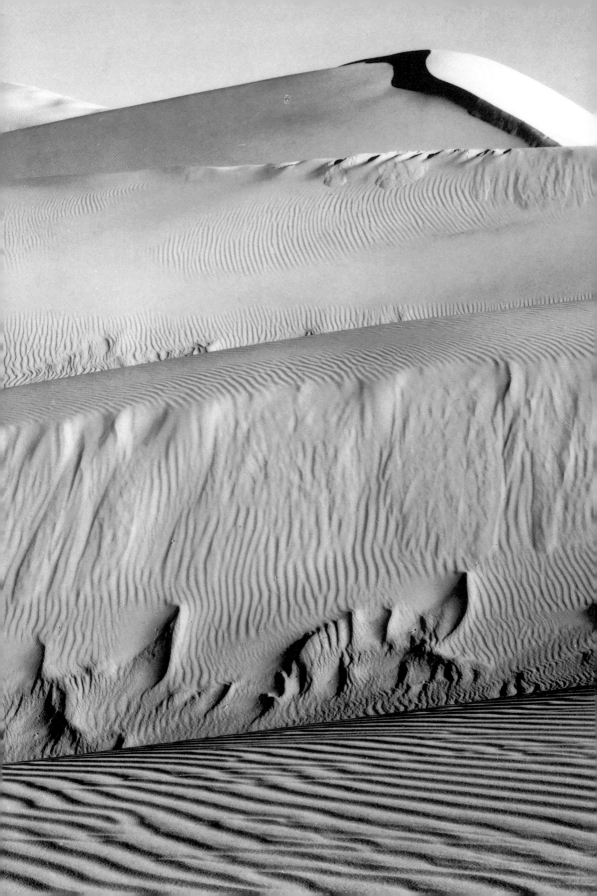

Landscape in Photography

4

Perhaps even more than the portrait, landscape photography remains encoded within the language of academic painting and the traditions of landscape art which developed during the eighteenth and nineteenth centuries. Talbot's use of the camera lucida in an attempt to draw a landscape scene in Switzerland not only underlies the concern with accuracy, the depiction of a particular locale, but lays stress on the implicit relationship between painting and photography in its depiction of landscape. Photography emerged at a time when painters were not only seeking a new realism of the kind we find in the work of the Barbizon School, and when western cultures were establishing a new awareness of the processes of the natural world, what John Ruskin called 'a science of the aspect of things'; it also emerged at a time of the continuing exploration and settlement of new lands. The photograph allowed the land to be controlled, visually at least—to be scaled and ordered, in the way that white colonial settlement attempted politically. But a photograph's ability to record a scene was equally matched by the increasing concern with light and time, which was to reach its apogee in the work of the Impressionists. By implication, a medium whose name meant 'light writing' was well suited to the instant recording of natural process and energy.

But the photograph also established itself at a time when the landscape, especially in England, was viewed through a highly developed and popular picturesque aesthetic. The notion of the 'picturesque' established a series of ideal images and terms of reference by which a landscape scene was to be judged and deemed appropriate for inclusion in a painting or a photograph. The picturesque tourist sought out ideal scenes according to specific assumptions; an outlook that became almost pervasive. In this sense landscape was not viewed so much in relation to its natural features as to the way it offered images of a rural idyll quite at odds with the reality. As a cultural index, the picturesque thus sought visual confirmation of a timeless Arcadia; a unified image of social life.[1]

Landscape photography, certainly within the British tradition and, in different ways, in the American context, has moved between these two poles of reference. On the one hand, photographing the basic elements of nature in its concern with particulars (trees, flowers, and so

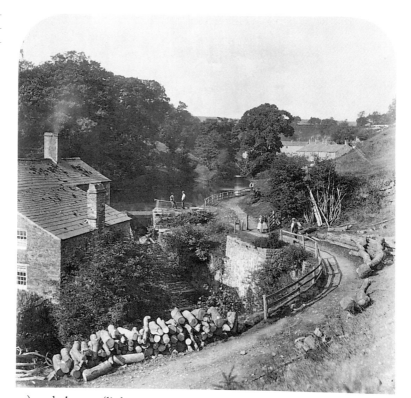

Mill at Hurst Green, 1859
Roger Fenton's landscape
photographs remain very
much within the picturesque
tradition. This image is a
postcard for the nineteenth
century. It views the village
as part of a pastoral tradition.
In relation to such writers as
Thomas Hardy, Fenton's
response remains idealized
and touristic. Note the way
the figures pose for the
camera. There is no evidence
of work, nor of poverty and
hardship. The viewpoint
confirms the imposed 'unity'
of the scene.

on) and change (light, water, sky, and the seasons); and on the other,
seeking out quintessential images of rural harmony—pastoral scenes
of a postcard culture. This is obvious, for example, in much
nineteenth-century English photography, especially in relation to
the work of Roger Fenton. In his approach to landscape Fenton
both reflects a highly specific cultural vocabulary based on literature
and painting, and does so in relation to specific social codes
and assumptions. Indeed, this sense of the photographer as privileged
tourist is underscored by the way Fenton often photographed
established tourist areas which had already been depicted in painting
(and literature). His photographs feed from the vocabulary of tourism,
and structure themselves according to their representation in painting.
His images thus reflect the leisurely assumptions of a class of people
who looked upon landscape scenery in aesthetic and philosophical
terms; part of a picturesque tradition that was as much the product of
William Gilpin as it was of Richard Wilson, Thomas Gainsborough,
and John Constable. Theirs was an image of Britain at peace with
itself. Whether it be the country estate, the village, or the country lane,
the land seemingly reflected a social harmony and beauty equivalent to
an assumed natural unity. They looked on approvingly; as Roger
Fenton declared, the English sought images of 'the peaceful village,
the unassuming church . . . the gnarled oak . . .': all central icons
of harmony, and he responded accordingly.

Fenton's landscape photographs offer an almost definitive index of Victorian attitudes to landscape.[2] *Mill at Hurst Green* (1859) [**23**], for example, suggests a quintessential English village scene, and views its subject from the point of view of the tourist, as a pastoral alternative to the vicissitudes of urban life. In such scenes Fenton records selected spots of space and imposes a hierarchy of significance on the land which guides the way he frames the subject. The result is to construct a highly edited version of rural England—exclusive and bound by mythology, rather than by the social reality that it encountered. Such landscapes show none of the observation or intimate knowledge of the kind we find in the writing of Thomas Hardy or that we would associate with a documentary photography of rural life. As *The Terrace and Park at Hardwood House* (1860) [**24**] reflects, the vantage point is as much social as it is physical. The eye confirms a conservative view of a unified picture. There is nothing which disturbs the pleasure of the eye as it looks out on to the prospect. Fenton confirms cultural privilege and, in so doing, records cultural myth.

There is, for example, no evidence of work in a Fenton photograph. Even at Hurst Green the figures have been stilled and turned into objects of curiosity. They are there to confirm their place within the fixed scheme of things. To allow their actual terms of existence into the meaning of the picture would be to expose the myth to historical analysis, a social realism inimical to the aesthetic embedded within the image. Such a view, endemic to much English photography, was continued by those English travellers who moved abroad to image 'foreign' landscapes. Here too, an alien landscape is not so much

24 Roger Fenton

The Terrace and Park at Harewood House, 1860

A Fenton image which reflects a privileged position from the security of the country house. This confirms the status of the country estate at the time. The figures look out upon a made and controlled landscape; an Arcadia which seeks the values of Claude and Poussin and rejects anything which might question the eye's pleasure in the scene.

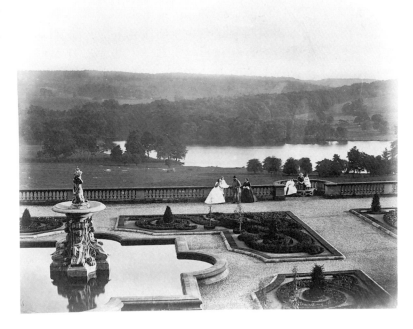

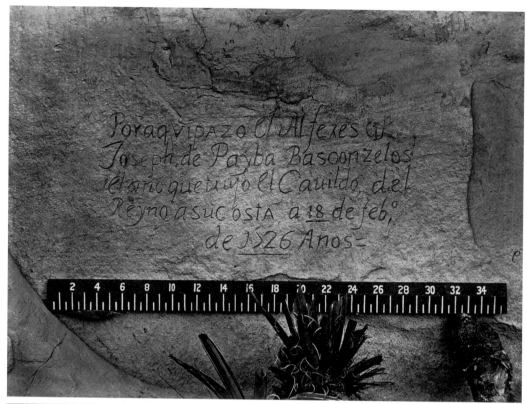

25 Timothy O'Sullivan

Inscription Rock, New Mexico, 1873

Although not a landscape, this image by O'Sullivan reflects American concerns in relation to the western areas of the United States throughout the nineteenth century. The measure in the photograph is an icon of the very act of surveying (associated with O'Sullivan's trip) and the need to bring such a massive area of land under political and cultural control.

photographed in relation to its own meaning or cultural difference, as it is brought within the frame of the picturesque and touristic. 'Foreignness' is made safe according to established terms of reference reflected in the photograph's composition and treatment of subject. Like Fenton, for example, Francis Frith and John Thompson reflect a series of highly selective vantage-points and photograph according to the tastes and values of their 'home' audience.

In the United States, whilst somewhat dependent on English models, photography (much like painting and literature) rapidly established its own terms of reference related to the settlement of the continent and the vast spaces that the eye had to measure and contain. The idyllic Arcadia of Fenton's images was hardly appropriate to a frontier culture, nor could it suggest the cultural symbolism embodied in the plains, prairies, deserts, and mountains that the American photographer encountered.

Timothy O'Sullivan (1840–82) is an exemplary figure in this development. O'Sullivan was involved in a number of government expeditions to the western territories and photographed the scenery of Colorado, Nevada, and New Mexico. These were extreme landscapes, sublime in scale and presence (the Grand Canyon) and bereft of evidence of settlement (the Nevada Desert). The eye, as it were, looked upon a land denuded of cultural reference. Such terrains were to be

painted by the likes of Albert Bierstadt and Frederick Edwin Church in the same century, and in their use of intense colour and panoramic space extolled a grandeur which renders the scene sublime. Although O'Sullivan's black-and-white images hardly produce such an impact on the viewer, they do suggest distinctive aspects of how the photographer approached the land as subject. The very fact, for example, that they are scaled images reflects the wider and fundamental concern with any landscape photograph: to establish an order bound by a cultural frame of reference; just as in these images we see reflected the processes of exploration and settlement. The eye scales and tracks the land as it establishes its own points of reference and the beginnings of a map of social and political control over 'nature'. *Inscription Rock, New Mexico* (1873) [**25**] is wonderfully suggestive of precisely the tension at the centre of landscape photography as a genre.[3]

In a similar way, *Desert Sand Hills Near Sink of Carson, Nevada* (1867) [**26**] is a quintessential nineteenth-century American landscape image: a desert landscape in a state of continuous change which, in its very absence of any kind of configuration, resists definition (in a similar way American photographers were to be attracted to the American deserts in the twentieth century). In one sense this is an image of

26 Timothy O'Sullivan
Desert Sand Hills Near Sink of Carson, Nevada, 1867
An image characteristic of the deserts of western America. The contrast between the ephemeral nature of the sand and the temporary but distinctive tracks on its surface creates a distinctive series of paradoxes which underlie the culture's relationship to the land.

nature rather than landscape. The wagon (O'Sullivan's dark-room for his collodion prints) maps out a series of lines as potential codes and areas of delineation. They suggest the need to scale and measure, to order and control and, in turn, to place a historical code upon the land. The stark contrast between the human and the natural here moves the image through extreme states of meaning. Even O'Sullivan's footsteps in the sand hover between the denotative and connotative. Each mark insists on the settlers' relation to their land, and O'Sullivan, like the government he represents, is embarked on a mythic enterprise the very reverse of Fenton's: the mapping and imaging of a land as at once a physical reality, a national symbol, and an order of political and cultural control. To that extent the desert is here a white page on which the culture writes out its terms of reference.

Other American photographers of the period respond in similar ways, underscoring the extent to which much landscape photography of the period was part of a larger definition and sanctioning of nationhood and independence. William Henry Jackson (1843–1942),

for example, was also involved in government expeditions as well as instrumental in the establishment of national parks. His photographs reflect a sense of wonder that is to remain a key element in the American tradition. Often it is the sheer scale of the land that is celebrated, and an image like *Grand Canyon of the Colorado* (1883) **[27]** sets the terms of reference for much twentieth-century American landscape photography. The sublime qualities of the subject are obvious, and the two figures, whilst crucial to any sense of scale, elicit the double relationship to the land: one reclines, 'bathing' (in the Emersonian sense) in the pleasures of the scene; the other is alert and with a telescope, looking out over the land. He could almost be holding a camera. The very lack of human evidence in the scene adds to the effect. The scale is suggested by the way that the figures can only look at it. Once scaled down to size, attempts to order and control give way to an underlying sense of the spiritual; as in so much later landscape American imagery, the picture begins to suggest a religious element. Thus the figures exist amidst a wonderfully realized setting of light, rock, sky, and space. It suggests parallels with Asher B. Durand's nineteenth-century painting *Kindred Spirits*, but where that placed a poet and a painter at the centre of the scene, Jackson's image has a telescope.

The sense of space here is suggestive of its place within the American experience. A primary icon of the culture, American space is always both a physical reality and a symbolic presence, and yet it remains very much a problematic concern for the photographer. In the work of Carleton Watkins (1825–1916), for example, we can see this concern as basic to his approach. One of his continuing interests was the Yosemite, which he first visited in 1861 (publishing *Yosemite Valley: Photographic Views of the Fall and the Valley* in 1863). Like O'Sullivan and Jackson, he was involved in government expeditions and undertook geological surveys to California and, in 1876, photographed the railroad to Tucson, Arizona. His work exemplifies the nineteenth-century conflicts at the centre of the American response to landscape and the *land. Panorama of Yosemite Valley from Sentinel Dome* (1866) **[28]** is characteristic of his work, and extends the frame of the photograph to stress not merely the scale of the view but its expansiveness. This is a panorama, an image that *pans* over the landscape in a broad sweep, in order not so much to frame as to encompass the scene in its entirety. It recalls to us the popularity of panoramas in the United States but equally, and tantalizingly, the questions raised by a scenery that in its sheer scale questioned the photographer's attempt to reduce it to the frame of a photograph. Other images by Watkins are more quietist in tone and approach, stressing the continuing influence of Transcendentalism on the American's response to nature. At his most powerful, however,

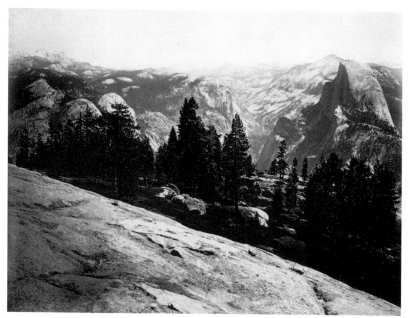

Watkins is a photographer who makes the act of structuring the land by the eye basic to his aesthetic. Whilst *A Storm on Lake Taho* (1880–5) approaches the stillness of Luminist painting, and of Alfred Stieglitz's images of Lake George, and *Cathedral Spires, Yosemite* (1861) declares itself as a precursor to such photographers as Ansel Adams and Edward Weston, it is an image like *Cape Horn near Celilo, Oregon* (1867) [**29**] which is definitive Watkins.

This is both brooding and complex as an image. It lacks the spectacle and panoramic approach of the grander scenes, but in turn retains a distinctive sense of felt space as a primary factor of the American experience. Indeed, part of the effect is to displace 'space' in favour of emptiness, so that the land becomes an almost solitary arbiter in its own right. Emptiness overwhelms the eye—the sky (which occupies a third of the photographic space) is devoid of any significant presence. It has been emptied of effect. The rocks to the right offer an obvious contrast, but do so in relation to the 'benign' configuration of the valley on the left, in turn confirmed by the presence of the lake. There is an extraordinary sense of stillness in the image, very much a part of the American tradition. There are no figures, suggestive of the way the photograph creates its meaning through absence. All is anticipation, but equally all is balanced between meaning and a visual vacuum. Thus there is a peculiar modernity about the image, not in the way we find it in Friedlander or Gary Winogrand, for example, but in the 'landscape' studies of Jim Allinder (1941–), whose *Plymouth Rock* or *The Center of the United States* merely notate significant marks of settlement without any sense of cultural coherence. The railway-line and the telegraph poles suggest increasing settlement and control, but

they do so in terms of a linear geometry, much in the way that so much of the United States had a grid of local and state boundaries imposed upon it: thus the play between the natural and the political.

If settlement and political control over the land (and native cultures) has marked one major tradition of American landscape photography, so Transcendentalism has formed another. Ralph Waldo Emerson's 1835 essay *Nature* remains a basic text for this approach, as does Henry Thoreau's *Walden* (1854). As Transcendentalists, they stressed the holistic basis of natural forms and scenery, seeing in both the detail and the larger whole a symbolic state whose meaning implied the ideal presence of God. To look upon the land, whether as a prospect or in detail, was to commune with a visual hieroglyphic in which everything was part of a larger symbolic whole. In this approach the land as a natural form is alive with potential meaning, so that, like Blake, the photographer can see 'the world in a grain of sand'.

Every natural detail is of significance, for it reflects a universal condition.[4] Edward Weston's (1886–1958) brilliant *Dunes, Oceano (The Black Dome)* (1936) [**30**] is exemplary in the way it represents a series of definitive American landscape concerns. Once again, the photographer takes an extreme American terrain (a desert) and makes of it something other than its physical appearance. The camera transposes it as part of a larger mythology of spiritual and mysterious presence. Its two primary elements, sand and light, are both subject to continuous change, but the photograph fixes a moment from that continuum and celebrates it as part of a unity of time and space, without (on the surface) reference to the social or political. Where so

many photographers use water as a central element in a purist vocabulary of the spiritual, Weston has made the most barren of substances, sand, into something remarkable in its effect as a visual spectacle. The play of light and pattern, of texture and contrast, expresses an almost metaphysical presence.

Characteristically, Weston makes whatever elements of the natural he confronts into something distinctive. The camera transforms the scene and gives it significance through the intensity of its assumed vision. *Point Lobos* (1946) [**31**] may lack the grand scale, but it implies a grand vision. Its effect lies in the way every detail is given equal significance, a democratic insistence on the efficacy of the merest detail of nature which, in American terms, finds its literary base in the philosophy of Thoreau and Walt Whitman. Whereas *Dunes* made light and process its subject, so this addresses the solid presence and textures of natural objects. The camera photographs not just solid things but presences which, in their realized textures and surface feel, promise some kind of metaphysical revelation. Weston's approach is typical of American landscape photography, especially in the twentieth century. Whereas American documentary photographs saturate the photograph with human figures, landscape images empty the land of human presence. Landscape photographers choose those areas beyond

29 Carleton Watkins

Cape Horn near Celilo, Oregon, 1867

This is a sombre but tantalizing image. The obvious aspects of the photograph are the railway line and telegraph poles as part of a larger web of cultural control by American settlement. As such the sky is washed-out as if it mirrors what is happening. Likewise the rock on the right has a gloomy aspect.

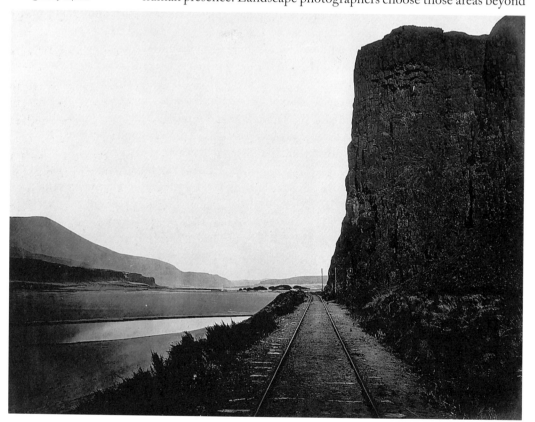

human habitation, extreme borderlands and national parks: pristine environments with as little evidence of human settlement as possible. In that sense they construct their own Arcadia, quite different from the English equivalent. Like the art photographer, they seek an ideal image in an ideal land.

Ansel Adams (1902–84), another major American photographer of the twentieth century, continues this search, but does so with a technical virtuosity which belies the historical context in which his work exists. *Moon and Mount McKinley* (1948) [**32**] is typical. An appropriate subject—for just as Mount McKinley is the highest mountain in the United States, so Adams seeks the 'highest' of meanings. The approach is such as to imbue the scene with a philosophical presence whose basis is, once again, the transcendental. There is not a trace of human activity. It is both a sublime sight and a pure scene; a pristine natural world which, in relation to its scale, evokes a mysterious otherness. In formal terms the image is organized according to a series of horizontal bands. In the foreground is a lowland area, in the middle ground foothills, followed by mountains and the sky. The eye ascends as it moves over the surface of the image. The effect is to create an ineffable sense of wonder, especially through the contrast of light and dark. Note, for example, how the cloud mirrors the mountain and how mass gives way to light and a sense of space. Adams is here the spectator recording the otherness of a world of mutual form and energy.

Adams, with Weston (and Stieglitz before them) forms the high point of a formal and ideal American landscape aesthetic. This tradition is continued in the work of Minor White (1908–76), another

central figure, and in Robert Adams (1937–) too we can find a similar
impulse, but here the terms of reference have changed. Whilst not
assenting to their idealism and the aesthetics of what became known
as the F.64 group (see Chapter 9), Adams carries many of the
preoccupations of the nineteenth century into a postmodern context,
revitalizing the terms of reference within a revised critical terminology.
Los Angeles, Spring (1984) [**33**] is Watkins in the twentieth century.
Compare it, for example, with [**29**]. The cliff on the left, with its
bristles of thicket and grass, seems little more than the remnant of a
lost nature, just as another Adams image, *The Garden of the Gods* (1977),
casts America into a symbolic darkness. The sky is not only drained, it
is smog-ridden. The middle ground is deceptive, for the more we look,
the more it becomes part of an urban and industrial scene. Four pylons
appear in mute profile on the horizon, linked to the wires which
emanate from the cliff on the left. A road curves over the land in the
centre. If it is spring, it is also Los Angeles, so that America, once the

'garden of the gods', has met its urban apotheosis. It is the landscape equivalent of Robert Frank's *The Americans*.

In contrast, British landscape photography of the twentieth century has followed a quite different path, and for the most part still finds its roots in the picturesque codes of the nineteenth century, although their efficacy is questioned by an increasing social awareness of how landscape should be read and the obvious sense of Britain as one of the most industrialized and populous landscapes anywhere in the world. The American can still, at least, contemplate a wilderness condition. In the British tradition the photographer is pushed to the margins of the landscape, using such habitats to recover a sense of isolation. The photographs make available icons of an alternative existence: primary spots of release and contemplation as if they, literally, stand in for a landscape that we rarely see but need to know.

For example, Fay Godwin, one of Britain's leading contemporary landscape photographers, releases the image of rugged upland areas from the aesthetic and cultural constrictions to be found in Fenton's work. *Land* (1985), like her *Forbidden Land* and Don McCullin's recent photographs of Somerset, takes as its subject desolate areas outside the domain of both the city and the suburb. This is a rugged, natural scene

32 Ansel Adams

Moon and Mount McKinley, 1984

An image of the grand scale in nature, this reflects the continuing sense of awe that the photographer brings to the natural scene. The primary elements—land, sky, water, mountains, and light—are imaged as part of a sublime union of the solid and the ephemeral. The photographer is once again the assumed arbiter of a natural world. The photograph, as such, reflects nature in its ideal state.

which resists a historical perspective. The scenes photographed remain as a tentative presence, lost, as it were, to the eye. And yet there is invariably a hint of human activity. In Don McCullin it might be a fence, a path, or a track. In Godwin it is more likely to be part of an archaeological trace: a land of runes and stone structures, monolithic rocks and sacred sites, so that the photographs engage with a continuing need to make sense of nature and its effect upon us. Godwin stands apart, using the camera to produce the evidence of past cultures on which her work is continuous. *Reedy Loch above Strathan* [**34**], for example, is perfectly suggestive of her approach and subject-matter and has about it an ambivalent and intense lyricism characteristic of her work. The primary elements of the scene are held in a delicate balance which hints at, but never fulfils, the promise of a meaning beyond what we see. The photographs seek an imagery of feeling but effectively offer the ghost of Wordsworthian romanticism. *Land* is full of such images: rugged and desolate areas which bring to us evidence of another land and another time. To read them from our predominantly urban perspectives is to return to a strange, almost forgotten, Britain.

Much of the strength of a great deal of post-war British landscape photography lies precisely in the way it seeks a path between the two poles of its traditional reference: a settled English lowland and its highland alternative, the traditional difference between the Burkean sublime and the beautiful. But landscape remains very much part of a larger cultural construction, wedded to its particular status within the tradition. We can find examples of this approach in the work of Paul

33 Robert Adams

Los Angeles, Spring, 1984

A brooding image, almost the opposite of Fig. 29. Here telegraph poles have been replaced by pylons and the wires suggest the imposition of an advanced industrial economy over the surface of the land. A Californian Arcadia has given way to its urban present. This is Los Angeles the city, not Los Angeles the land of the angels. The title is basic to the photograph's meaning.

Nash and Bill Brandt, but an image like John Davies's (1944–) *Agecroft Power Station, Pendlebury, Salford, Greater Manchester* (1983) [**35**] is exemplary. Whereas in a photograph like *Drurridge Bay No. 3 Northumberland* (1983) Davies seeks to photograph pure natural forces, in *Agecroft Power Station* those elements have been given over to a very different kind of power. Indeed, in part we could read this as an ironic riposte to Fenton's *Hurst Green*. This is a landscape made almost unreadable by the activity of industry and urbanization. It is exhausted. The power station dominates (and is suggestive of an earlier sublime vocabulary in terms of early responses to industrialization). The sky and land are denuded of any sense of life and energy. What grass there is is given over to a football pitch, the recreation ground of a nearby colliery serving the power station. To the left is an area of detritus where a horse coexists strangely with a car. Although the foreground

Davies's image pictures an
almost derelict scene worn
down by the detritus of
industry and settlement.
There are remnants of a
'natural' past, but such
isolated details are
subsumed into the scarred
terrain. Likewise the sky is
washed out. This image
confirms Britain as an urban
culture. Indeed, the looming
presence of the power station
achieves an iconic status
equal to the monumental
symbols (such as Stonehenge)
of earlier periods.

exhibits the remnants of an earlier, and recognizable, rural imagery in terms of its trees, fences, gates, and streams, these are all but emptied of iconic significance—so many empty ciphers. The background is full of industrial images: a chimney, a pylon, and so on. The typically 'English' ambivalence between country and city is here given an underlying melancholic atmosphere. The English countryside, and with it the myth of Arcadia, has all but disappeared.

Davies's approach is similar to that of another central figure of landscape photography in the same period: Raymond Moore (1920–87). As he stated, he used landscape photography to seek out 'structures and images which allow me to comment on life in general'. Landscape photography abounds in cliché, and Moore, once a postcard photographer himself, is acutely aware of the terms by which we reduce scenes to their stereotypical obviousness. In contrast, his landscapes are subtle studies of meaning. Each is full of substance, without statement or definition. Able to move between the sublime and the banal, he makes of the most ordinary scene a wonderful play of the recognized and the mysterious. *Dumfriesshire* (1985) [**36**] is a mix of multiple signifiers, a mishmash of directions which lead us nowhere. The scene, although recognized, retains its own distance and otherness. To a culture based on seeing the land from and through the car, it is a major statement.

In recent years other British photographers have created a distinctive critique of landscape as a cultural construction, and in so doing

have established a body of photography which deconstructs the myth of England as it observes images of the contemporary scene. Martin Parr's (1952–) work, for example, is consistently ambivalent about, and critical of, England and Englishness. A landscape, for Parr, is as much a social map of attitude and life-style as it is a supposedly rural area. Parr's England is always part of a larger social reality, inhabited by a mass of figures who vie for the appropriate panorama and prospect in order to escape from the suburban and urban constrictions of their own lives. The country is reduced to its equivalent in an advertisement: a weekend jaunt in search, essentially, of the picturesque or a decent spot for a picnic. England, in Parr's images, is increasingly cluttered. Space is at a premium, and the country is no more than a tourist route. England's 'green and pleasant land' exists only in books and images. *Glastonbury Tor* (1976), for example, is a study of middle-class excursions intent on traditional prospects, and has about it much of Parr's characteristic humour. Although much of his work involves (like recent work by Anna Fox) the rural imagery of a new middle-class suburbia, other studies suggest a much more desperate and darker sense of contemporary England. His *New Brighton* series (1984) is a case in point [**37**]. The garish colours evoke a crude and cheap contemporary life-style, the very opposite of a pastoral past. The culture here is dominated by the spurious and the peripheral. Plastic and polystyrene, rather than the 'traditional' materials of wood and metal, abound. Everything reflects a transient, dislocated, and throw-away culture in an England supposedly based on its traditions and

36 Raymond Moore

Dumfriesshire, 1985

In its own way this suggests confusion and exhaustion. Natural images are as much hemmed in by manufactured signs as the land is controlled by human activity. The tree in the background has a fragile presence amidst the plethora of telegraph poles, signposts, and place-names.

37 Martin Parr

New Brighton, 1984

Martin Parr's brash colour studies deconstruct the terms of reference by which an idea of England is imagined. The garish reds and blues reflect a society based on the crude and the cheap; a miasma of rubbish amidst which the culture struggles to retain any sense of coherence or national identity.

underlying continuity. The figures in this image can barely see beyond their own immediate physical space. Parr images a culture without meaning or coherence, without a history or substance. England, as such, is now unreadable. Landscape, except as a memory, has all but disappeared.

In a more extreme form, the work of Chris Killip (1946–) offers a political perspective on an idea of landscape which he associates with a dominant conservative ideology.[5] *In Flagrante* (1988), for example, offers a radical image of the North-East of England dogged by unemployment and poverty. Landscape, such as it is, consists of urban squalor and emotional helplessness. The use of black and white, as against Parr's heightened colours, provokes the sense of a bleak and barren atmosphere.

Much of this new photography underlines the extent to which landscape is very much bound by an atmosphere of melancholy, just as in our own snapshots of scenes we invest them with a personal dimension which records a lost past. The moment, not so much the scene, is retained. And much landscape photography is bound by this search for an ideal representation. Whereas, when Talbot photographed a tree, it remained a tree, failing to expand into a larger sym-

bol of significance precisely because it had no context other than its literal presence, landscape photography, on the other hand, is framed within its own conventions and its own codes. It declares, in whatever terms, a pre-determined aesthetic and philosophy of the way we read the land and invest it with meaning. But the landscape photograph implies the act of looking as a privileged observer so that, in one sense, the photographer of landscapes is always the tourist, and invariably the outsider. Francis Frith's images of Egypt, for example, for all their concern with foreign lands, retain the perspective of an Englishman looking out over the land. Above all, landscape photography insists on the land as spectacle and involves an element of pleasure. The image is an analogue of those attributes we associate with a rural existence, so that to look at a landscape is often to enter precisely into an alternative world of possibilities. This is, perhaps, in a clichéd sense, why so much landscape photography finds its way on to calendars. And yet much landscape photography continues to suggest an emotional index which is crucial to its meaning. Gustave Le Gray (1820–62) produced wonderfully modulated scenes which suggest a visual equivalent to the music of Debussy, and in a contemporary context William Clift (1944–) has achieved an equal response, where the image effectively makes itself felt as a mood poem.

Harold Sund's *Yosemite Valley from Wawona Tunnel* (1971) recasts the language of landscape. A complex image with an exposure time of some ten minutes, this takes one of the primary American landscape areas, endlessly photographed, and places it in the context of the contemporary tourist. The grandeur that Watkins, for example, photographed has now been reduced to a day-trip in search of temporary sustenance. The perspectives have been reduced to little more than an extension of Disney and McDonalds. Like Tony Ray-Jones's *Glyndebourne* (1968), a satire on English social mores and the countryside, it is what the land now signifies in a cultural, not a 'natural', context which is crucial.

The City in Photography

If landscape photography fed from earlier developments in landscape painting and aesthetics, then the photography of the city has its foundations in the way urban spaces were beginning to be viewed in the late eighteenth and early nineteenth centuries. We need to remember that photography established itself in a period when the growth of the city and industry had already provoked a formidable literature and art in response to the increasing influence of urban areas, especially such cities as London, Paris, and New York. Photography takes its place in this process, but it does so in a consistently active sense, simultaneously responding to the variety and multiplicity of urban life and experience, and to the questions of how urban space was to be perceived and represented. In brief, its underlying response has always been in relation to the visual complexity of a city as both an image and an experience.

It is, of course, significant that the depiction of the city in painting related much to the development of the panorama.[1] Robert Barker's *Novel View of the City and Castle of Edinburgh* (1788) singles him out as the inventor of the 360° view of an entire cityscape, much in the way a landscape prospect might be viewed from the top of a hill. As early as the 1790s, there were panoramic exhibits of London, New York, and Paris, the three cities that were to remain as basic locales for the photographer of things urban. Although the panorama had a long development (for example, Barbari's *Bird's-eye View of Venice*, 1500), the panorama proper reflects 'an attempt to bring painting closer to the actual nature of seeing than it had ever been before'.[2] The photograph was an appropriate form to succeed it. Thus it is significant that it was Louis Daguerre who both invented the diorama (in 1822), and established the view as one of the most basic of subjects for the camera. Indeed, Daguerre's early responses to Paris were photographic equivalents of the diorama. Charles Chevalier's view of Paris (1844), the work of Frith, and (often ignored) the panoramic views by Muybridge of San Francisco (in 1878) all show the importance of the panorama to the photographic tradition of the city; an importance stressed by such recent examples as Len Dance's *London from the Nat West Tower* (1975) and Arthur Cross's *The Barbican After the Blitz*. In

essence, a panoramic view suggests control and possession by the eye. As its derivation implies (Greek *pan* = all), we see all of a city from a single viewpoint. The eye imagines that it dominates a dense and disparate space whilst simultaneously keeping the city at a distance. The view suggests the totality of the urban scene and, crucially, makes the eye of the viewer the centre of that totality. And the height of the camera above the city has established one of the primary axes by which the photographer has sought to image the urban scene. Whether it be a fully fledged panorama, a prospect, or looking down from an upstairs window, the photographer has always attempted to rise above the street and, when he cannot, has viewed the highest parts of the city from the street: looking up towards the sky. Such a vertical axis has a dense symbolic function and, especially in relation to New York, accrues a distinctive tradition in its own right. In the period 1900–1940, especially, the skyscraper became a symbol of the modern, literally an icon of a new kind of city and visual experience.

The city has always been celebrated in terms of its central icons, and many of these plot a visual hierarchy; if not of skyscrapers, then of church spires and towers. The camera has followed these, and indeed, such icons remain the basis of our own tourist maps through the city as we construct our individual geographies of urban space. The direct opposite is the street and the negotiation that such a space at eye-level implies. Street-level both engages with the clutter of the city, its chaos and process, and also celebrates its multiplicity, difference, and (at times) danger. It suggests a human dimension rather than an ideal prospect. William Wordsworth's sonnet 'Upon Westminster Bridge'[3] looked out on to a London when it was still and quiet. In contrast, the street invites disunity, and involves a different sense of space and a different relationship on the part of the eye of the photographer. To be a walker in the city is to engage in a very distinctive relationship with the urban scene, and the *flâneur* has been rightly celebrated as a distinctive figure of the modern city. The camera negotiates between two poles, the vertical and the horizontal; extremes of visual unity and disunity which suggest part of a larger dialectic as to how the city has been seen: the public and the private, the detail and the general, the exterior and the interior, the historical and the modern, the permanent and the temporary. All add up to the compulsive complexity and enigmatic quality of the city as both an experience and a phenomenon, for effectively what the urban photographer has consistently asked is what Charles Dickens, in his great urban novel of London, *Bleak House*, also asked: what does the city mean and how can one represent it?

In the nineteenth century the city became a central image for the camera, although the response was mixed, effectively underlining the extent to which photographers were attempting to establish the terms

of reference for the new medium. Daguerre's images of Paris have a wonderfully modulated approach, a postcard quality which reflect the daguerreotype's way with the world. They declare a new order of space and scale, and there is a similar response on the part of American daguerreotypists of the same period. In England, though, the response is more qualified. Talbot, for example, moving beyond the confines of Lacock Abbey, photographed both Paris and London, and yet his photographs reveal little sense of perspective or of using the camera as a way visually to read the city in which he photographed. The images of Paris remain passive and mute, and establish not so much the tourist eye-view, hungry for *sights* to record, as one that was looking for *things* to record. In a similar way his London images, for example, *Nelson's Column* (1843), keep the city at a distance and follow the eye in its way with the urban world. Their value is that they show the extent to which photography has always constructed a series of different cities, different perspectives and value systems. For the most part, most of the city remains invisible and anonymous.

In the same period, however, Paris attracted a different attitude and response, and one that was to feed into later developments, especially in relation to Atget and Brassaï. Paris must vie with New York as being the most photographed of cities, and, like New York it has undergone fundamental visual change. Street-level, however, is pervasive, and photographers responded early on to the variety of the streets and their ambience, as well as to the implications of the visual changes going on around them. Charles Nègre (1820–79), for example, established the street figure as a significant subject for the urban camera, breaking away from the picturesque figures of an earlier period. His *The Organ Grinder* (1853) is a prime example of the way occupations became central examples of the visual variety of the city, and also of its multiplicity and mix of social classes. And yet Nègre does not reduce the figures to types, but allows them to retain their own identity and relative, if limited, place within the city's space. It is a response that we are to meet as much in Riis and Lewis Hine as in Strand and Atget. In a different context, the work of Charles Marville (c.1816–79) takes a longer view, and encounters old Paris as it gives way to the massive planning changes that take place under the auspices of Baron Haussmann. Marville's images thus preserve an old city in the process of disappearing. They embody the image as a photographic record, but also reflect the city as a series of mysterious and enigmatic presences, of the kind we find, once again, in Atget. In comparison with Marville's atmospheric pieces, Talbot's Paris *Street Scene* (1843) (2) is both bland and neutral, and shows little sense of, or interest in, the city as a phenomenon beyond its immediate presence. It is as if Talbot has no sense of what the camera is to do with an urban scene.

It is easy to align early photographic responses to the city with a

38 Alfred Stieglitz

The Flatiron, 1903

One of Stieglitz's most central images of New York, this needs to be viewed in relation to the other, equally famous images of the building by Edward Steichen, Alvin Langdon Coburn, and Berenice Abbott. Stieglitz's image idealizes the scene and naturalizes the city. Trees and snow dominate so that the Flat Iron itself, one of the foremost skyscrapers of the period, seems to grow out of a landscape rather than be built upon solid foundations. Note how the tree in the foreground replicates the 'map' of Broadway and Fifth Avenue where the building is situated.

concern for realism. The documenting of social conditions, for example, that Thomas Annan (1829–87) was to reveal in Glasgow was part of a larger recording and exposure of social and economic conditions in urban areas. Like Riis's images, the camera lit up for an assumed middle-class audience those areas of the city otherwise invisible to their own experience; it allowed them to see what they would otherwise not see. The camera thus acted as detective, moving through streets and areas otherwise prohibited to an outsider's eye. The approach remains basic to documentary photographs of the urban scene, and we only have to think of Bruce Davidson's (1933–) *East 100th Street* (1970) to see how potent it remains. And yet many responses to the city image it in its most ideal form, limiting the realist response and implications by assuming a higher aesthetic of spectacle and possibility.[4]

In this respect, one of the most sustained attempts to photo-graph New York City, for example, is the work of Alfred Stieglitz (1864–1946). Stieglitz brought to the city an idealism which bordered on the spiritual, seeking to find in New York an image of America's promise as a dynamic and modern culture, aligning it with a romantic idealism in which the city was alive with spiritual possibility. And yet what we find in the period from the 1890s, when he started to photograph New York, to the 1940s, when he abandoned photography, is an underlying conflict between the attempt to create ideal images and the evidence of a material and human world of urban conflict inimical to the ideal vision he sought.

The Flatiron (1903) [38], for example, is one of his definitive images of New York. One of the first skyscrapers in the city, this was built close to Stieglitz's famous 291 Gallery on Fifth Avenue. Situated on the corner of Fifth Avenue and Broadway, it gained its nickname from the triangular area of land on which it was built. On the morning Stieglitz photographed it he was overwhelmed by what he saw, for it seemed to shimmer amidst a fall of 'fresh snow', and appeared to him as an image of the 'new America still in the making'. Typically, Stieglitz bases his image on a mix of tonal range and compositional formalism. In turn he lays stress on the natural elements within the scene: trees, snow, and the sky. The urban scene, as it were, is reduced to a minimum. The building appears to rise above a delicate, almost filigree pattern of trees as part of a lyrical *frisson* which lays stress on its delicate presence. Ethereal, it has been flattened by the point of view: no longer a building, it has been transformed into a mirage. Stieglitz, as he does so often, denudes the building of its solidity and function as an office. The realist context gives way to an imposed ideal frame of reference. Thus Stieglitz seeks to maintain his perspective always at the expense of the commercial, historical, and material aspects of the city he photographs. The Flatiron was photographed endlessly as an icon of

the new modernity of city life (see the images by Coburn, Luchasz, Steichen, and Abbott, for example), but only Stieglitz photographed it divorced from the chaotic textures of the city streets that surrounded it.[5]

This is typical of the way in which Stieglitz approached the city *per se*. From 1902 he virtually abandons the street as an area of interest, preferring instead the perspective of the new skyline, or he retreats behind the windows of his various galleries as he moves, literally, higher and higher above the city itself. He photographs *Old and New New York* or *The City from Across the River*, but it is as mythic spectacle, not as insistent reality. His primary vocabulary remains one based on light, water, and sky—the very opposite of what a city is made of. More problematically, he empties his images of any human presence, so that he seems to inhabit a city given over to ideal forms and ideal moments. From the 1930s he looks out on to a midtown Manhattan from his apartment high above the streets. What Lewis Mumford called a 'ghost city' is now the dominant mood of the last images: sombre, still, bleak, and melancholy. *From the Shelton, Looking West* (c.1935) [39] is typical of this final period.

Thus Stieglitz was effectively defeated by a city he sought to unify and idealize according to an underlying philosophy of meaning. He rendered the social and human context neutral, and increasingly faced the material evidence of the city, not as symbolic image, but as raucous and callous reality of the kind we find in the paintings of the Ash-Can School, and in the naturalist writing of Stephen Crane and Theodore Dreiser. He found what John Dos Passos, in *Manhattan Transfer* (1925), called a 'city of scrambled alphabets' which was to become the increasingly dominant condition to confront the urban photographer as the century advanced: a continuous condition based on disunity and fragmentation—a made world always hovering on the edge of meaninglessness.[6]

But other American photographers of the period did allow their cameras to inhabit precisely that photographic space so inimical to Stieglitz's vision and, in so doing, established one of the central bodies of work in relation to the American urban tradition. In many respects this has been read as a documentary, even journalistic, response, but that is to take it out of its ambiguous context as an example of urban photography. Here the city is not a spectacle, much less a unity. It is, rather, an invisible city, at times an underground city, in which the sheer density of the human presence threatens to overwhelm the camera as it seeks to image street-level experience. Jacob Riis (1849–1914), especially his images for *How the Other Half Lives* (1892), remains basic to the viewpoint. Riis focused on the appalling conditions of New York's Lower East Side in an attempt to alter housing conditions amongst the overcrowded and infested tenements.

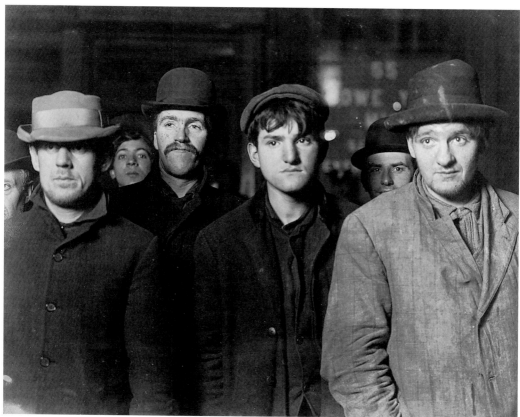

40 Lewis Hine

Bowery Mission Breadline, 1906

Lewis Hine was one of the central photographers of New York at a crucial period in its development. His images of Ellis Island, of the Lower East Side, the Empire State Building, and of the infamous sweat-shops offer a view of the city as a social and economic reality. This image is characteristic of his approach and pays due attention to the human context of the city. Hine always read the city through the figure and made it central to his work. Typically the image balances the plight of the figures with a needful sense of dignity and individual worth.

The images that go into *How the Other Half Lives* raise many questions, but their status in terms of the photograph's ability to move into forbidden and invisible urban geographies is exemplary. They penetrate a secret city. Indeed, as the response of the photograph developed, what emerges is a series of cities within a city: multiple layers of what constitutes the meaning of an individual urban identity. No single photographic response achieves any definitive vision of what it stalks. So, where Stieglitz favoured the avenue—broad expanses of urban space where the eye is free to roam at will, either upward or indiscriminately—Riis limited himself to the alley and the court. Both are extremes, but both equally underlie very different aesthetics of the city and the way in which the physical and perceptual space of the city scene is to be negotiated and interpreted by the camera. It plays into the complicated language of visualization and what the eye privileges as part of its preconceived image of what the city might or should *be*.

There is much that is ambivalent about the use of space in the urban context, and the contrast between private and public space is to remain fundamental to the whole way the city has been seen (as much in photography as in literature, painting, and film). But space is also related to the terms by which figures are framed within their environment. Thus, any focus on the figure enters into part of a

complex typology as to how space is suggestive of the mythology of possibility and freedom, and historical and sociological realities. Lewis Hine (1874–1940), for example, records New York over a period of some thirty years and does so in direct opposition to Stieglitz. Where Stieglitz sought the long look, so Hine makes the street and the figure absolutely central. Over this period he concentrated on three separate but related areas: the European immigrants arriving at Ellis Island, the 'processing centre' for immigrants before they were allowed entry into the United States; the Lower East Side, a densely populated area of New York which contained much of the mix of the recently arrived immigrants; and the Empire State Building—as the official photographer he photographed its entire construction. Collectively, his photographs remain an extraordinary record of a city's process of change. What marks them out, however, is their continuing commitment to the human figure. The images of Ellis Island fix individuals in a strange land. Often shown as confused, they picture for us the very process of realignment and regrounding of lost cultural certainties. The Lower East Side images involve work and the terms of everyday existence which, collectively, respond to the density and plurality of the area at the time. The Empire State Building images celebrate the enormity of the enterprise, and give us almost sublime *panoramas* of the city from the highest building in the world (as it was in 1931). What distinguishes Hine's approach is the way that the human figure is always central to the meaning. It is the workers on the Empire State that Hine celebrates, and he allows them to dominate the scene. This is not a city constructed through the photograph; it is a made and built city dependent upon labour, and Hine's achievement is always to relate that labour to the larger workings of the city's superstructure—its being, so to speak, as a social and economic organism. *Bowery Mission Breadline* (1906) [40] is characteristic. It offers acute attention to the details of each figure as a clue to the assumed complexity of their individual terms of existence. Never a dealer in stereotypes, Hine allows the figure to retain its own distance and unique space within the city's amorphous meaning and geography.

Although never sensational, Hine's work underlines the extent to which the city has been viewed as a spectacle. And much photography of the city has viewed it (and continues to view it) in terms of the bizarre, even the surreal. Like the narrator of Edgar Allan Poe's 'The Man of the Crowd', so the photographer roams the city in search of the strange. Both day and night exhibit a sense of *film-noir* as the city, through the photograph, is revealed in its true condition. The photographer as *flâneur* is basic to this development, but there is also a commitment to an underground, almost subterranean city, which the photographer must seek out and become privy to. The city is part of a perverse world of sensation, danger, and the violent: not an ideal

environment of the kind Stieglitz wanted, but a nightmare environment of the vicarious and the brutal—*Tableaux Vivants* of a bizarre world.

Weegee (Arthur Fellig) (1899–1968) is a case in point. Photographing New York in the 1940s, his is primarily a secret imagery of what he saw as a naked city. His subject is its exhibitionism and he is the photographer as the voyeur. His mode is the press flash-gun, literally exposing his subjects in a sensational manner, and concentrating on the extremes and moral foibles of the urban crowd. Weegee's subjects constitute an underworld in their own right, so that each image has the element of the bizarre. One feels that, like Brassaï, Weegee images a secret city: murder victims, muggers, transvestites. But he also images private moments—anything that might feed his hungry eye in search of the sensational and murky photograph. *Murder in Hell's Kitchen* (1940) [41] is exemplary Weegee, and both in its title and approach defines the photographic ground that makes up his most significant of texts, *Naked City* (1945). (The grubby and gritty nature of the alternative city he imaged was made the basis of a film of New York of the same name (1948), filmed entirely on location.) Weegee thus raises the act of looking and its concern with spectacle and the spectacular to the level of an analysis of a subconscious 'terrain'. We should not be surprised that he is, along with Lisette Model, one of the central influences upon another New York photographer of the bizarre and hidden: Diane Arbus.

Arbus is in many ways a unique portrait photographer (see Chapter 6), but in the context of New York her work has a particular significance.[7] Hers is a limited and personal urban geography, and if she photographs the street she does so always in relation to the figure which dominates the space of the photograph. Her quintessential terrains are the rooms of people's private spaces—especially bedrooms, where the public showing of city life is disregarded as so much make-up and masking. Her vision reflects a terrible sadness and loneliness, a city made up of isolated individuals. The pervasive sense is one of dislocation and angst. Arbus extends Edward Hopper's images of intense loneliness into a psychological mapping of the urban condition. In this context the street, as it was for Dickens, remains a theatre of public faces and anonymous types. No wonder, then, that two of her 'favourite' areas were the New York Morgue and 42nd Street.

As noted above, photography has a long tradition of the street figure. John Thompson's (with Adolphe Smith) *Street Life in London* (1878) and *Street Incidents* (1879) are part of a continuing concern to place the figure in an urban context without recourse to the picturesque or caricature. Many of these pictures attempt to convey the terms of existence to an audience otherwise ignorant of the life imaged.

Thompson's images of the London poor, for example, *The Independent Shoe Black* (1876) [**42**][8] allow the figure its own independence, at least in terms of the way the image judges its existence. Thompson's figures, in this sense, are similar to Strand's, and in a later period, to William Klein's. But perhaps the quintessential study of 'street' figures remains Walker Evans's *Many are Called*, photographs of people on the New York subway. These are candid images, and Evans took them with a concealed camera. What they suggest [**43**] is an intense and quite extraordinary sense of ennui and emptiness. This is the people of the city, both underground and caught off guard. The black-and-white images suggest an unrelenting greyness quite at odds with some of the more dynamic images produced by New York painters in the same period. Collectively they create an image of urban loneliness and separation. The irony is that they do so *underneath* the streets. They picture, as it were, the city's subterranean condition where people are

42 John Thompson

The Independent Shoe Black, 1876

One of a number of street images from the nineteenth century by Thompson, this is in many ways a stereotypical street figure of the period. However, Thompson's approach allows the individual figures to remain very much within their environment. Note the detail, not just of the figures, but of the entire scene.

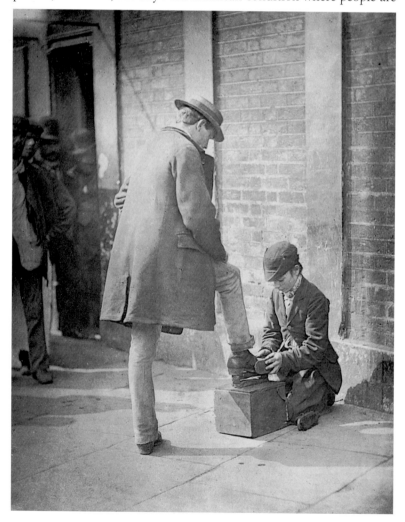

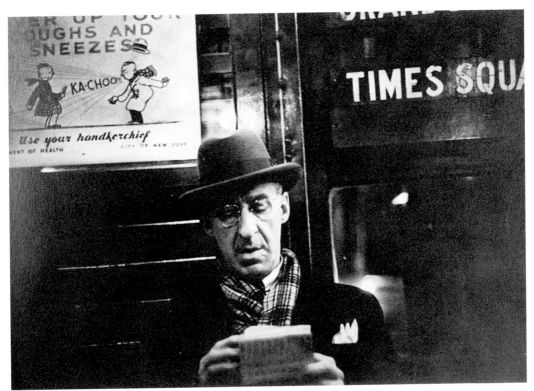

43 Walker Evans

Many are Called, 1938

One of Evans's images from a series of candid photographs taken on the New York subway. Evans used a concealed camera hidden beneath his coat. The result is one of the most incisive series of photographs of city life ever taken. There is a haunting quality appropriate to the environment in which the figures are placed. Everyone appears as alone and separate.

isolated in an anonymous environment.

New York has maintained its centrality as a photographic icon of the urban condition. Moving between extremes, photographers have photographed it as a mosaic of urban contexts and texts. Indeed, the problem of trying to read it has become increasingly potent. As long ago as the 1930s Berenice Abbott, confidante of Eugène Atget, whom she befriended in Paris, established one of the major photographic enterprises of the twentieth century—the photographing of New York City as an entire urban space in its own right. To look at these images is to be overwhelmed by the sheer variety of approach: Abbott refuses to limit the camera or to focus the lens on a specific register of meaning. She is as various and as pluralistic as possible, and there is often a freshness to the images which belies their quasi-documentary nature as a record of the city in the period.

And yet, as they accumulate in their visual effect so we begin to sense an underlying ambivalence in meaning. New York, for all its spectacle, will not yield to the camera in the way Abbott wants it to. *Columbus Circle* (1933) [**44**] is a central image in this context and constitutes a visual essay on the picturing of the American city. Both 'Columbus' and 'circle' suggest part of a traditional American historical urban iconography, the very things the image can no longer read. This is a photograph that makes the city as text basic to its concerns. The scene is, in effect, a series of signs on which we look, and from which

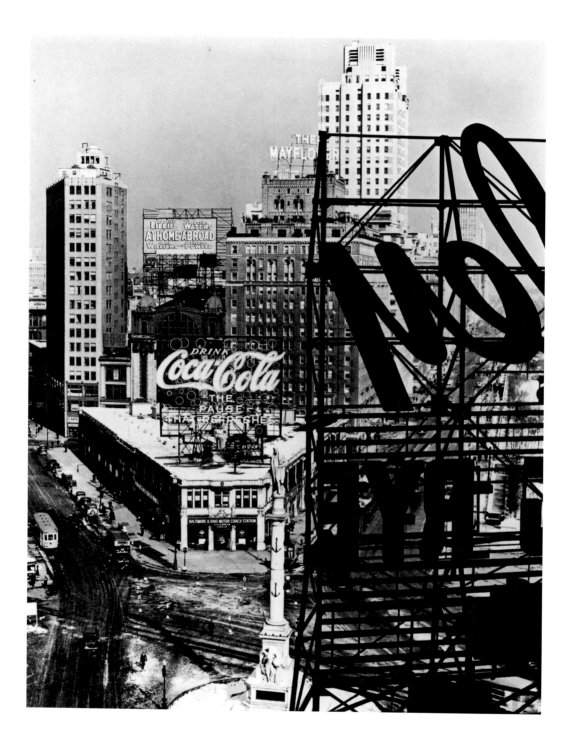

Columbus Circle, 1933

A quintessential Abbott image and a brilliant rendition of the modern city. This reflects the urban scene as a process of signs. The title, *Columbus Circle*, belies the confusion and transience of the scene. There is no unity or coherence, merely the play of advertising codes which create their own terms of reference.

we derive the sense of two very different cultures and two very different traditions, in a process of fundamental transition. What dominates the scene is a series of signs which have displaced the traditional codes of meaning. Thus 'Mayflower' points to no more than a hotel, and 'Columbus' refers to a statue marginalized by a new kind of urban architecture and symbolism. In brief, there is no historical perspective. Whatever suggests history has been subsumed into an iconography of advertising which not only dominates (the signs, especially those for 'Rye Whiskey' and film) but determines the way we view the city.

Abbott is acutely aware of the sign and its implications for how we understand the city as a text rather than an environment. Her photographs are full of adverts, signs, boards, directions: the basic alphabets of communication in an urban space. *Columbus Circle*, in that sense, is ahead of its time and suggests a postmodern condition. All is flux, and the solidity of its title has given way to a transitory state of relative placement, much like the bus-station in the centre of its space.

More and more the photograph has reflected a fragmented sense of the urban. We have moved, in this view, from the nineteenth to the twentieth to the postmodern city, urban spaces which cannot be read visually. An example is Joel Meyerovitz's *Broadway and West 46th Street, New York* (1976) [**45**]. A colour image, this gluts the eye with the way in which the city has become a text in its own right, and yet the codes have been scrambled. Effectively this is an environment given over to high capitalism, so that despite the variety and detail at street-level, the guiding presence is of an all-encompassing ambience which belongs to a corporate America and international market-place. New York is here the international city, but it exists without any sense of its past, or of its different localities. For all its colour and vibrancy this is, in many ways, a deeply pessimistic photograph.

If New York remains one of the key sites of photographic practice, so Paris remains another. One of the most photographed and celebrated of cities it exists as much as an atmosphere as a cliché. Perhaps more than New York, Paris as an image is predominantly a series of photographs, a visual construction which foregrounds the most limited area of its geography, and the most banal levels of its social and economic life. As a city it has been hijacked by its representation in painting, literature, and photography. As noted above, Marville left us quintessential images of a brutal reordering of urban space, and if we see this in the work of Marville and Nègre, we also see it in the work of Hippolyte Bayard and Henri Le Secq (1818–82). All looked to the past, and to a historical Paris about to disappear.

But perhaps the central photographer of *Old Paris* was the Frenchman, Eugène Atget (1857–1927). Beginning to photograph Paris in the 1890s, his is a record of a specific area of the city at its point of

45 Joel Meyerovitz
Broadway and West 46th
Street, New York, 1976

An image of New York as the
postmodern city. Taken at
street level, this offers an
eye-level view of incipient
confusion. The eye is
overwhelmed by signs, and
the colour adds to the effect
of chaos. Although the image
is full of detail there is no
sense of tradition or of unity.
Indeed, it is difficult to find a
solid building at all.

extinction. And yet Atget is not so much concerned with sights as sites.
He seeks out places which have, despite the paucity of figures in his
images, a deep and abiding human presence. Atget is the photographer
as archaeologist, the *flâneur par excellence*. Paris is ineffably a site of
ancient and old rhythms and values: one looks in vain in Atget's work
for an image of the Eiffel Tower or one of Hausmann's grand
Boulevards. Atget's focus is on a medieval Paris of the artisan and the
local area. Everything is on a small scale, and just as he endlessly
wandered the streets first thing in the morning, before the city 'awoke',
so his camera inches along the streets it observes. Everything is of
significance to Atget, a door as much as a building, a tile as much as a
sign. All suggest the density of what was, so that, in effect, his project is
to preserve old Paris as a series of photographs. His aesthetic is the very
opposite of the way photographers attempted to photograph New
York. Where this was celebrated as an image of change, Atget saw
Paris as a museum—the photograph preserved the past, and became a
talismanic signal of something special, almost magical, as part of the
city's meaning.[9]

His photographs of Paris gather together objects, shops, doors,
buildings: the bric-à-brac of a city under threat from the new. He seeks
to carry away the evidence and insists on the power of the image to
preserve the atmosphere and integrity of a lost urban scene. Atget's
images imbibe rather than photograph the city. His *Cour 41 Rue Broca*
(1912) [**46**] is a quintessential Atget image, in its typical presentation of

an interior space. He seeks out an endless series of interiors, as if the internal space, rather than the external space of the boulevards, is significant. It is a psychological not a physical mapping of Paris that he seeks, as if the buildings have a living presence in their own right. But this Paris is also emptied of figures, so that every detail points to the evidence of human habitation and yet turns that presence into something strange and problematic. Above all, Atget traces the evidence of time and rhythm, of daily routines and fundamental human needs which make their mark on the surface of the city: signs of true habitation. He thus seeks out a secret city, intent on the mystery that would, in some way, declare the essence of the city's identity, as if in a detective story. As the photographer, he is 'The Man of the Crowd', and in that sense his photographic mission could never end.

Atget sought *le Vieux Paris*, but other photographers of the period responded to the novelty of modern Paris and modern life. Jacques Henri Lartigue (1894–1986), for example, and Ilse Bing (1899–) who arrived from Germany in 1920, like Edouard Barbot (1923–) and Willy Ronis (1910–) in the post-war period, sought out a new Paris, akin to its modernist image and atmosphere. But Paris retained its secret aspect and some of the most distinctive imagery emerged from its underside, contrasting with the clichéd aspects of its increasingly touristic perspectives. Another immigrant figure who was intent on a secret Paris was Brassaï (Gyula Halász, 1899–1984) who arrived from Budapest in 1924. Brassaï gives the impression that he photographed from a hotel, and only emerged on to the streets at night. He stalks the city as the voyeur, and only leaves the street to steal illicit images of

46 Eugène Atget

Cour 41 Rue Broca, Paris 5, 1912

Atget's image creates a profound sense of menace and presence. Its acute attention to detail creates an atmosphere at once strange and expectant, made more potent by the characteristic lack of human figures. Like many of Atget's images this borders on the surreal. Paris emerges as an organic city; a dream-like environment which pictures the collective mind of its absent inhabitants.

47 Brassaï

No 27 of Paris After Dark, 1933
Brassaï's vision of an illicit and
dark city constructs the sense
of an underground Paris in
which the photographer is
the voyeur *par excellence*.
Many of his images reveal
him 'peeping' at his subjects,
just as many are taken from
hotel windows.

prostitutes with their clients. In *Paris After Dark* (1933), one of his major collections of Parisian night-life, the photogravures he produces retain a deep and heavy blackness. He views the city as a surreal event, both bizarre and unexpected. The public terms of reference at night give way to a kind of Dionysian riot which he can only witness. *The Secret Paris of the 1930s* continues his search, although one is left unsure as to what our position is in relation to the scenes he opens up to a public readership. His habitat is an interior Paris of illicit liaisons and private pleasures: bars, hotels, brothels, and clubs. It is a sexual territory where identity is as much an enigma as are the areas in which he photographs. Any physical sense of the city by day gives way to a fluid, almost dream-like quality at night to suggest the darkest and deepest of the city's needs and desires. This is, in one sense, the underside of a public and bourgeois heterosexuality, and his images put into play a series of questions which move far beyond the city as an image. All is in flux, a psychological space of the imagination which has little to do with the city's architecture. This image from *Paris After Dark* [47] is, in that sense, characteristic, and leaves us, both from the perspective of the photographer and the way we are placed in the scene, uneasy, to say the least.

Like Brassaï, the photographer André Kertész (1894–1985) arrived in Paris from Budapest in 1925. He too photographed the city from his hotel window in Montparnasse, but, unlike Brassaï, moved among the daily and daytime occupations of its workings as a city. Even though he viewed the city as a tourist, he points up the way outsiders negotiate urban spaces. Never intent on the obvious sights or icons, Kertész works on the margins and borders of our visual and mental awareness. The urban scene is given over to serendipity: a constant amalgam of chance juxtapositions and unresolvable ironies. As a spectacle it is, as the poet William Carlos Williams insisted, a *perpetuum mobile*. And yet his work also responds very much to the individual signature of each city: his response to his native Budapest is as different from his response to Paris as it is from that to New York.

Kertész remains very much a photographer of the city as a spectacle which cannot be resolved. The city remains an enigma. As a photograph, it is an endless source of imagery; as an experience, it is endlessly complex and ambivalent. Rather than create a visual space which insists on his own personal identity, he photographs precisely that dangerous ground between urban confusion and private negotiation. The city exists as a series of photographic possibilities, all keys to its larger mystery; hence the way in which Kertész photographs the city from both street-level and from above. All is part of a relative and continuous series of strategies as a way, not so much of reading the city as of recording its endless multiplicity. As has been noted, he will often photograph with a 'tourist's exhilaration'. Like his *Self-Portrait*

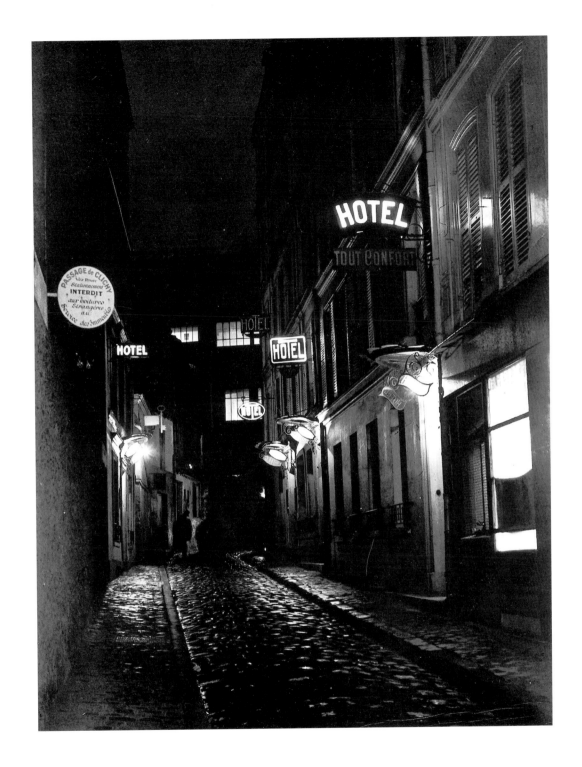

48 André Kertész

Overhead Crosswalk with
Clock, 1947

In some ways an
uncharacteristic image by
Kertész, although it renders
the city as both enigmatic
and oppressive. There is no
indication of the inhabitants.
The birds beneath the clock,
however, suggest a telling
series of contrasts. Typical
of Kertész, this implies rather
than states its meanings.

49 André Kertész

Meudon, 1928

This is an image full of
questions and visual puzzles
and places the suburbs of
Paris in the context of an
unsettling sense of the
strange. Every detail, as
much as the bizarre set
of circumstances and
coincidences it captures,
has significance.

in the Hotel Beaux-Arts (1936), Kertész gives the sense of observing rather than knowing the city. His images are, in the end, densely enigmatic.

The result, invariably, is a series of disparate elements which momentarily unite in a field of visual possibilities—a geometry of achieved formal relationships with a rich suggestiveness of what the city offers the photographer. *Overhead Crosswalk with Clock* (1947) [**48**][10] is a central Kertész image. One of his New York pictures, this establishes a primary sense of photography's way with the urban scene. The buildings are all-encompassing but ambiguous. They appear as monumental presences, and yet their status remains on the surface.

There is, however, a sinister presence which belies their function. The bridge is symptomatic of the city as a series of structures, of meanings suspended between relations. The clock dominates, almost equivalent to a statue as an icon of significant meaning. But the clock is also meaningless, for this is both the record of a moment and, in turn, the picturing of a city. All is a hierophany of possible meaning. The rubbish in the street, the car, and the birds all carry with them a weight of possible meanings that can never be known. Such is the nature of the city as an image. The eye has no point of rest, unless it turns away, for it is left with the charge of looking, endlessly, in order to know something that cannot be known. There is a similar significance in an earlier Kertész image, not of New York this time, but of an area associated with Paris, *Meudon* (1928) [**49**]. This is, effectively a parallel image to that of New York; together they suggest the continuing enigmatic nature of the city as both an experience and a place. Full of strange and chance relationships, it refuses to be explained by the sum of its parts. The 'picture' wrapped in newspaper is, in this respect, the perfect urban icon. It is everything that the photographer has felt and looked about the city. The city is, thus, seen as an enigma.

As such, it is at once a rich, dangerous, and problematic subject for the camera. Like Louis Faurer's *Goggle-Eyed Man* (1947) [**50**], the city is both real and surreal. It continually challenges the eye of the camera as to how it is to respond, and always remains ambiguous. Michael Spano's (1949–) *Street Scene* (1980) [**51**] returns us, in many ways both to the panorama of the late eighteenth century and the interest in street figures of the nineteenth. But both perspectives are redundant as ways of confronting this image, as disparate, in its own ways, as was Mejerovitz's. The urban space is both insistent and unreadable, even unknowable. The camera can only photograph a series of disparate elements, details which hint at a larger unity but remain as fragments of an indefinable process. The city, as such, remains oblivious and impervious to the photographer's attempts to 'capture' it in visual terms.

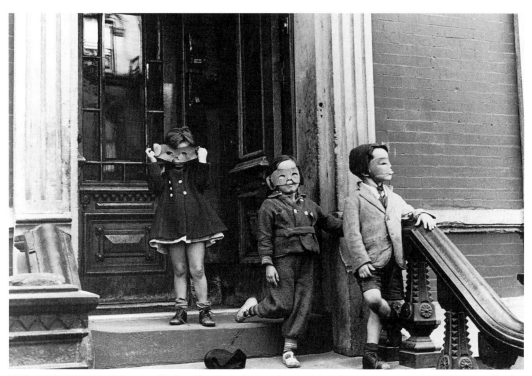

52 Helen Levitt

Untitled, 1942

A typical Levitt image, this pictures children entering into an adult world of 'games' on the street. The masks on the children are basic to the effect of the photograph and suggest connections with the work of Diane Arbus.

Helen Levitt's (1918–) *Untitled* from 1942 [**52**] is well named. An image of masked children about to enter a New York street it resembles both the condition of the city that photography has suggested as well as the mask the photographer has adopted. There is, thus, nothing to identify except the unidentifiable. The postmodern condition, perhaps, is that every city will begin, as far as the photograph is concerned, to look the same. Every image will be untitled: the postmodern city will not so much be a place as a condition; and to capture that condition will be the challenge for the camera.

And yet the photograph has shown itself capable of responding to the individual context by which each city seeks to be recognized. London, for example, has a long and distinctive photographic tradition in its own right. One thinks of Talbot and Fenton, obviously, but also of Henry Delamotte's (1820–89) images of Crystal Palace, of Coburn, Brandt, Roger Mayne, George Rodger, and even Don McCullin, as well as, more recently, Alison Marchant. William Klein's images of Rome and Moscow, in another way, are brilliant examples of the way the photograph can define a city's *timbre* in a single image. The Rome images have a sculptural quality, as they show a series of quasi-Renaissance figures amid the clutter of modern Rome. In contrast, Moscow remains a stark and bleak presence; a city of large-scale vistas suggestive of the, then, political regime.

The photograph has consistently made the city yield to its probing, and, as photographers have consistently moved between cities (see, for

example, the work of Count Giuseppe Primoli (1851–1927)). In turn, there is no single traditional development by which we can map the photographic response. Rather, there is a continuing dialectic between the local and the general in what is increasingly acknowledged as a process rather than a place. Cities, thus, advertise themselves as part of a larger signifying condition; a condition which becomes increasingly problematic as we look at images, not of London, Paris, or New York, but of Bombay and Calcutta, of Beijing, Shanghai, and Hong Kong, and of Tokyo. These are not only 'new' kinds of cities, they demand new kinds of images and a new approach by the photographer.

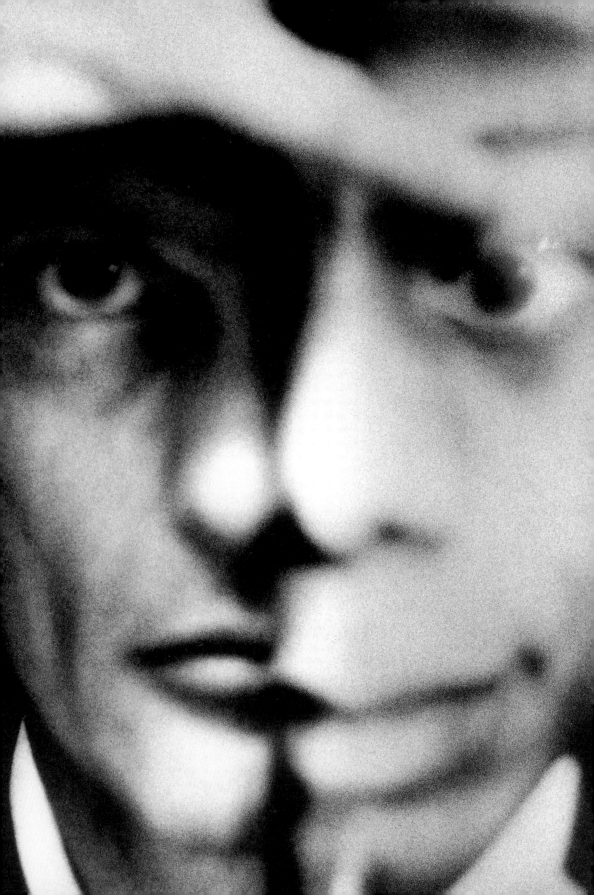

The Portrait in Photography

The portrait in photography is one of the most problematic areas of photographic practice. As I have suggested elsewhere, 'at virtually every level, and within every context the portrait photograph is fraught with ambiguity'.[1] And part of this ambiguity relates to the question of precisely what, and who, is being photographed; which is why I want to begin this chapter with what might be considered a strange subject for a history of the photograph: Robert Mapplethorpe's *Apollo* (1988) [53], a black-and-white image from the final phase of his contentious career.

This seems to me an exemplary photographic portrait precisely because it suggests the enigmatic nature of the portrait *per se*. To begin with, it is not an image of a person, an individual or personality, but of a sculpture, and a sculpture which is the apotheosis of an ideal image of manhood. Apollo was not only a Greek god, son of Zeus and Leto, he was 'the most Greek of Greek Gods', an ideal image to be placed against his direct opposite, Dionysus. Where Apollo represented perfection, order, and harmony, so Dionysus represented chaos and the disorder of life. Apollo exists as an image in space; Dionysus stands for its efficacy in time. And Mapplethorpe's picture suggests exactly this conflict. *Apollo* as a 'portrait' insists on the perfect smoothness of a stone face immune to time and experience. Indeed, the play of black and white here points up the extent to which the face looks into a void and is devoid of any sense of self, of character and identity. And this, of course, is the point. Mapplethorpe's photograph refers the portrait to a myth, not a history; to an ideal, not an individual.

But *Apollo* equally suggests a further dilemma basic to the portrait photograph: in what sense can a literal image express the inner world and being of an individual before the camera? From the inception of the portrait photograph photographers have been concerned to express in the single image an assumed 'inner' being. Thus, 'character revelation is the essence of good portraiture'. As Inge Monath asserts, a successful portrait 'catches a moment of stillness within the daily flows of things, when the inside of a person has a chance to come through'. A position similar to Yousuf Karsh's insistence on the 'inward power' of the personality before the camera. Consistently, the language of

Detail of 66

portrait photographs involves a sense of the inner self declaring its 'being' in terms of a single composite image, *sans* history, society, or conflict. In a sense, every portrait seeks its apotheosis in *Apollo*.

The portrait photograph is, then, the site of a complex series of interactions—aesthetic, cultural, ideological, sociological, and psychological. In many ways it simultaneously represents the photographic image at its most obvious and yet at its most complex and problematic. As has been suggested, 'The portrait is . . . a sign whose purpose is both the description of an individual and the inscription of social identity'.[2] The portrait photograph hovers between opposing terms of meaning—a constant dialectic of significance in which the problem of individual status and self is held. Part of the problem, of course, lies in the question of what constitutes a 'portrait' to begin with.

At photography's inception in the nineteenth century the portrait

was equated with oil painting, further encoding the dichotomy between the portrait in oils as an individual text and the photograph as part of a populist and democratic form of representation. Traditionally the portrait in oils was not only a highly privileged medium, by its very nature confirming status and declaring significance—it was the assumed distillation of a personality. In the portrait painting of Reynolds and Gainsborough, for example, individual meaning is established through a series of codes and symbols by which the self is at once framed and advertised. But of course the portrait was a study over time, whereas the photograph suggests an instantaneous capturing. The portrait in oils claimed to give a composite, even definitive, image of the personality—a formal representation in which was embodied an assumed status and public significance.

Superficially, at least, the photograph is directly opposed to the portrait painting, and yet it is extraordinary how the portrait photograph remains encoded within the context of painting—hence the complexity and contradictions at the heart of any photograph of an individual. If the democratic and populist base of such an image is suggested by the fact that 'for most people, photography is primarily a means of obtaining faces they know',[3] they do so within the context (and associations) not just of a face, but of a formal study and representation of an individual presence. Like the painting, a portrait photograph conferred individual status, and advertised the presence of personality.

The nineteenth century saw an increasing demand for portraiture, the silhouette and physionotrace being early examples of the popularity of such images just as, in an official sense the photograph was to be used by governments and official bodies as the stamp and authority of individual identification. And thus it is appropriate that the daguerreotype rapidly established itself as the most popular form of portraiture in the 1840s and 1850s, so that by 1853 it is estimated that in New York city alone there were some eighty-six portrait galleries, thirty-seven of them on Broadway alone, including that of Matthew Brady.[4] The daguerreotype was, in some senses, the perfect portrait medium. To begin with, each image was unique; unlike Talbot's multiple positive/negative process, a daguerreotype plate produced only a single image. Secondly, it was a mirror-image—not as we see ourselves, but as others see us. It gave, that is, the public image of a private person. And thirdly, because the silver surface was so delicate that it had to be protected, daguerreotypes developed an entire panoply of covers—of velvet, brocade, and leather—suggestive of the way the individual image was both prized and, because enclosed, mysterious [54].

But equally the daguerreotype portrait underscored the extent to which photography was part of a new technology (which was to reach a new peak in the development of the Kodak Brownie camera, with

which everyone could take photographs and everyone could have their photograph (and portrait) taken). Individuals would visit a photographic gallery (or studio), with all the overtones associated with oil painting, but the studios were also known as 'operating rooms', a phrase denuded of any associations with high art. If the portrait photographer established a central role as the inspired *artist*, so operating rooms employed 'operators'—Matthew Brady employed twenty-six operators at his New York 'studio' in 1858. The daguerreotype, though, was hardly the medium to probe or to suggest a personality. It was overwhelmingly formal, not least because exposure times were relatively lengthy. Most sessions, even late in the period, still involved the subject remaining 'still' for between 20 and 40 seconds.

Early portrait photography existed within a series of larger cultural codes which compounded the means, as well as the terms, of representation. The work of Julia Margaret Cameron (1815–79) is a case in point, one of the leading British portrait photographers of the Victorian period and a friend of some of the dominant cultural figures (especially Alfred Lord Tennyson, a frequent subject). The literary and painterly influences on her images suggest a specific series of codes affecting how and what is being photographed. In particular, there is an extraordinary split in Cameron's work between her depiction of men and women, suggesting the influence of sexual stereotypes basic to Victorian Britain in general.

Look, for example, at her famous portrait of Sir John Herschel [55], the then Astronomer Royal and (assumed) originator of the word 'photography'. This is typical of Cameron's treatment of male personality. The body has been reduced to the head only, without any sense of background or external reference: the head becomes an iconic presence implying intelligence, individualism, and above all, genius. Consistently Cameron's images of male personalities confer, and insist on, a whole register of such attributes: power, strength, imagination, creativity, and *action*. Her 'eminent' Victorians (among them Herschel, Darwin, or Tennyson), through their images, reinforce the myth of male dominance and individuality. Herschel stares directly *at* the camera, suggestive of a parallel inner gaze and, in turn, reinforcing the sense of single-mindedness. But equally Herschel's genius is adumbrated by the way his eyes stare into space as he, supposedly, contemplates matters of an astronomical and universal stature. His hair is meteor-like, as if the face came at us from a physical universe rather than a social world. We are clearly in the presence of a unique (male) individual, and Cameron's image indulges almost to its limits what Walter Benjamin was later to call the 'spell of personality'.

But look at how different is Cameron's depiction of women. Her portrait of Mary Hillier, for example [56], shows an approach and style quite the opposite to Herschel's. Where Herschel faced the camera (and us) so Hillier is sideways on. She is looked at rather than looking; this simple distinction underlines the wholly passive nature of the image. The exaggerated depiction of the neck, like the hair, is redolent of Pre-Raphaelite painting. Any sense of Mary Hillier as an individual is deferred to a larger, passive, female ideal based on assumed sexual difference and social significance. This is not so much a portrait advertising a self as a general idea to be consumed (by men). It seems to me that Cameron consistently underwrites this sense of *difference* and stereotype—male figures are given a signature and approval, female figures relate to an index of beauty and passivity: a spiritual ideal not a physical presence—with all that that implies about the underlying sexual assumptions.

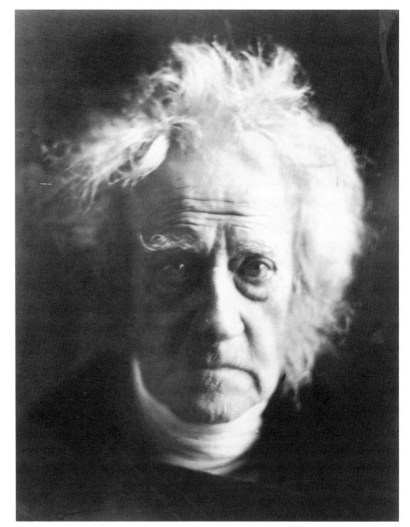

Cameron's images are all studio-based and very much staged events. They declare implicitly the extent to which any 'portrait' is a construction, an advertisement of the self—so obviously underlined by the way in which the *cartes-de-visite* became so fashionable in nineteenth-century Paris as the mark of identity and social significance. As calling cards they asserted the reality and the presence of the absent personality.

In contrast to Cameron, the work of David Octavius Hill (1802–70) and Robert Adamson (1821–48) seems positively candid in its setting and approach. These former painters extended the nature of the photographic portrait in radical and novel ways, taking it away from the studio and insisting on giving the figure a context in which its life and day-to-day existence could be suggested and felt. In this sense they were invariably democratic in their subject matter. Rather than prominent public figures, for example, they would photograph Newhaven fishermen [57]. Neither rendered as picturesque figures nor

56 Margaret Cameron

Mary Hillier, 1872

An image in direct contrast
to Cameron's portrait of
Herschel. Mary Hillier is
sideways-on to the camera,
implying at once a passive
pose to be looked at rather
than admired. There is no
confrontation with an implied
viewer, as there is with the
male portraits of Cameron.

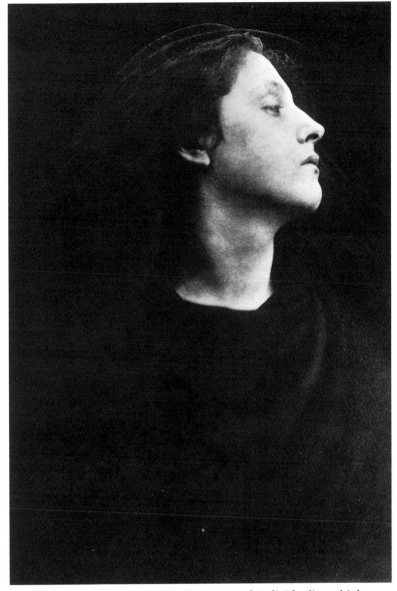

as social types, these retain a substance and individuality which pays homage to their existence and history as unique personalities. The photographs' use of the whole figure is suggestive of the way in which the whole space of a body's presence is given value: a maximum use of detail amidst a larger complex of social, cultural, and individual indexes. The portrait of David Hill by Robert Adamson (1843) is characteristic of the approach—a use of space and tone which establishes the presence of the figure as a discrete personality. Endlessly ambivalent in their meaning, the figures in these photographs insist on their problematic nature as individuals as complex and unique as anyone else—no matter what their social status.

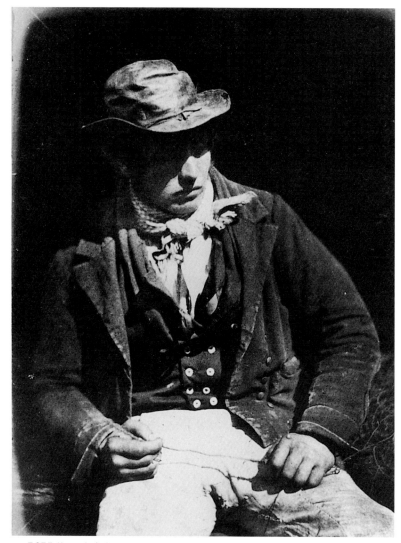

If Hill and Adamson extended the range of portraiture, making it
an almost populist and documentary field, the leading nineteenth-
century French portraitist narrowed his subject-matter down to an
even more limited area than Cameron. Félix Nadar (1820–1910)
concentrated unashamedly on the rich and famous of Parisian soci-
ety. His photographs suggest a virtual *Who's Who* of nineteenth-cen-
tury Parisian life: Daumier, Delacroix, Sarah Bernhardt, Dumas,
Baudelaire—painters, writers, composers—all illustrious figures
suggestive of the mystique of individuality and genius. Concerned
with what he referred to as the 'inner' being of the subject, Nadar
established a style of portraiture virtually denuded of anything
extraneous to the central, and singular, presence of the individual
before the camera. His studies are studio based, with (invariably) a
plain background. The light is natural, a skylight allowing the outside

to 'enlighten' the interior (indeed, there is an implicit play between interior and exterior in Nadar's images). The result is a brilliant intensity, allowing the camera symbolically to stare at the subject in order to establish and reveal a distinct presence. Although formal studies, these go beyond a social context in favour of a declared individual signature—the most definitive *cartes-de-visite* one could have. In terms of their concern with the fashionable it might seem appropriate to align Nadar with such society portraitists as Sarony and, much later, Cecil Beaton. But these are ultimately concerned with setting and surface rather than subject and substance. Nadar's palpable images are difficult to empty of attraction, such is the potency of their presence.

Part of Nadar's significance is that, while he echoed the formal procedures of academic portrait painting, he used the camera to establish a *literal* image of the subject. But like all 'portraits', his images remain framed within a context which asserts simultaneously individual significance and the myth of genius. They promise access as they declare privilege. And consistently, the 'portrait' hovers between extremes: on the one hand the passport image, an identity card which stamps itself as an authoritative image; and on the other the studio portrait, which is offered as a study—the realization of the photographer's definitive attempt to reveal an interior and enigmatic personality. Edward Steichen's (1879–1973) *Self-Portrait* (1908) underlines the dichotomy. The photographer photographed himself holding, not a camera as one might expect, but a paintbrush and palette. Just so, the style is not so much 'photographic' as painterly: it has a diffuse impressionistic quality which directly aligns the image with its painterly equivalents.

Like so many self-portraits of the photographer, Steichen's knowingly announces its iconic framework. The obvious strategy is the use of secondary elements specifically associated with the individual. Ida Kar, for example, photographed Ionesco (1960) surrounded by copies of his plays, a newspaper (to suggest the writer's contemporary concerns), and with half the figure in darkness (suggestive of his Existentialism). Similarly, Jean Paul Sartre was placed against shelves and (piles) of books, as well as stacked manuscripts. Bill Brandt (1906–83), a major British photographer, also used such symbolic motifs in his portraits of 'significant' British figures. In the images of John Betjeman (the poet), of Harold Pinter (the playwright), and Francis Bacon (the painter) the external space in which the figure is placed becomes a symbolic objective correlative, concerned to signify a sense of achievement, status, and personal philosophy. The mood, dress, and significant objects and settings [58] combine to create a dense web of association and often poetic resonance.

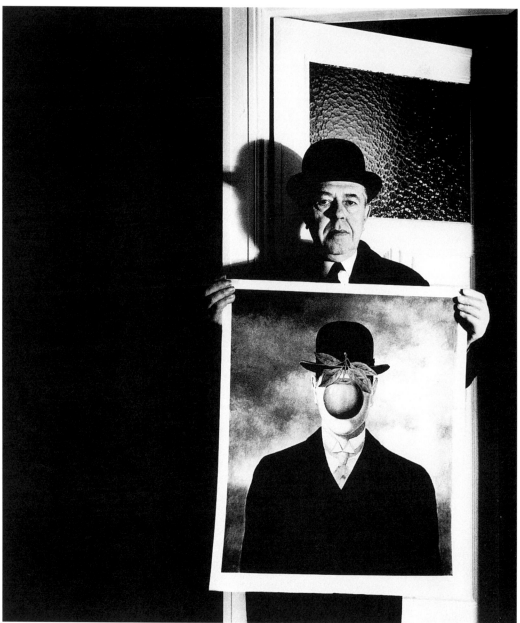

Brandt's images, in their often compelling intensity, suggest the ambiguous nature of what constitutes a portrait. Indeed his visual style recalls the obvious fact that in the formative years of the development of photography, oil painting, like literature, was increasingly questioning the very basis of mimetic (and representational) images. The literal nature of so much photography would seem to place it at the opposite end of modernist aesthetics and philosophical inquiry. Novels like Henry James's *The Portrait of a Lady* (1881) and James Joyce's *A Portrait of the Artist as a Young Man* (1916) made the very act of

portrayal problematic,[5] denigrating any *literal* representation as part of a surface response which ignored the complex psychological inner space in which the self was held. Cubism and Surrealism, like Dadaism and Expressionism, abandoned literal forms of representation in their attempts to establish a visual picturing of an internal as much as external complex of 'being'. But which way the portrait photographer? Surrealist photographers like Man Ray made the questioning of 'self' and 'identity' basic to their photographic aesthetic, often producing extraordinary images which in many ways were forerunners of the later photographs of Diane Arbus and Robert Mapplethorpe.

But the paradox remains, for overwhelmingly the photograph insisted on the principle of representation and the depiction of space that modernism rejected. Perhaps this suggests the extent to which the photograph reflected a populist base—encoding the 'snapshot' into its basis as a democratic art form. But equally it suggests that the individual, whatever material context is involved, is given significance, and definition within an everyday world of codes and signifying registers of meaning. In that sense, and for all its limitations, the photographic portrait inscribes into its meaning precisely that play between internal and external worlds that remains one of the great subjects of the nineteenth- rather than the twentieth-century novel. Above all, the great portrait photographs simultaneously declare identity as they probe the terms of definition.

Look, for example, at two contrasting images: Paul Strand's (1890–1976) extraordinary portrait of a *Blind Woman* (1916) and Vandyk's *Edward, Prince of Wales and Lloyd George* (1919) [59]. The images, of course, could not be more different in terms of social position. But both, in different ways, involve complex typologies of significance—interacting sets of social and cultural codes—by which each image is given meaning.

The Vandyk is an image of the heir to the throne and a prime minister—two figures at the very centre of British power and influence. As such, it suggests as much about their social status as it does about any private index. Everything in the image is as measured, and as calculated, as their dress and bearing. Look at the way, for example, that each is given equal space—on either side of the 'cross' on the floor—suggestive of a sharing of power and influence (and made obvious in the context of the Houses of Parliament). Each is bound by his place within a settled political and social establishment—echoed by the almost identical dress (and uniform) each wears. But look at the way that the camera has established a sense of *difference* between the two figures. A series of detailed distinctions speaks of a dense code of social class and individual histories. The contrasting faces, for example: Lloyd George's is bullish, Edward's hesitant, almost old age against youth. The faces speak of a genteel and well-fed life-style, as do

the haircuts. But then look at the way they stand, their feet placed in suggestive stances *towards* the camera—evocative of their own sense of power and self-confidence. The prince is distinguished by a different tie, collar, even length of waistcoat. His dress is moulded around him. Lloyd George is placed, as it were, into his. The hands extend this sense of difference. They hold the cigars in different ways, and Lloyd George's left hand is clenched, whereas the prince's is hidden. In brief, each slightest difference suggest a distinction which has its place, its meaning, in a context outside the photograph. The result is a complex intertextuality between photographic significance and the social and cultural codes which define status and power.[6]

Paul Strand's *Blind Woman* [**60**] is the very opposite. One of a number of candid camera shots Strand took of New York city street

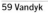

59 Vandyk

The Prince of Wales and Lloyd George, 1919

Although this is very much a conventional portrait, it suggests a series of definitive aspects of the portrait as a genre in its own right. The emphasis on the whole body of each figure gives obvious weight to their status. In turn, all the elements of the image reflect the sense of power and self-confidence which, of course, is underlied by the subjects' own positions as representative figures of the Crown and Parliament.

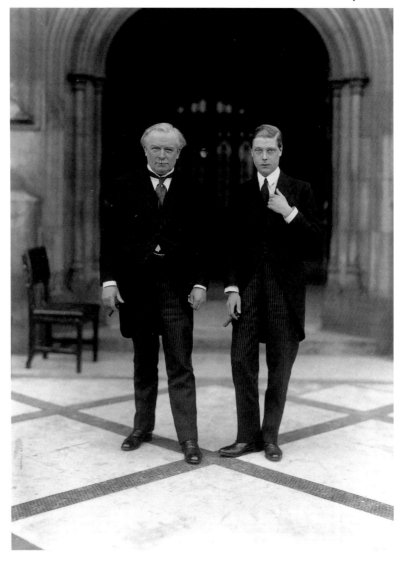

60 Paul Strand

Blind Woman, 1916

Strand here offers a
documentary photograph
which retains an extraordinary
emotional intensity. The
text ('blind') compromises
the terms by which we look
at the person before us in
the photograph.

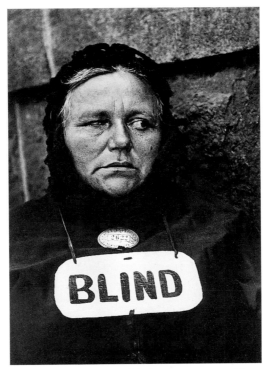

figures in the 1900s, this is at once a problematic and poignant study.
The subject has no name, merely a number registering her as an official
beggar. Equally, she cannot see, cannot gaze at the camera with all that
that implies about identity and status. Unlike Vandyk's image, Strand's
is an intense study of absence, denial, and, in terms of what we see in
the face, of pain. Typical of Strand's street portraits, he displays here an
almost vehement insistence on the way the blind woman demands
significance, and status, if for no other reason than the *fact* of her
existence, and the emotional resonance of her condition.

Vandyk's and Strand's portraits point up the extent to which the
camera has capacity to define a personal history within the context of
other frames of reference. And perhaps the photographer who, above
all others, excelled in this kind of portrait photography was the
German, August Sander (1876–1964). Sander's is a portraiture
dedicated to a *social* picturing of the individual. His complex but
expansive attempt to photograph an entire 'social arc' of German
society between the world wars, what he referred to as his *Citizens of
the Twentieth Century*, remains one of the most sustained attempts to
define individuals within their time and culture. Sander's subjects are
above all *social beings*. Defined by their profession (or lack of one), they
take their place in a dense hierarchy of meaning established through
social difference and distinction. As he declared, 'the photographer
with his camera can grasp the physiognomic image of his time'. The
figure, in this sense, gains credence from its relative position, for it

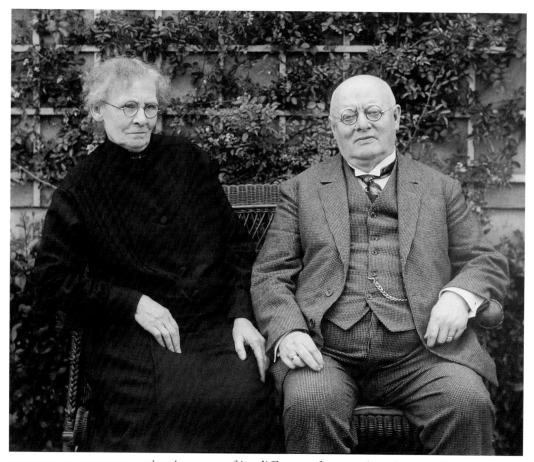

exists in terms of its difference from, rather than similarity to, other
figures. The individual is always referred to a larger frame of social
identity—not by name but by occupation: a boxer, or accountant,
lawyer, baker, cook, bricklayer, customs officer, and so on [**61**]. Every
detail in a Sander portrait is of significance—everything *means*; but we
need to probe the images for any hint of an internal, and private self.
This is a society on show—a public space in which the self has meaning
only in so far as it has access to that public forum.[7]

Sander's images suggest an almost hidden sense of self—one asks
where is the emotion, the felt dimension of these individual lives. But
then these are *portraits*, not candid shots or documentary images
probing the terms of the individual's existence. They reassert and
reaffirm the extent to which we *show* rather than *reveal* a face in any
public context. Perhaps we are entitled to ask at what point an image
may be *called* a portrait? Those haunting, even desperate images of
New Yorkers in the New York subway taken by Walker Evans (entitled
Many are Called) are not 'portraits', but they do express a remarkable
authenticity in their gritty and painful excess. They seem to speak of
emptiness and exhaustion, but rarely declare any figure in an individual

sense. We are left with the private self cast amidst a public anomy—*sans* the formal (and assumed) sense of confidence which sustained, for example, Lloyd George and the Prince of Wales.

Much twentieth-century portraiture has questioned the very terms by which an individual can be 'known' or 'expressed' in terms of a photographic image. Alfred Stieglitz's images of his wife, Georgia O'Keeffe, are an obvious example. These suggest an extended sense of construction—of O'Keeffe photographed in detail in relation to her body—torso, breasts, legs, arms, and head. The number of images Stieglitz amassed from a clearly deeply intimate (and fractious) relationship constitute a veritable serial biography—and yet they do not, ultimately, define 'O'Keeffe'. They represent a series of images, facets, aspects of her being which denies the camera access to *its* private spaces. O'Keeffe defines herself in the way she resolutely refuses to

62 Yousuf Karsh

Georgia O'Keeffe, 1965
Karsh's image of O'Keeffe extends its meaning in relation to three obvious areas: O'Keeffe's work as an artist in New Mexico, Stieglitz's portraits of her, and her private self. She remains a diffident and enigmatic figure.

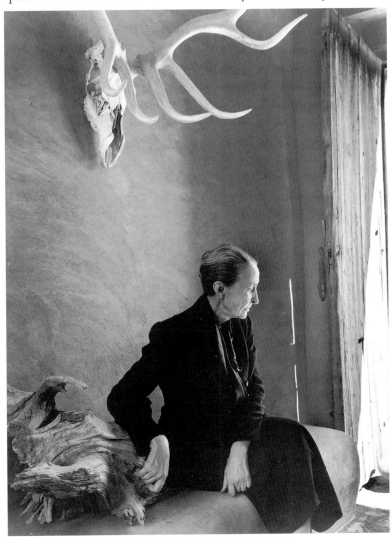

63 Robert Mapplethorpe

Self-Portrait, 1971

One of a series of self-portraits
which, in their accumulative
effect, make the very question
of identity fundamental to their
meaning. In this context,
sexual identity is viewed
as basic to any sense of self.

assent to the camera's presence. Ironically, it is Yousuf Karsh's 1956 image [**62**] which suggests the enigmatic and problematic nature of her 'self' more than anything Stieglitz achieved—superb as that was and I will return to that 'self' in Chapter 7.

The case of O'Keeffe is significant, for it underscores the extent to which many post-Second World War portrait photographers have made the *problem* of identity basic to their *œuvre*. Four Americans in particular: Richard Avedon, Diane Arbus, Robert Mapplethorpe, and Cindy Sherman have all, in different ways, responded to this question, and I want to devote the rest of this chapter to a brief estimation of their remarkable achievements.

Robert Mapplethorpe (1946–89) was one of the most contentious of post-war American photographers, partly due to his homosexuality. Indeed, one of the central aspects of his photography is the extent to which he began not just to explore 'portraiture' in a gay context, but to so do in relation to an assumed gay audience. Like *Apollo*, his portraits of male nudes (black and white subjects), as much as the female studies and those associated with sado-masochism, seem to suggest a determined and problematic aspect of self-identity in which *sexual* proclivity, rather than social distinction, is uppermost. And nowhere is this more obvious than in the protracted series of self-portraits that he made in the 1970s and 1980s.

The series is, perhaps, characterized by the *Self-Portrait* of 1971 [**63**], an overtly dramatic rendition of Mapplethorpe's body encased within wire and silky material—opposite extremes of his private and public self. He faces the camera naked—his body cut up—as if both self and the physical substance of the individual are subject to cultural and psychological torment. This is a poignant image—and informs the relatively large number of self-portraits in other guises and garbs. Often Mapplethorpe, in contrast to this, *dresses* for the camera—in a tuxedo, in leather, in make-up. Most contentiously, in a 1978 self-portrait he has inserted a bull-whip into his anus as he looks at the camera: an obviously radical and extrovert *reversal* of virtually all the conventions of the portrait photograph. These photographic portraits place themselves within a larger context of gender and identity, but *as photographs* they insist upon themselves as part of a continuing metamorphosis in which a single personality does not so much change as reject the codes through which identity, private as much as public, is assumed, determined, and declared.

Cindy Sherman (1954–) is an equally central presence in relation to portrait photography. Beginning with an extensive sequence of 'Untitled Film Stills'—single black-and-white shots of imaginary Hollywood films—she embarked on an exhaustive visual analysis of the very meaning of identity in terms of its significance as an *image*. Her pictures feature both social and sexual stereotypes fed by a

consistent sense of individual ambiguity and self-questioning. The remarkable aspect of her images, despite their self-avowed advertising of the terms of reference, is that the subject is always Cindy Sherman. She equally is everywhere and nowhere—a continual presence suggesting meaning through her constant absence. And just as Mapplethorpe explicitly questions heterosexual codes of being, so too does Sherman question the terms by which woman is to be known and viewed. The dense detail of her constructions suggest a series of worlds as much imagined by Hollywood and Madison Avenue as anything 'real'. In the end there *is* no literal reality. All is construction and myth and, ultimately, self-enclosed fantasy. Perhaps this is why her later portraits blatantly advertise themselves through colour: images which exhaust themselves by their dependence on appearance and style. But equally Sherman's images have about them a dangerous precocity. *Untitled No. 122*, for example (1983), is a colour photograph [**64**] whose effect is boosted by its scale (it measures 220 × 146.5 cm). The audacity of this image is compounded by its deft mix of anonymity, with the distinct presence (and power) of an overpowering individual. The photograph declares a daunting and dangerous energy—the clenched fists, the single eye, the overwhelming black coat, the redness of the skin, and the shadow all create a distinctly disquieting experience. The 'self' here is at an extreme point of definition—and possible break-

66 Richard Avedon

Self-Portrait, 1964

An image full of deliberate
ambiguity, this is a study
concerned with the very
process of identity and the act
of portrayal. It resonates with
its own sense of the enigmatic.

down. Encased within its social contexts, it reveals a fierce and frightening otherness which, paradoxically, threatens to destroy the very act of photography itself. No wonder it is untitled.

Like Sherman, but through different methods, the photography of Diane Arbus explicitly questions the terms of social identity. Arbus, who committed suicide in 1971, originally worked in fashion photography—at the opposite extreme from her fearsome images of seemingly displaced and lonely individuals. Two of the major influences on her work, Weegee and Lisette Model, suggest the terms of reference for her images. She chose to portray individuals very much in a private context—transvestites, for example—who do not so much undress physically before the camera, as undress themselves psychologically. Collectively, her photographs suggest an overwhelming sense of angst and loneliness. Her use of masks and cosmetics questions a surface meaning in which the inner (and private) self is sought [**65**]. Ultimately, Arbus images a pervasive condition—underlined by the way her photographs suggest the use of a polaroid, with all its 'cheap' associations.

Like Arbus, Richard Avedon has metamorphosed from a 'formal' portrait and fashion photographer into one who consistently questions the terms of reference by which an individual can be photographed. His series of photographs of characters from the Western United States, for example, placed against a white background, give off an atmosphere of loss and displacement. But this is, perhaps, the point. Avedon's work suggests the formal portrait at its stage of disintegration whilst retaining a compulsive ambiguity. The self-portrait, for example [**66**], taken in 1964, involves a photo-booth and a mask of the black American writer James Baldwin. The implications, and the terms of reference, are overwhelmingly complex. But the *presence* of the image, in all its ambiguity, achieves a definitive summary of portraiture in photography. Here we no longer look at an individual, but view the *process* of how the camera and the photographer make sense of an ambivalent and ever-changing condition. Like all significant portrait photographs, it declares as it questions its terms of reference. In that sense the portrait photograph, unlike the portrait painting, has always belonged to the twentieth century—simultaneously using, as it resists, its implicit contradictions as a means of representation.

The Body in Photography

If the portrait photograph reveals one of the most problematic areas of photographic meaning, so the image of the nude and the body remains one of the most contentious. Like the portrait, much of the formal iconography and symbolic structuring has its roots in painting, but photography substitutes for the painting's presence a veracity and immediacy which, in going beyond questions of aesthetics, involves us in what has been called 'the entwined problematic of representation and sexuality'.[1] Like John Berger's argument that the ideal of 'classic beauty' is essentially one of 'mystification',[2] so much recent criticism and theory, drawing on recent developments in the understanding of social and cultural codes, as well as on psychoanalysis and gender theory, has increasingly viewed the depiction of the nude and of the body in relation to a complex series of social and cultural structures and values, in which sexuality is not so much a given as a construction in which are reflected other values and relationships; especially in terms of sexual difference, the image of women, and homosexuality. Photographs of the body imply a larger politics of power and representation, and the work of many recent photographers, especially women, has been an attempt to change the terms of reference, most notably in relation to the nude female body, and make the process of representation, rather than the image of the body, the subject of the photograph.

Of course, the depiction of the body has become pervasive in a culture dominated by advertising and Hollywood narrative cinema, and the photograph, as such, takes its place within that process. But equally, the photograph has a long history of imaging the body, especially naked women, and of pornography produced for private consumption. Since its inception the photograph has delighted in the depiction of nude bodies within a private space—implying a sense of the hidden, the illicit, and of the secret. It makes the private space of the body open to the public eye and, overwhelmingly, that eye has traditionally been male. Stephen Heath noted a report in the London *Times*[3] of 1874 of a police raid on a London shop which found some 130,000 'pornographic' images, and there are Victorian photographs from as early as the 1840s depicting heterosexual and male and female

The Chiffonier, 1904
This is a 'period' piece,
although the interest lies in
the way in which the female
figure is totally passive. The
male photographer dominates
the scene from above, with
obvious implications. The
entire image is suggestive
of submission and passivity.

homosexual sexual acts, as well as images of masturbation, defecation, and flagellation.

It is, however, not so much what is depicted as the relationship between photographer and subject that is significant. Academic painting sanctioned the image of the body in terms of an official classic tradition, and so does early academic photography, but it does so in terms of its promise of the actual. An image of a body as distinct from the painting of a body insists on a privileged access normally shared only between the artist and (his) model. Delacroix even used photographs of models by Eugène Durieu—they could replace the actual model, such was their sense of being the real thing. It is the photograph's veracity which has allowed it to play into the problematic area of sexual fantasy and desire, and which underpins much of its efficacy in relation to both public and private images of the body and pornography, for example, in the work of Frantisek Drtikol

(1883–1961) and the homo-erotic images of Count von Gloeden (1856–1931).

Much of the photography of the body in the early twentieth century is an extension of nineteenth-century preoccupations and attitudes. Clarence White's *The Chiffonier* (1904) [67] is characteristic. Soft-focus and passive poses hide, as it were, an underlying structure of female stereotypes in relation to male fantasy and expectation. The woman is to be looked at in her dual role as spectacle (for the male gaze) and stereotype (mistress, wife, mother, and so on). These are demure images, with the female subjects rarely looking at the camera. Their downward, sideways, or averted eyes represent them as objects to be looked at, framed within a specific symbolic iconography (flowers, streams, clothing, and so on). Rejlander's 'studies' of the female form follow the same stereotypes (especially of the body in a sitting or lying position), as do those of Frank Eugene (1865–1936) and Edward Steichen (1879–1973).

Although in the same period many of Stieglitz's early studies of the female form were within the terms of pictorialism, it was with his photographs of his second wife, Georgia O'Keeffe, that he created a distinctive and new kind of imagery for the depiction of the human form. The large number of studies of O'Keeffe constitute an *œuvre* in their own right and question many of the assumptions touched on above. But equally, they insist on the subject as the active centre of the images. It is O'Keeffe, not Stieglitz, who determines the frame of reference, so that instead of a passive subject, we look at a decisive and distinctive individual personality who resists the power of the camera to reduce her body to an extension of the male gaze.[4] Over a period of twenty-seven years Stieglitz photographed her as the single subject of a unique body of work. In so doing he imaged virtually every part of her body: face, hands, torso, breasts. The result is a continuing tension between the way in which Stieglitz attempts to image O'Keeffe according to his own predilections and assumptions, and the way that she resists such 'power' and retains both her body and her self as her own property and presence. In the end O'Keeffe is always 'there' but is never 'seen', so that she retains her own space and is her own person. The 1919 *Torso* [68] is a characteristic example of Stieglitz's approach, and remains cast within the dual relationship of how Stieglitz sought to use the body, and how O'Keeffe resisted his interpretation and appropriation through an aesthetic which, for all its ideal notions of form and meaning, is based on the male gaze. She will not be seen as 'woman'; she will be seen as who she 'is': Georgia O'Keeffe, American painter (see Chapter 6).

O'Keeffe, then, questions the terms of representation, a position that has become increasingly the subject of depictions of the body. Barbara Kruger (1945–), an American photographer, makes this

Georgia O'Keeffe—Torso, 1919
One of a number of O'Keeffe
images by Stieglitz, this
reflects both his approach
to the female body as well as
O'Keeffe's resistance to the
terms by which he sought to
define her within the frame of
the camera. Thus the absence
of her face, her hands, and
her feet (all arbiters of an
individual self) allow her to
remain absent from the image.
The image reflects the body as
part of a sexual territory open
to the male gaze.

central to her work and establishes it as a distinctive focus. Where we might say that it is implied in the O'Keeffe images, Kruger articulates it as a basic element in her work. Her images declare themselves as part of a larger polemical questioning of both the terms of representation, and the terms by which we read the image. They thus actively question (male) assumptions constituted into the culture as part of a previously assumed natural and invisible representation of the body as image. *My Face is Your Fortune* (1982) [**69**], for example, puts this in context. This is both a photograph and a poster. The words on the image are not so much a title as a typology of values related to the image. They take their place within an inferred structure of meaning in relation to the female body as spectacle. 'My' and 'Your' insist on an underlying relationship involved in the very act of looking. The black-and-white bands suggest a distinct but simplistic distinction between the polemical and philosophical terms of the image. But the text declares difference on another level. 'My face' suggests ownership, not just of an image, but of a physical and moral territory unique to the individual history. 'Fortune' is equivocal, and hints at both a material aspect (the money to be made from the production and advertising of images of women) and of 'good-fortune' for the viewer of the image. Indeed, Kruger once worked for commercial magazines.

But as we move beyond the written text so we engage a further set of dialectical relationships. The basic image is of a woman washing her face. In one sense the water has been 'captured' by the camera, and has its own kind of 'beauty' which edges into the way the female face is seen. But equally the act of washing is here ambiguous. The face is washed, cleaned, as it were, of make-up as part of a larger mask of presentation that is the role of women. To wash, in this sense, is to reclaim the face as 'mine', as part of an authentic physical reality. This subject will not fall prey to consumer stereotypes. But equally the action of washing recalls to us many impressionistic paintings of women washing, combing their hair, dressing and undressing, and of course looking into mirrors. These project the figure of the woman in relation to private space and private activities, placing us in the room as an invisible presence. Kruger refutes that stereotype, for it is an action that is photographed, not a passive interpretation of a woman's ablutions. Taken in this context, the image is an active mapping of a confident and assertive act of cleansing and washing in the largest of contexts: a history of representation and consumption which this both questions and rejects, even while giving way to its continuing ascendency which frames the image of woman within a structure of male power and values. Thus, the eye is ambiguous and, to add to the ambivalence, the thumb-nail is painted with nail varnish.

Kruger's images establish a deep, subtle, and powerful rhetoric—a mix of the visual and the written in which the subject is presented

My Face is Your Fortune, 1982
A poster as much as a
photograph, this declares
its polemical and radical
approach in terms of a self-
conscious typology. The words
in the image are as significant
as the visual elements—
indeed, the image must be
read in relation to the words
in the photograph. Note the
painted fingernail.

within the site of a dense and complex series of codes and meanings. Another image from 1982 (untitled) has a woman's face, supine and passive, in a traditional pose. The eyes are covered with leaves, an obvious but effective visual pun, for the caption reads 'We won't play nature to your culture'. 'You' here is clearly male and 'we' female. 'Nature' and 'culture' are placed in the context of patriarchal values and assumptions, especially in terms of what constitutes the natural. The image offers a radical questioning of culture, and notions of sexuality

and 'womanhood' based on constructed meanings, signifiers hiding a historical and political condition. Kruger's images foreground the extent to which no image of the body is neutral, and in turn stress the extent to which any image of the body, male or female, involves the reader of that image in questions and attitudes which go far beyond the immediate frame of the photographic image. In turn they remind us of a basic fact, that 'notwithstanding the equally lengthy tradition of homosexual erotica, in the modern world the vast majority of such images are of women made by men for use by men'.

Part of the difference might be suggested by one of the studies of human motion carried out by Eadweard Muybridge (1830-1904) in the 1870s [70]. Muybridge, acknowledged as the first photographer to establish the use of the camera as an accurate recorder of human movement,[5] created a detailed portfolio of images which present themselves as scientific studies of human anatomy and the body. Both nude men and women are photographed serially as they walk, jump, and perform other activities. They are all concerned with action. But even here some of the differences are significant, for invariably the

70 Eadweard Muybridge

Nude Men, Motion Study, 1877

Muybridge's images, the first accurately to record the movement of figures and animals, have a major place within the depiction of the nude body. Although supposedly scientific and objective images, they suggest the way the body is inevitably viewed in relation to sexual stereotypes and attitudes.

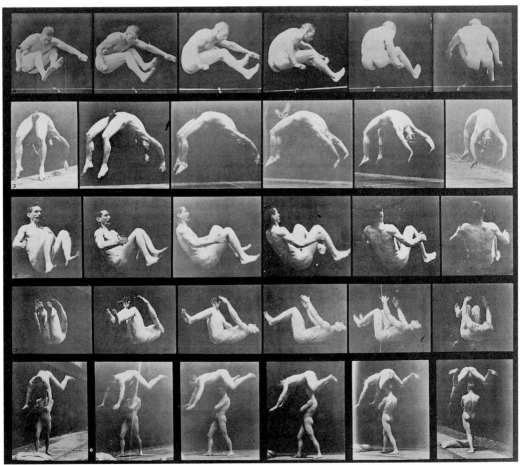

71 Cindy Sherman

Untitled, 1992

One of Cindy Sherman's colour prints, this is a complex if blatant representation of her concerns with sexual difference and identity. The passive stance, the arms, and the gruesome (male) face add to the effect. Its impact is completed by the sausage, which reduces the image to an absurd and outrageous study of male sexuality.

male figures are active, while many of the females perform passive and traditional roles, despite the images' relationship to a new awareness of the body (medically and anatomically) and its physical measurement. Here the eye seems to calibrate motion as a denotative structure, but looks at the figure in a connotative context.

Whenever we look at an image of the body, be it ours, someone else's or even a dead body, we enter into a highly charged area which, if invariably sexual in content, concerns a dense set of signifiers and attitudes which constitute the terms of reference by which we judge and respond to the image before us. The body, especially the nude body, is so contentious as an image in relation to sexual questions, that it replicates visually those cultural, social, and aesthetic aspects which give it meaning in the first place. In part, as was suggested above, this refers to its literal presence, and the extent to which so much photography has played into a fantasy space where the hidden, the private, and the forbidden is made available to the eye. The photograph thus feeds on fantasy and on the fetish, and reinforces an assumed relationship between reader and subject that many critics would argue exists as the basis of the social differences between men and women. The image, in that sense, not only allows scopophilia[6] (the pleasure of looking) to dominate, but does so in terms of a passive subject and an active eye with absolute power over what it sees, and upon which it looks as an invisible presence. The eye subjugates the subject as it replenishes itself without fear or restraint. The subject remains an image in a sealed world open to the power of the male gaze,

72 Anonymous

Nineteenth-Century Nude, 1850

The extreme perspectives of Sherman's image are placed in context by this image from 1850. Compare the expression of the face to that in **71**.

and as such is part of a mythology within a larger mythology. Fantasy feeds fantasy.

In this context the work of Cindy Sherman is again of significance. Much of Sherman's later work is a radical example of both the realization of critical issues and concerns basic to a postmodernist understanding of the body as sexual object, and the development of a new photographic language within which to present them. While her portraits examined the configuration of self as a social and cultural construction, especially in relation to the stereotyping of female identity, her images of the body (as distinct from the person) create a much darker and more extreme visual language. *Untitled* (1992) [**71**] is typical of her recent work and pays an ironic homage to the entire canon of photography (and painting) concerned with the depiction of

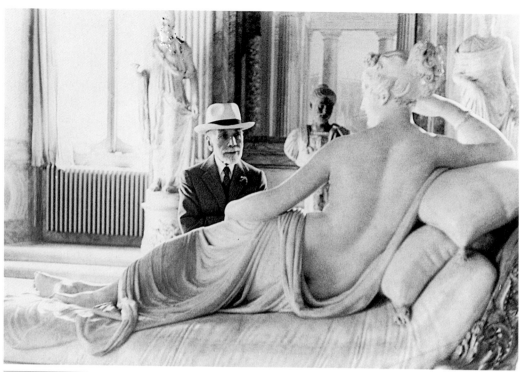

the female body. The colour emphasizes the garish and crude terms of
the image. In a typical Sherman manner the subject is both a per-
ceptual and conceptual conundrum. Simply by looking at it as an
image we are, by implication, engaged with wider ideological as-
sumptions in which not just the female body has been defined, but
sexuality and identity in relation to aspects of gender and sexual
difference, age, and physicality. But this is equally a play on the subject
of the nude (and the naked) within a tradition of the visual depiction of
the body which places the woman at the centre of its focus. The female
'body' here is nothing but a construction (ironically it has been
constructed by Sherman herself). The emphasis is on the breasts and
the vaginal area. The body rests on wigs, and the pose is typical of so
many images of women, especially in the photograph: it is supine,
passive, helpless and we look at it from above. The focal point, the
vagina, is deeply coloured and has a salami sausage placed in it; a
blatant satire on male 'power' and the mythology of the penis. This is a
doll, a visual plaything whose terms of reference are suddenly reversed
in relation to the face, which is that of an ageing male, situated in the
very position of the woman that his staring eyes seem to look upon. A
grotesque but brilliant image, it constitutes a visual essay on both the
politics of the female body and the representation of women in relation
to the male gaze. It deserves an analysis beyond the scope of this
chapter. Those who consider it an outlandish, even extreme response
need look no further than [72] in order to place it in a cultural and

historical context. Dating from 1850, this Victorian image, in all its sad absurdity, speaks of the very conditions Sherman has imaged from her postmodern perspective. Each are mirror images of the other, with similar critical and cultural implications.

Much of the way the photography of the body is to be understood, then, must be related to the male gaze. In the single act of looking can be represented precisely those relationships, values, and assumptions on which are based the terms of sexual representation. David Seymour's *Bernard Berenson at the Borghese Gallery, Rome* (1955) [**73**] places such a relationship in a wonderfully subtle yet telling context. This is a study on the act of looking, although filtered very much through the life-style of a refined and aesthetic patrician figure. The civilized encounter allows it to be placed within the ambience of fine art and the museum; but, Berenson apart, it also places it in terms of the male gaze and female passivity. The female presence here is seen only in terms of a frozen object. The male figure is free to roam the gallery in search of female images and female forms. It is, as it were, a feast for his eye.

Such an image stresses the essential nature of the visual in terms of the body, and underscores how the eye involves an entire cultural baggage as it focuses on the world of its choosing. Freud referred to this as *scopophilia*, the pleasures of the eye, and Hollywood film has made much of it in relation to the female presence on the screen. But much photography takes the subject away from the scopophilic and places it in a larger cultural set of relationships. The 'gaze' is more than a look, it is the reflection of those structures that photographers like Kruger and Sherman want to expose. It implies power, but it also implies the voyeuristic and the fetishistic: primary terms of reference in which a body is subjected to assumptions which have nothing to do with its individuality; its uniqueness in terms of the person, rather than the image, being photographed.

Thus photographs of the body speak to wider social and cultural assumptions. In part the body is invariably photographed within a private space, and the context of this, when we can identify it, is crucial. A bedroom, a bathroom, above all an interior seems necessary to define the nude as a subject, and this clearly involves the dense structure of meaning associated with the act of the voyeur, for the voyeur looks upon a secret and uninvited space, an area illicit in its geography and its contents. And yet invariably this is dependent upon the passive and unknowing figure of the female being looked at and, once again, exposed to the male gaze. Photographs of brothels, especially Brassaï's images from Paris, suggest this negotiation with an interior space. The photographer surreptitiously intrudes on a private moment in order to expose it to a potential public viewing. The film *Klute*[7] was exemplary in this sense, for it insisted on the way in which a female person was

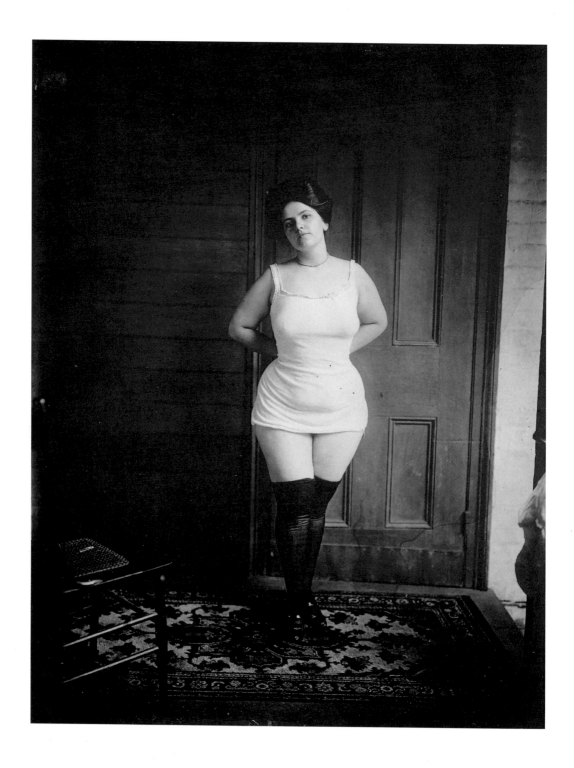

subjected *to* that gaze, specifically by someone looking at her through a window on the roof of her apartment, and indirectly by her passage through the city of New York where she worked as a prostitute.

E. J. Bellocq's images of prostitutes from the 1900s [**74**] encapsulate precisely this issue of the look. They are, in their own way, extraordinary photographs taken of the interior of a brothel in New Orleans at the beginning of the century. But looked at in relation to recent criticism they encapsulate a particular male way of viewing the female body. The women display themselves to the camera, but do so within the terms of their environment and profession. Equally, the photographs raise a series of central questions about the body and its depiction. In many of the images the face of the woman photographed has been blacked out to prevent identification; but the blank area is reflective of the image of the body that they collectively suggest. These

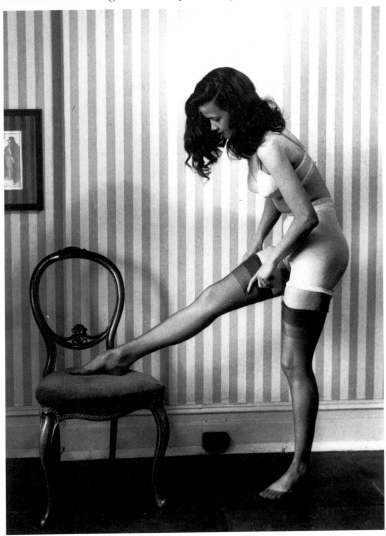

La Poupée (The Doll), 1935
Bellmer's dolls represent
a subjective rather than
objective delineation of the
female body. In many of his
images there is an underlying
sense of violence and the
sadistic. The doll is openly
manipulated by the
photographer to his
own ends (and fantasies).

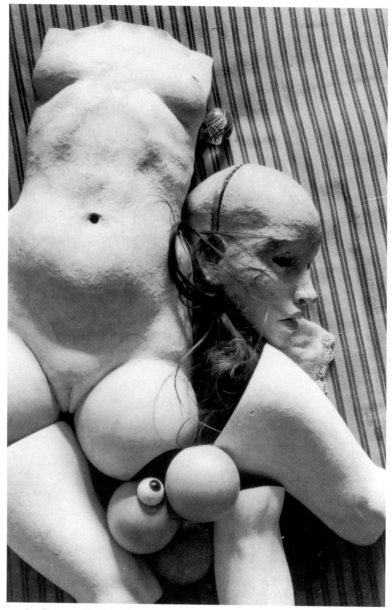

are bodies on display. Interior shots, they undress the figure in relation
to the male gaze. As prostitutes, it is as if the women's sole function
before the camera is to advertise what the body offers. They stand and
sit in anticipation. Never individuals, the camera's focus is on the body.
There is an underlying sadness about these images, indeed they are
usually seen as documentary photographs, but Bellocq's camera is very
much a prurient presence and frames the women in terms of their
social position. He seems to photograph from the 'client's' point of
view and does not question the terms of reference nor the implications
of what he photographs.

photograph asserts the physical presence of the individual. This is not a type, nor is it a model. The shadow on the wall and the picture behind make this part of a private space in which intimacy is about to or has taken place, so that the figure becomes part of the scene and suggests a relationship to the photographer which places him on equal terms. Rarely do we have the same sense with photographs of the female form, and if a bedroom is featured the female body is invariably placed on the bed, not standing above it. Likewise, in this image the hands are placed on the hips as part of an assertive pose. In Bellocq's image the hands were behind the back, emphasizing the nature of the female body as a display, and reflecting a passive and submissive pose.

More recently, the work of Robert Mapplethorpe has extended such issues into what we might see as a fully fledged homo-erotic photography based on an assumed gay audience. In the America of the 1980s and Aids, such a picturing has radical and problematic implications. (Indeed, Mapplethorpe died from Aids.) Like his own self-portraits, his photographs suggest an ongoing attempt to find an approach and an imagery which both questions the dominant heterosexual tradition whilst imaging gay fantasy and values on their own terms. Criticized for both his images of children and a series of images involving sado-masochism, Mapplethorpe's photographs raise questions about the relationship between image and viewer, and the assumptions we bring to them. In particular, his photographs of black male models and of male genitalia further complicate the question of the body in terms of racial as well as sexual identity and the mythology associated with them.

Other photographers, especially women, have questioned such a tradition not in the way Kruger, for example, has but by presenting the body bereft of its usual terms of reference. Jo Spence, who died of breast cancer, made her own body the subject of representation. Before her death she photographed herself, showing the result of what breast cancer had done to the sight of her body. Like other photographers who have photographed the scar of their operation, these pictures not only image a painful and disfiguring condition, but open up private grief and suffering to insist that the body represents an individual identity and not just the site of male desire. In turn, and in almost brutal terms, they cut away at the photography and the focus on breasts as so crucial to female identity as part of what they offer to the eye. *Industrialization* [**78**] is, thus, an equivalent image. This reverses the submissive body and places before us an image suggestive of the physical weight and presence of the figure, rather than the body as an image. A powerful presence, this is a heavy body, the direct opposite of the ideal commercial image. But it is also a tough body, and shows its own scars and history. The hand, for once is the centre of attention, just as the camera has deliberately avoided any explicit sexual imagery. It is

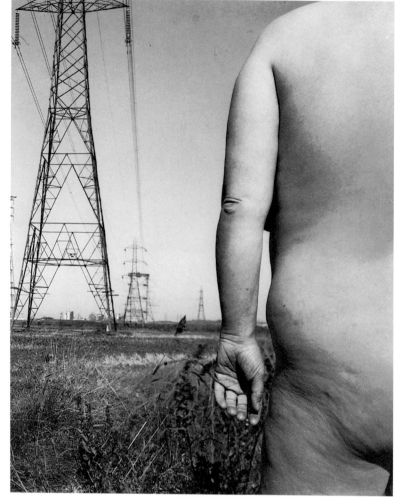

78 Jo Spence and Terry Dennett

Industrialization, 1982
The body is here placed within a series of contexts which redefine its assumed terms of reference. 'Nature' and the natural are questioned in relation to the image of the body and the obvious power-lines strewn across the land. Note the hand, which is given a remarkable resonance and detail.

79 Annette Messager

Mes Vœux (My Wishes), 1989
A 'mobile' of change and complexity in which the body and the nude have been re-cast and reconstituted. The individual viewers look upon those aspects which interest them; they thus construct their own 'body' according to their own predilections and biases. It is a deeply probing image of sexual desire and fantasy.

the skin that we look at here, and a skin which bears the marks of age. But we also look at a series of pylons, integers, again, of the cultural constructions strewn across the land. This is, in many ways, a raw image and denudes the scene of all our usual assumptions about the body. But in so doing it achieves its own radical position and identity.

To the response of Jo Spence could be added a series of photographers who together constitute a veritable alternative tradition to that based on the assumptions of the male gaze: Deborah Turbeulle, Linda Benedict Jones, Shirley Beljou, Carolee Schneemann, and Hannah Wilke all, in different ways, offer radical and probing images of how the female body is seen and interpreted. Their work not only reflects contemporary debates and awareness about the problematic nature of the body in the photograph, but alters our terms of reference for the interpretation of the whole history of the way the photograph has imaged the body, especially that of women by male photographers.[10]

80 Judith Joy Ross

Untitled, 1988

Almost a snapshot, or a holiday photograph, this resonates with a palpable sense of sexual innuendo. The two figures on the left are reminiscent of Arbus's *Identical Twins*. They are, however, clearly contrasted to the figure on the right who is 'exposed', so to speak, in terms of her own body. Note the different stance of the legs, the difference in the attitude to the camera, and of course the different depiction of the genital areas. Note also the male figure in the background. The image is by a female photographer.

Something of the pervasive nature of such imagery, and its centrality as a subject, is an image (or series of images) by Annette Messager entitled *Mes Vœux* (1989) [**79**]. Its title, 'My Wishes' is, to some extent, the very reverse of Hans Bellmer's work in that part of its effect is to deconstruct the very basis of the sexual fantasies so prevalent in his images. *Mes Vœux* is based on some 250 framed black-and-white images, suspended on strings. Their notional size, collectively, measures something like 2 × 1.4 metres. In one sense this is a metaphor for the very act of photographing the body. As we look at each of the images a series of limitless patterns, rhythms, and pre-occupations is established. The viewer focuses upon certain parts of the body, creating an individual hierarchy of significance. Yet these are also hints and guesses at something larger. By breaking the body down to its constituent parts, it suggests a taxonomy or index of meaning, a celebration of the body itself, but also its endless ambiguity and attraction as an object of possible pleasure. The eyes, ears, breasts, legs,

and genitalia offer themselves to the imagination. Meaning, as such, is suspended like the installation. This might be a series of visualized fantasies, but the sealed nature of its image, and its refusal to complete the frame of reference (for it hangs suspended before the eye), questions other critical issues and cultural assumptions. It will not be made into a single, coherent photographic space, but breaks the body down into a series of presences which question rather than complete meaning.

As this chapter has tried to suggest, the body remains problematic, as much in the commercial, artistic, pornographic, and erotic senses. The canon of male photographers underlies many of these questions, so to look at the images of nudes by Drtikol, Brandt, or Lee Friedlander is to confront the same questions. I want to close this chapter with one last image which, in many ways, places these issues within a problematic of seeing; what has been called the 'ideology of gender'. *Untitled* (1988) [**80**], by Judith Joy Ross (1946-), is an exemplary image of the body, and has the distinction of being by a female photographer. It is a deceptively problematic photograph, and has implications for the viewing of the body which take it beyond its immediate impact. It focuses upon three adolescent girls, two of them twins. It is a casual shot, almost a snapshot, of a cursory swimming interlude. The three girls face the camera as happy, if self-conscious subjects. But look at the detail of the image and the way it changes a snapshot into something quite different. The twins are almost mirror-images of each other, with their hands placed in front of them. The girl on the right has a different stance, does not look at the camera, and has a different costume. Above all, the bottom of the costume has been displaced to suggest her pubic area. It is both intrusive and revealing. As if to prove the point, a male adolescent hovers in the background. Seemingly the most innocent of images, it slips into a different kind of index and, even unwittingly (or not), exploits its subject in favour of the spectator. And, as recent photographs have shown, the body is as much exploited in its living as it is in its dead state; one thinks of media responses to recent wars and of course, the depiction of Aids.[11]

Documentary Photography

In many ways documentary photography has dominated the photographic history of the twentieth century, and many of the great names have been associated with the genre: Eve Arnold, Werner Bischof, Robert Capa, Henri Cartier-Bresson, Bruce Davidson, Leonard Freed, Ernst Haas, Hiroji Kubota, Inge Morath, George Rodger, Sebastião Salgado, and Dennis Stock all, in their different ways, made documentary photographs. And yet the term is limiting both in relation to the range of reference and the approach to the subject. 'Document' means 'evidence', and may be traced to *documentum*, a medieval term for an official paper: in other words, evidence not to be questioned, a truthful account backed by the authority of the law. And documentary photography, as a genre, has invariably rested within this frame of authority and significance. It seems the most obvious of categories, and is used precisely *as* evidence of what occurred, so that its historical significance is employed further to invest its status as a truthful and objective account (or representation) of what has happened.

Equally, documentary photography shows the camera at its most potent and radical. The very subject-matter of the documentary photographer is an index of the contentious and problematic as well as of emotional and harrowing experiences: poverty, social and political injustice, war, crime, deprivation, disaster, and suffering are all difficult areas to photograph and all potentially problematic in the way a photographer will approach their meanings in terms of his or her own assumptions. The documentary photograph is equally one of the most intimate forms of photographic practice and, in turn, one that explicitly associates itself with public space. It assumes a bond between reader and subject, buoyed up by an assumed mandate not just to record, but to expose: the 'camera with a conscience'. Whether it was in *Picture Post*, *Time Magazine*, *Life*, or a newspaper, the photograph, as evidence of events, was basic to the presentation of the story. In terms of the twentieth century, documentary photography has visualized history as a series of events and discrete images which speak of the complexities of human experience and disaster.

From its beginnings the photograph has been understood through

Detail of 89

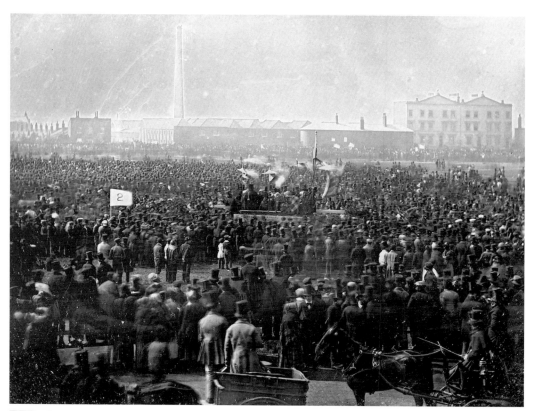

81 William Edward Kilburn

The Great Chartist Meeting on Kennington Common, 1848

An early daguerreotype, this retains its significance as a documentary photograph. Indeed, its veracity is underlined by the way the camera appears to have been simply directed at the scene. All the figures have their backs to the camera.

its ability to record an objective image of events with an assumed veracity that painting and drawing could never claim with equal authority. The cliché that the camera cannot lie is, thus, part of a deep but misplaced notion of the camera's veracity as an agent of recording. The trace of the past, the mark of historical significance, clings to such images, giving them an almost talismanic quality and presence as evidence of what was. Certainly this is the sense one receives from one of the earliest 'documentary' images, William Edward Kilburn's record of the *Chartist Meeting on Kennington Common* from 1848 [**81**]. Like Southworth and Hawes's *Operation Under Ether* (*c*.1852), or the anonymous *Communards in their Coffins* from 1871, this has about it an extraordinary presence which privileges the event as a significant moment for all time. They are literally records of a history otherwise unavailable to us. In that sense as modern readers so they privilege us as they foreground events which we look at as if through a glass darkly. As documents, such images are windows into a world otherwise lost and, to that extent, are significantly and appropriately *documentary* photographs.

But in many contexts the notion of a literal and objective record of 'history' is a limited illusion. It ignores the entire cultural and social background against which the image was taken, just as it renders the photographer a neutral, passive, and invisible recorder of the scene.

And perhaps the documentary photograph suffers from this more than any other form of photographic representation. Much of this ambivalence over the veracity of a photograph's status can be traced to the way many early 'documentary' photographers used the camera to expose what would otherwise remain invisible. Just as police organizations rapidly appropriated the camera as a means of evidence, either of criminals or to record the scene of the crime and the victim, so social reformers sought to educate a middle-class public with images which made visible those areas of their society where injustice and poverty abounded. Indeed, from the beginning of this tradition the use of light and dark is related to a radical recording of the scene. The camera exposes the subject to an assumed public conscience which, having seen the evidence, accepts the moral implications recorded by the camera.[1]

Although the pioneering work of Thomas Annan is of significance in this context, it is the work of Jacob Riis (1849-1914) that is invariably taken to mark the beginning of the documentary tradition proper. In *How the Other Half Lives* (1890) Riis produced both a visual and written account of living conditions in New York's Lower East Side which revealed the appalling conditions and social deprivation under which a largely immigrant population had to live. The images record an existence of unremitting squalor and deprivation in an environment based on waste and exploitation. Although we can place Riis's images in the context of naturalist writing of the time—Stephen Crane's *Maggie* (1893) has a similar concern, for example—their distinctiveness lies in the way they made available an otherwise unknown world. Indeed, this element of strangeness underpins the sense of exposure so basic to the 'documentary' photograph.

How the Other Half Lives associates documentary photography with a moral and radical vocabulary; another major radical figure of the time concerned with social injustice, the French writer Émile Zola, was also interested in the camera as a means of recording. And indeed, this moral drive increasingly becomes one of the main aspects of the tradition. One photographer, however, who remains outside any propagandist mode but who makes the human condition central to his work is Lewis Hine (1874-1940). Hine's is an exemplary photographic career highlighted by the way he declared himself as a 'sociological' photographer in opposition to Stieglitz's 'artistic' values. Hine photographed a range of documentary subject matter: child labour, immigrants, and the sweat-shops on New York's Lower East Side, for example.

Taken as a whole, his *œuvre* constitutes a remarkable rendition of private lives in a public context.[2] Hine's great strength, however, was to inform each image with a complex (but seemingly effortless) awareness of the multiple contingencies which informed and controlled an

individual's life. In the images of Ellis Island, for example, an extraordinary social record in their own right, he allows the immigrants to retain their own sense of self. Hine never exploits. Just as he would alert the subjects to their being photographed, so his treatment is to allow the subject to remain separate from, rather than be dominated by, the camera. The figures remain ascendent, free of propagandist or polemical intentions on the part of the photographer. *Bowery Mission Bread Line* (1906) [**40**] is typical of his approach. This is a muted image, and one not easily classified. It has about it what we might call a 'stark dignity', and the figures, certainly in the way they face the camera, achieve a presence which resonates through the photograph. A typical Hine image, it moves beyond 'documentary' to suggest a whole series of complicating levels and meanings. Hine never simplifies for an effect. He observes and allows the camera to soak up the dense structures and terms of reference of the subject before him. The figure remains central, not because of what it represents but because of what it is. The achievement is a visual text in which the merest detail has enormous power: a missing button or the style of a hat, for example, insists on its significance as part of a larger history. If they document the figure in relation to wider social and cultural questions, his images equally remain independent and true to themselves.

If Hine's work underpins much of the development of the documentary photograph in the United States, his approach is hardly characteristic. The 1930s saw the making of some of the definitive documentary photographs of the century, but equally many of them reflect the problematic of the documentary image as supposed arbiter of truth. The Wall Street Crash in 1929 coupled with the Dust Bowl disaster in Oklahoma made the decade rich in opportunities for the practice of documentary photography. The Depression, 11 million unemployed Americans, and the migration of the 'Okies' to California made it a period of extreme disruption which demanded a continuing attention to social problems and possible conflict. Indeed, in American writing and painting of the time we can see a pervasive move towards social realism and left-wing politics.[3]

A number of American photographers responded accordingly. Under the auspices of what was known as the FSA (Farm Security Administration), a government-sponsored agency directed by Roy Stryker, rural and urban life was recorded (and scrutinized) by some of the leading American photographers of the time: Dorothea Lange (1895–1965), Margaret Bourke-White (1904–71), Russell Lee, Walker Evans, and Arthur Rothstein (1915–85), for example. Much of their response has been read as examples of photo-journalism, so that their images are valued as part of both a permanent record of the times, and are equally seen as having an immediate place within the context of the

period. They 'reported' visually on the state of the nation. As Beaumont Newhall insists, they sought 'not only to inform us, but to move us', and they did so through a series of visual strategies which John Sirenson has appropriately termed a 'dramatic language'.

The work of the FSA is to a large extent characterized by an emotional language which feeds the visual rhetoric of the photographic space. This is most obvious in the collaborative efforts with writers at the time. *Camera with a Purpose* (a review of the period) defines the terms of reference just as *You Have Seen Their Faces*,[4] a 1937 pamphlet Bourke-White wrote with Taylor Caldwell, suggests both the response to the subject and the effect (direct, powerful, moving) they sought to have upon the public. The reader of the photograph is intended to respond accordingly in terms of an appropriate emotional register. 'Purpose' and 'you' suggest a distinct polemical rhetoric— evinced in a visual register which, in its accumulative effect over the decade, we come to note as part of an almost clichéd register of meaning. The vocabulary, like the visual strategies become obvious. And yet such approaches were justified as part of a wider programme of action. In images dedicated to 'ordinary' lives the photograph was used within a polemical, even propagandist context. The *frisson* of recognition one feels as everyday life is given not only acute attention but, in *The Land of the Free*, implicitly related to basic American ideals and beliefs is a potent one. As Erskine Caldwell declared: 'Ten million persons are living on Southern Tenant Farms in degradation and defeat.' The camera, given such evidence, was an obvious form by which to record that 'degradation and defeat' vividly.

Margaret Bourke-White's *Sharecropper's Home* (1937) [**82**] may be seen as a typical example. Seen in relation to 1930s documentary photography this uses an obvious visual discourse and does so in terms of an emotional and political plotting characteristic of much interior photography of the period. Indeed, the poor figure in the shack establishes itself as a minor genre in its own right. The black child looks directly at the camera with his dog (presumably the family hunting dog) by his side. Beyond is the mess of a room; the child is dressed in ragged clothes, without shoes on his feet. But surrounding the boy is a host of visual texts, newspapers from the time which advertise the essential elements of white consumer America. This is the good life, the 'American Dream' from which the black child is excluded. Sharecroppers used newspapers on walls for insulation, but photographers use them endlessly as part of a political register. Here they create a direct contrast, a visual statement which asks political, social, and cultural questions. This is a photograph not just about poverty, but also about injustice and the inequalities of a political system. The photograph is constructed to make us question that very system in relation to the example before us.

Sharecropper's Home, 1937
In many ways a blatant
presentation of a clichéd
subject, and yet it retains its
significance and impact. The
use of a black child and his
dog is an obvious sentimental
ploy. The surrounding
newsprint (full of adverts from
a consumer culture) confirms
the polemical approach of
the photographer.

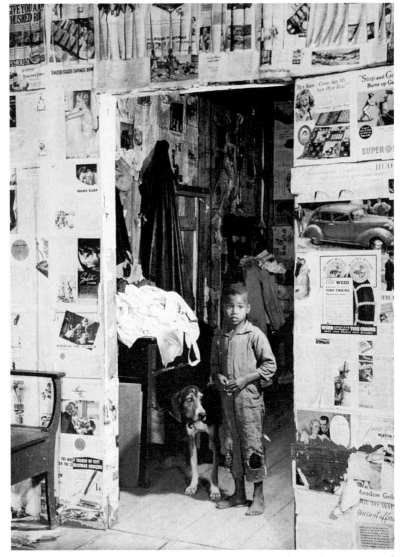

Bourke-White's image raises other questions about the status and effect of the documentary photograph. It establishes its terms of reference in a way that a similar interior of the period by Russell Lee [**83**] does not. As we look at this image it remains unreadable, even though what we look upon is as desperate and as pathetic as *Sharecropper's Home*. In other words, Bourke-White constructs a reading for us and much of this is produced through the deliberate use of obvious codes and symbols. Lee's image has those elements but lacks a coherent syntax. In order to speak to us the documentary image uses a highly charged and controlled photographic space. Far from being a 'witness', it is often a director of the way events are seen. In these images this is suggested in the way interior space is appropriated by the camera. Private areas are declared as public property, almost exhibits at

83 Russell Lee

Interior of a Black Farmer's
House, 1939

The difference between this
image and Fig. 82 is obvious.
Lee's interior is a mess and
fails to suggest a coherent
message. It is difficult to read
and as a documentary image
it has no obvious context or
frame of reference.

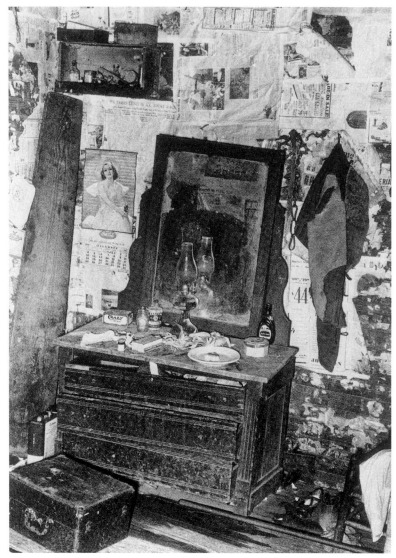

which we peer. Ironically, the actual is seen both through and as a series of photographs.

Look, for example, at another definitive image of the period, Dorothea Lange's *Migrant Mother* (1934) [**84**]. In a 1960 article for *Popular Photography* Lange discussed the circumstances leading to the taking of the picture. On her way home after a long assignment, she passed the members of the family on the road and, after travelling some distance, decided to go back and photograph them:

I saw and approached the hungry and desperate mother, as if drawn by a magnet. I do not remember how I explained my presence or my camera to her but I do remember she asked me no questions. I made five exposures, working closer and closer from the same direction. I did not ask her name or her history . . .[5]

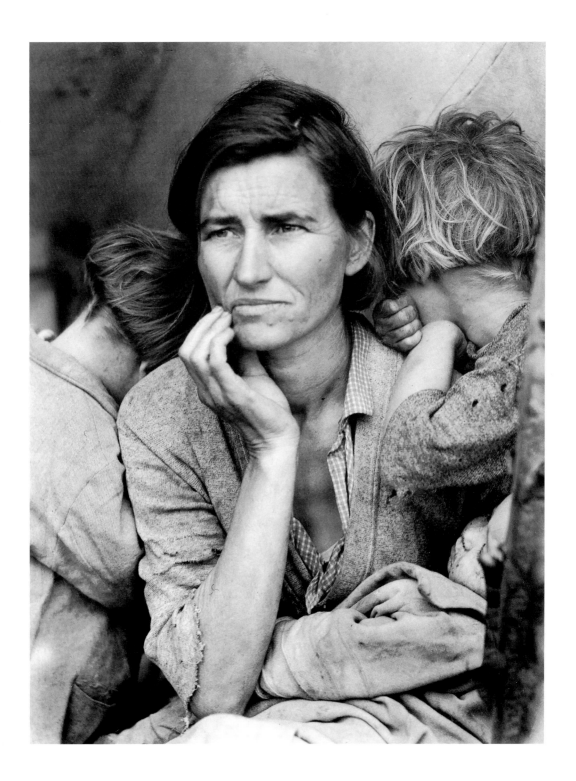

Lange's response is characteristic of so much 1930s documentary photography and the language she uses is telling. The woman is used purely as a subject. She is appropriated within a symbolic framework of significance as declared and determined by Lange. Indeed, the other images taken by Lange at this 'session' add to the sense of construction and direction. They remain distant, though, and lack the compelling presence which Lange achieves in the *Migrant Mother* image. In this Lange creates a highly charged emotional text dependent upon her use of children and the mother. The central position of the mother, the absence of the father, the direction of the mother's 'look', all add to the emotional and sentimental register through which the image works. The woman is viewed as a symbol larger than the actuality in which she exists. As Lange admitted, she wasn't interested in 'her name or her history'.

When Edward Steichen declared in 1938 that 'one of the favoured words in the photographic literature of today is "documentary"', he underscored its appeal as appropriate to the age. But it would be wrong to think that such photography established an objective account of the period. As in the Lange image, time and again the photography associated with the FSA, in particular, declares its meaning in relation to a highly charged and specific set of visual strategies, codes of reference in which the subject, like the history, is subsumed into a larger symbolic role and meaning. The subject is seen as iconic, so that the ideal documentary image, ironically, would speak to an assumed universal condition. It is part of the myth of the documentary photograph.

Other documentary photographers establish quite different terms of reference, although even here we can find the camera dominated by a personal philosophy. Walker Evans, an American photographer central to the whole genre, is a case in point. And two of his texts reflect the ambiguous status of documentary in the period. *American Photographs* (1938), and *Let Us Now Praise Famous Men* (1941, with written text by James Agee) are exemplary texts of their kind. *American Photographs*[6] makes the United States its subject, a series of wide-ranging studies of American localities, architecture, and iconography. It reports on the nation's endemic identity, but it does so through a complex vision very much cast within American myth. As much a philosophical as aesthetic photographer, Evans approaches his subject in search of definitive American images, *ur*-forms as primary integers of the culture. His penchant for rural America, small-town life, shop fronts, and vernacular architecture, as much as for the basic artefacts and materials of an old America, turns his camera into a tool, as part of an anthropological probing in which a lost, lyrical America is laid before us with an almost museum-like presence. The present is measured against an assumed past, an ideal cracker-barrel America

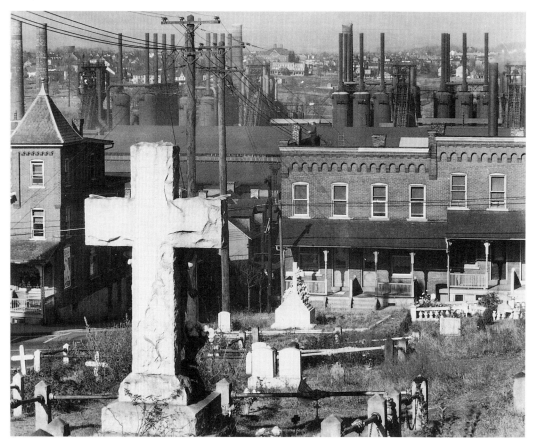

85 Walker Evans

Graveyard, Houses, and
Steel Mill, Bethlehem,
Pennsylvania, 1935

In the context of Evans's
images of America, this is
both daunting and depressive.
The houses to the right are
archetypal Hopper, although
the scene is overwhelmingly
industrial and urban.
The photograph is given
substance by the white cross.
This is very much an image
which suggests the 'death'
of American culture and is
a clear precursor of Frank's
The Americans.

based on the fundamental beliefs and values of Evans's democratic eye.
And yet he can hardly sustain his vision, for what emerges is a kind of
archaeology where remnants of that past make themselves felt as
intermittent and static images. What he confronts is a series of
Americas which lack the continuity and coherence Evans wants.
Graveyard, Houses, and Steel Mill, Bethlehem, Pennsylvania, (1935) is
definitive [**85**]. This is the very opposite of what Evans seeks. Its
location, in Pennsylvania, recalls an earlier figure (and photographer)
who shared Evans's concern with American vernacular and who also
faced a new urban and industrial present: Charles Sheeler. In Evans's
image we observe a series of Americas each with its own alphabet of
meaning made incoherent by history. The iconography on which he
depends for unity is here broken up into a scene almost unreadable
except in negative terms: hence the underlying sadness and stillness.
The graveyard completes the melancholy, as if Evans has, so to speak,
laid his own vision to rest. Evans is a subtle and distinctive
photographer and I have simplified his effect, an effect made clear by
the almost lyrical images of poor sharecroppers and their possessions in
Let Us Now Praise Famous Men. But his documentary approach is of a
particularly American kind, obsessed not with people but with things,

so that objects are photographed as talismanic icons of lost times. The work of Wright Morris (1910–), a novelist as well as photographer, is in the same mode. He creates images of local artefacts which reflect intense but slowly measured lives and environments.

The fractured vision of America that *American Photographs* delivered made it a radical text and led the way for its later equivalent by the Swiss-born photographer, Robert Frank (1924–): *The Americans* (1959). A ground-breaking volume, Frank's book redefined documentary in terms of a radical photographic style. Indeed, its approach was felt to be so radical that it could not find an American publisher. As with the very different work of Lee Friedlander, Frank uses the image to reflect a larger condition. The photographs are full of traditional American icons: the flag, the road, portraits of former presidents, fast food, televisions, diners, and so on: the symbolic paraphernalia of American identity, especially in the post-war period. But in his travels across the States Frank finds little, if anything to celebrate. The dominant mood of these images is one of a bleak and gloomy sadness, as if the psyche of the culture has been laid bare through its own terms of reference and structures of meaning. *Parade—Hoboken, New Jersey* (1958) [**86**] is characteristic. This is a brilliant image on photographic meaning and moves the documentary approach into a new photographic space of possible meanings and muted atmospheres. Its black-and-white format belies the intense poetic quality there is about Frank's images. The American flag, for example, eclipses the wall (and the figures), and has a poetic immutability so that the surface imagery conspires to suggest the period's inner condition in the way we meet it in Diane Arbus.

Part of Frank's radical viewpoint is the extent to which it not only reversed notions of 'America' as a culture, but did so in relation to an underlying sense of alienation, emptiness, and ennui of the kind

discussed by Riesman in his sociological study of the 1950s, *The Lonely Crowd*. In so doing it revoked the notion of documentary photography as part of a 'family of man'. Indeed, *The Family of Man* exhibition, held in 1955 at the Museum of Modern Art in New York and curated by Edward Steichen, seems in comparison almost anachronistic in its approach and subject. Its stated themes of 'creation, birth, love, work, death, justice, the search for knowledge, relationships, democracy, peace, and opposition to brutality and slaughter' suggest a series of ideals absent from the world Frank experienced, the world beyond the walls of the museum. Along with such figures as W. Eugene Smith, William Klein, Leonard Freed, Gary Winogrand, Jim Alinder, and Bill Owens, Frank's work both rewrote the terms of reference for American documentary and questioned its basis as a genre.

American documentary photography has a long and distinctive tradition, but other traditions, and other figures, exist as counterweights to its own preoccupation with things American. Documentary is as central in Europe, for example, and a news agency like Magnum, established in 1947, although having offices in both Paris and New York remains decidedly European in its approach. Since its inception it has been associated with an extraordinary number of distinctive photographers, including Americans. The founding members, Robert Capa, Henri Cartier-Bresson, George Rodger, David Seymour (Chim), and William Vandivert were to be joined by amongst others, Abbas, Eve Arnold, Werner Bischof, Cornell Capa, Bruce Davidson, Elliot Erwitt, Burt Glinn, Philip Jones Griffiths, Hiroji Kubota, Susan Meiselas, Sebastião Salgado, and Chris Steele-Perkins: a veritable who's who of post-war documentary photographers in its own right.

Magnum is very much international in its concerns and styles, and has produced some of the definitive images of the last fifty years. But it is also eclectic and lays stress on individual approaches and philosophies as part of its 'documentary' approach. Its pluralism remains one of its great strengths. Another is its range of reference, for although concerned with Europe and the United States in a medium traditionally dominated by them, it has opened its awareness to anything which demands attention. Sustained studies of South America, Africa, and Asia especially offer acute probings of cultures free from the cliché of so much earlier photography. And yet it retains its distance, seeking to observe and interpret in terms of the culture's meanings and beliefs rather than the photographer's preoccupations. Rather than 'universal', Magnum is international, and has made such a range a part of its currency, even if, invariably, the images speak to Western eyes and minds. Mobility is the central aspect, and in moving between cultures documentary photography becomes 'about everything' and 'nothing'.

Magnum alerts us to the extent to which we recognize so many

87 Bruno Barbey

Left-Wing Riot Protesting the Building of Narito Airport, Tokyo, 1972

The riot is deflected in favour of a concern with form and colour. As such the effect of the image is in terms of its aesthetic impact rather than the social and political question implicit in its subject.

'documentary' photographs in relation to individual styles. Each image has the stamp of an individual personality upon it. Henri-Cartier Bresson (1908–) is an obvious example, as is Werner Bischof (1916–54) and Robert Capa (1913–54). Indeed Capa's status as a war photographer depended as much on his style as his subject-matter, and supposedly reflected a philosophy akin to Ernest Hemingway's brand of existentialism. Yet many of his images remain questionable as to their significance as documentary *records*. *Death of a Loyalist Soldier*, one of the most famous of the Spanish Civil War photographs, has been questioned as a fake, whilst the characteristic 'shudder' of many of his images is a deliberate act to simply gain effect and kudos.

What Magnum has always stressed however is the *moment* as crucial to the meaning of an image. Cartier-Bresson, of course, made this the very foundation of his own approach and philosophy, so that 'the decisive moment' became a cliché of photographic practice. But this is not to deny its place within the making of the photograph; clearly it is basic to the terms by which any documentary photographer must work. Look, for example, at Bruno Barbey's *Left-Wing Riot Protesting the Building of Narito Airport, Tokyo* (1972) [**87**]. Barbey's image has a monumental quality about it, and uses the space of the photograph to suggest the scale of the event and the intensity of the emotion. Colour adds both to its immediacy but also hints at a map of political difference within the mass of figures. And yet the single viewpoint lays stress on confusion. This does not impose meaning on

Bergen-Belsen Concentration
Camp, April 1945
A definitive image from the
concentration camps but
equally an image impossible
to paraphrase. We can only
note details: the park-like
presence of the trees, the
strolling child, the piles of dead
bodies laid out on the right, for
example. The incipient horror
of the scene remains almost
understated.

the scene but speaks to it as an event. The camera gives way to it and uses the moment to encapsulate rather than interpret what is before the lens. All is relative, and the eye can wander at will over its diffuse and complex texture.

An earlier figure, the British photographer George Rodger (1908–95), shares the approach although he works in black and white. Like so many Magnum photographers, however, Rodger approaches his subjects with a respectful distance. Unlike Lange he is committed to history, and to difference, so that the camera records the implicit complexity of every event and every moment. His images of Africa, for example, are central to his effect. As he declared, he 'was interested in the minorities throughout the world . . . downtrodden people, the people of Africa who didn't have a voice of their own'. And yet Rodger never indulges in a visual rhetoric. *A Korango Nuba Tribesman, Victor of a Wrestling Contest* (1949) one of his best-known images, is characteristic of his approach. It looks on a culture whose ways of life are vanishing before the camera; but the underlying response is one of difference and of respect, so that once again Rodger is the observer, not the interpreter, of the scene. As in his photographs of the London Blitz, and most obviously of Belsen Concentration Camp, taken immediately after its liberation, Rodgers evinces a muted and diffident

perspective on the scene. He never exploits or reduces it to what he sees as the sensational. Along with Bourke-White and Lee Miller, Rodger's images of concentration camps remain painful and difficult studies of mass suffering and evil, and show the documentary photograph at the limits of its expressive terms of reference.

Although the images of *Bergen–Belsen Concentration Camp, April 1945, Bergen–Belsen, Germany* [88] has been frequently reproduced they never lose their power as images. Whereas Lee Miller's images shock through the dense accumulation of human bodies or their explicit confrontation with the results of violence and brutality, Rodger adopts a low-key perspective which displaces the sensational as inappropriate to the meaning of the scene. The key to this image is the figure of the child on the left, casually walking past the bodies strewn on the ground. It suggests the line of dead and emaciated bodies as part of a daily routine so that they merge into the unreal landscape of the camp. And yet the horror of its meaning is given added effect by the way we come upon it. The image, indeed, demands a long and deliberate 'look' in order to take the measure of what we see. Every detail (a sock, an eye, hair) adds to the meaning of what has happened, so that the image can only speak through its silent and sealed world.

Rodger's images raise the subject of war as part of a documentary tradition, and once again question the idea of the photograph as a witness. We have seen how Brady's images of the American Civil War opened out the event to a series of wider questions, and we could say the same of Timothy O'Sullivan, Alexander Gardner, and Roger Fenton. Much of the meaning of war photography, like documentary itself, is linked to the history of technology as basic to its possibilities. Early photographic processes restricted the mobility and access of the photographer, especially the cumbersome wet-plates of the Crimea and American Civil War periods. It was not until the development of the Leica camera in the 1920s that the war photographer achieved a state of mobility and speed appropriate to the subject. But even then the war photographer was, as always, subjected to official censorship and restrictions on what could be photographed. The British photographer, Don McCullin, for example, was refused a press permit as recently as the Falklands War (1981), because of his radical approach and style.

What does war photography show the reader of the image? If Eugene Smith could assert that he 'wanted to use [his] photography to make an indictment against war', equally the American philosopher William James could declare that 'showing war's irrationality and horror is of no effect on men. The horror makes for fascination.' One could say the same about documentary photographs *per se*. The Vietnam War certainly posed such a dilemma, and much of the photography from it suggests a difficult moral context. In images like

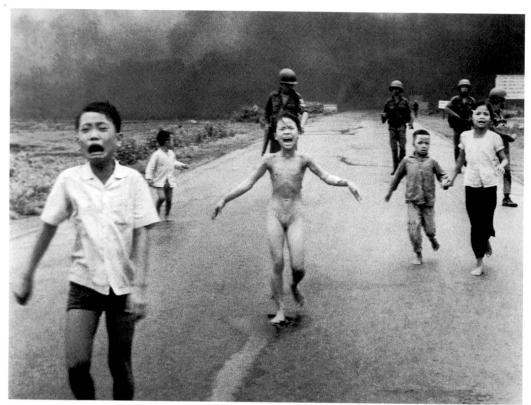

Accidental Napalm Attack [**89**], one of the most reproduced images of the period, we are presented with a moral conundrum as well as with an extreme moment of human suffering. It is one response to view this in terms of an anonymous war machine raining down indiscriminate napalm 'accidentally' on innocent children, but such a 'narrative' cannot deflect us from the presence of intense agony, so that the specific human frame remains crucial to its effect. An entire vocabulary of sound (screams, cries, groans, and sobs) has been lost in a seamless visual vacuum.

In a different way Robert Haeberle's *People About to be Shot* [**90**] raises different questions. Taken during the notorious My Lai massacre, this is a harrowing picture of people huddling together seconds before their death. Haeberle's own statement illuminates the picture's history: 'Guys were about to shoot these people. I yelled "Hold it" and I shot my pictures. M16's opened up and from the corner of my eye I saw bodies falling but I did not turn to look.'[7] His vocabulary exposes a daunting series of paradoxes and empties the experience of any emotional or moral reference. Everything is in terms of taking the picture, of literally seeing *it* in terms of a photographic frame. 'Shoot' and 'shot' have a terrible resonance in terms of what is happening and the taking of photographs in the face of such an event. The effect is to suggest a sense of moral exhaustion; a cynicism which

90 Robert Haeberle

People about to be Shot, 1969
Haeberle's image retains
a ferocious power to shock
us and, through the impact
of its title, exposes us to a
sudden and brutal realization
of what the image involves.
The more we look at it
so the more emotionally
charged it becomes.

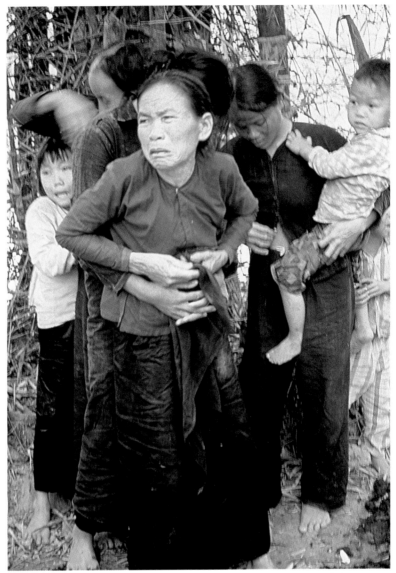

bites into the (comparatively) naïve certainties of the FSA photo-graphers.

Vietnam elicited an often extreme response from photography, in part bound up with what was often viewed as its unreality as an event. Just as in literature we can trace a distinct change in perspective and form in trying to understand and depict the nature of war (*The Red Badge of Courage, All Quiet on the Western Front, A Farewell to Arms, The Naked and the Dead, Slaughterhouse Five, Catch 22*, and the fractured response of Michael Herr's vision of Vietnam in *Dispatches* are examples), so war photography has increasingly reflected a sense of underlying meaninglessness. There seems, in that sense, little left to photograph, even though there is everything to record.

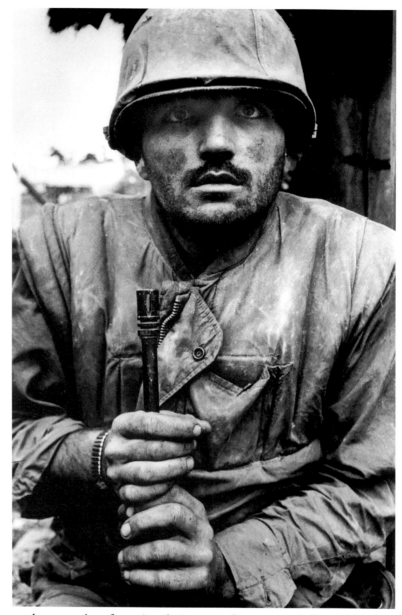

An exemplary figure in relation to such a position is Don McCullin, one of the leading documentary and war photographers from the 1960s onwards. For David Mellor, however, his work 'marks the point where open nihilism structures war photography'. McCullin's career has plotted virtually all the areas of conflict in the period, so much so that he asserted that he uses 'the camera like a toothbrush'. His *Shell-Shocked Soldier* [91], another Vietnam image, is characteristic of his extreme approach and confirms Mellor's point. This is a Conradian 'heart of darkness', a *nada* of the self and, in one sense, of the photograph also. It is significant that after Vietnam McCullin started

92 Warren Neidich

Contra-Curtis; Early American Cover-Ups. Number 7, 1989 One of a number of historical reconstructions, this fakes history in order to question both the myth of a specific historical past and to show what was never seen. In this example the slaughter of American Indians is placed against Indian images as suggested by the photographs of Edward Curtis. Neidich's approach reveals both a radical perspective on the representation of the past and a programmatic questioning of the way American history has been depicted in the photograph.

to photograph landscapes and domestic images, as if he needed not just areas of calm and quiet, but spaces and environments which could still be ordered by the camera.

What such images as these from Vietnam suggest is that 'documentary' is itself confronting some form of exhaustion. As was recently argued, 'To speak of documentary photography either as a discrete form of photographic practice or, alternatively, as an identifiable corpus of work is to run headlong into a morass of contradiction, confusion, and ambiguity', a position made more problematic by the way in which the increasing sophistication of visual technology makes it difficult to know what is 'real' and what has been 'faked'. The assertion that 'if even a minimal confidence in photography does not survive, it is questionable whether many pictures will have meaning anymore, not only as symbols but as evidence', is significant.[7]

In part photography as a practice has created such a position for itself. The assertion, simplistic as it is, that 'the camera does not lie' is easily undermined by the way that at every level photographic images are fraught with ambiguity. We have seen, even in this brief survey, how some of the most central of so-called 'documentary' images contain their own contradictions. When we add such examples as Gardner's 1869 *A Sharpshooter's Last Stand*, where Gardner moved and rearranged the body, or the famous image by Joe Rosenthal, *Marines Raising Flag: Mount Suribachi, Iwo Jima*, which had to be restaged, then any claims to speak to a historical event are obviously undermined.

This is the approach of a recent book of 'documentary' photographs

by the American photographer, Warren Neidich. *American History Re-invented* (1989) makes the whole question of constructing and re-constructing history basic to its concerns. In a series of carefully staged images we see nineteenth-century America presented to our eyes, a staging aided by the use of nineteenth-century photographic processes. They recall the images of Michael Lesey's *Wisconsin Death Trip*, and picture native Americans, black Americans, and pioneer scenes. But they also involve images of violence, exposing a hidden or invisible history that we know but cannot see. *Contra-Curtis; Early American Cover-Ups* [**92**] is typical. A fiction constructed in the twentieth century, this takes its place within what it sees as equally fictitious and fraudulent views of American history from the nineteenth century, in this instance questioning Edward Curtis's images of American Indian life. Neidich, like many recent photographers, makes ideology and representation basic to his subject-matter. The very act of reading the past, of recording 'history' is dominant.[8]

And yet part of photography's contradictory nature is the way in

93 Bill Brandt

Northumberland Miner at His Evening Meal, 1937

A distinctive, even seminal image of the English class system and social difference. The image is glutted with significant images and deft details which addresses an entire way of life. Every aspect of the image relates to a larger meaning. Nothing here is neutral.

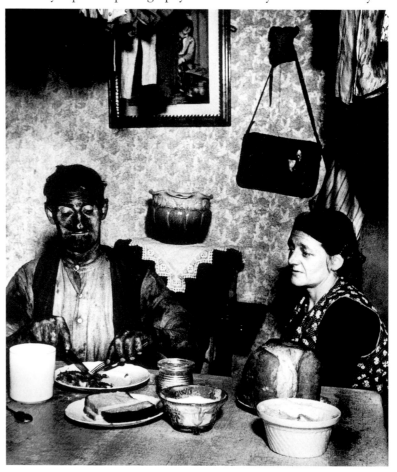

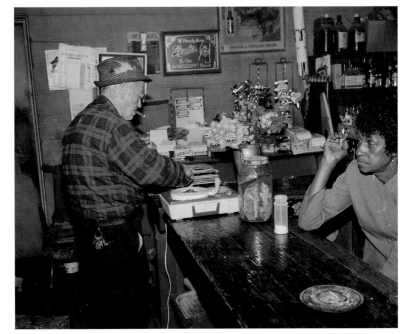

which the photograph remains so powerful as a supposed recorder of
social space. Bill Brandt's *Northumberland Miner at His Evening Meal*
(1937) [**93**], for example, continues to exist as part of a register of 1930s
British life and allows us to read the terms of the miner's (and his
wife's) existence in relation to larger ideological questions and social
differences. But the subjects still remain exhibits for the camera (and
the viewer) as if 'ordinary' lives are part of a pervasive museum culture
of collectible images. The camera's capacity to take the measure of
private lives remains dominant. Birney Imes's *Blume and Mary Will
Thomas* (1984) [**94**], for example, exhibits a much less plotted concern
with the social and political than Brandt's image. The colour brings us
into the space, dissolving the distinction between subject and reader.
We are in the scene here, and enter the terms of the life pictured. For
once, the detail and the clutter retain their own histories and private
terms of reference. The image, so to speak, has been placed back into
the world of its meaning. It has not allowed the camera to steal
meaning from its subjects.

'Documentary', then, remains problematic, an area of the
photograph which includes W. Eugene Smith's famous 'Country
Doctor' series for *Life* magazine in 1948, as much as it does the work of
Larry Burrows and Philip Jones Griffiths, Ben Shahn, Jack Delano,
and Doris Ulmann. Even when looking at the FSA photographs we
need to remember that its photographers produced over 270,000
prints. If the documentary photograph wants us to accept it on the
terms in which it is given, then it equally needs to be looked at in
relation to the way it was taken.

The Photograph as Fine Art

9

Writing in *Camera Work* in 1913, the Mexican-born writer Marius De Zayas posed the question as to whether photography was an art. The question was apposite, for *Camera Work* was itself a leading photographic journal which, under the auspices of Alfred Stieglitz, extolled photography as an art form in its own right. For De Zayas, however, 'photography is not Art, but photographs can be made into Art'.[1] The statement is of significance because it puts into play so many assumptions regarding 'art photography' which remain basic to its aesthetic. The very notion of making an image *into* art has been a dominant aspect of its tradition, and as such feeds into endless debates concerning as assumed higher or 'purer' form of photography. Indeed, De Zayas called art photography 'pure', a conceptual idealization of form which seeks a realization free 'of all representative systems'.

Thus De Zayas moves beyond nineteenth-century parallels between painting and photography, claiming for the photograph an ideal form based on its own terms of reference and its own potential as a means of representation. The use of the photograph by Gustave Courbet or Eugène Delacroix (and one could add Gaugin, Degas, Toulouse-Lautrec, Sheeler, and Nash), for example, or the way Atget would photograph objects and scenes for use by Parisian painters, is quite different from the art imagined as 'pure photography'. Photography envisioned as a fine art seeks both a different pedigree and a different basis, and involves, especially in the 1890s and 1900s, the establishment of a distinctive aesthetic credo which was not only a reaction against the documentary, but, in turn, against the way photography had become bound up with painterly concerns.

We can see important elements of this in the work of P. H. Emerson and his own involvement with the Linked Ring group. But it is essentially the figure of Alfred Stieglitz who was the focus and, in many ways, the force behind the attempt to raise the photograph to the status of an art in its own right. In 1912, for example, an exhibition in New York, where he had his studio and gallery, included images by Stieglitz himself (as well as Coburn and Clarence White), and attracted the following response from the *New York Times*:

Detail of 102

95 Alfred Stieglitz

The Steerage, 1907

One of the most famous images of the early twentieth century and one of Stieglitz's central photographs. Taken from the first-class deck of a ship on its way to Europe, this is an image characteristic of Stieglitz's approach. There is no social or documentary concern. Stieglitz saw a picture of 'shapes', not of human figures, and concentrated on an abstract pattern which for him suggested the feeling he had about 'life'. The abject condition of the figures in steerage is completely ignored.

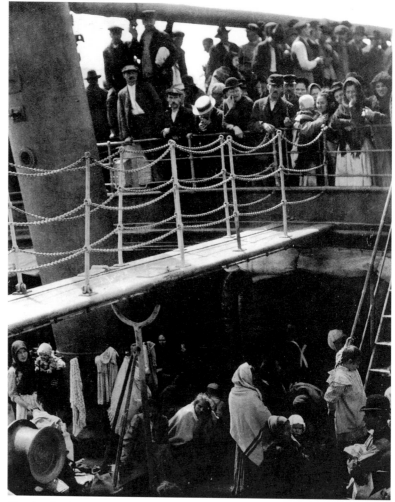

Nearly all of the work shown is what is called … 'straight photography', not photography, that is, which has been supplemented by manipulation. The advocates of pure or straight photography feel that by manipulating a print you lose the purity of tone which belongs especially to the photographic medium in trying to get effects that can be more satisfactorily obtained by the painter's brush.[2]

The statement is, in many ways, definitive and encapsulates the basis of Stieglitz's own sense of the photograph as an art. Speaking against manipulation, as such, it distinguishes photography from painting as a unique medium in its own right with its own unique possibilities. But we also recognize here terms that are to be basic to the 'tradition' of fine art photography[3]: 'straight', 'pure', and 'tone' are fundamental parts of the vocabulary and lay stress on a sense of clarity and intensity without reference to the way the subject is imaged in any literal form. Indeed, the notion of purity not only emphasizes the formal elements of the scene, it suggests an ideal imaging and has crucial implications for a

Platonic (and in the American context a transcendental) belief in an ideal visual form.

Certainly this is fundamental to the work and philosophy of Stieglitz. Rejecting what he felt to be the false principles of pictorialism (soft focus, for example, as a stylistic effect) he sought an image 'by means strictly photographic'. The photograph was to reflect 'The subject itself, in its own substance and personality'. His rejection of manipulation, retouching, and fake effects was part of his search for ideal form and a purity of vision. 'Photography', he declared, 'has its own possibilities of expression, as it sought to record a feeling for life.' Stieglitz stands in stark contrast to another contemporary, Lewis Hine, who foregrounds precisely those aspects of a subject which Stieglitz ignores. Hine's sociological perspectives made economic factors central, so that any aesthetic preoccupation gave way to the implications of the human scene before the camera. Stieglitz was rarely concerned with such elements. Even when he travelled to Europe in the last quarter of the nineteenth century, his response was as a picturesque traveller. His famous description of the circumstances surrounding the taking of one of his central images, *The Steerage* (1907) [**95**], is characteristic of his approach as a whole.

Stieglitz, bound for Europe on board the SS *Kaiser Wilhelm II*, had been meandering around the first-class deck when he came upon a group of figures in the steerage (the cheapest form of travel on a boat), who were on their way back to Europe after being refused entry to the United States at Ellis Island. Confronted by a scene of abject human misery and defeat, Stieglitz recalls his response thus. He saw, he said,

A round straw hat, the funnel leaning left, the stairway leaning right, the white drawbridge with its railings made by circular chains, white suspenders crossing on the back of a man in the steerage below, round shapes of iron machinery, a mast cutting into the sky, making a triangular shape ... I saw a picture of shapes, and underlying that the feeling I had about life.[4]

Stieglitz speaks here as a formalist. Indeed, the entire scene is described as a composition, 'a picture of shapes' which bears no relationship to the facts of the scene itself. The separate elements are reconstituted by the eye in terms of a planar geometry. There is no interest in the particulars of the scene or the condition of the figures. Rather, the whole is referred to an implied higher frame of reference which, ultimately, is centered in the photographer/artist; what Stieglitz refers to as the 'feeling' he 'had about life'.

The approach is pervasive in the photographers associated with Stieglitz at this point in his career. Paul Strand, for example, declared the photograph to be the result of an 'intensity of vision' resulting in the 'fullest realisation' of the potentialities of a subject 'through the use

of straight photographic methods'. Once again the language is cast in relation to a revelatory process in which the photographer, through the camera, lifts the subject out of a historical context into its potential ideal condition. The photographer does not record, he creates, and the material world is, effectively, no more than the outward manifestation of a spiritual other waiting to be discovered. The photographer is a seer, with all that implies in relation to a romantic tradition based on the artist as inspired philosopher who transforms a dull literal reality into something new and ideal.

In the American context this underlies the extent to which so much 'art' photography is committed to landscape, for as a natural form it constitutes the primary symbolic language of a higher process and unity. The concern with light is obvious, but its meaning is given an added dimension as a spiritual presence. The world is luminous in its possibilities for revelatory moments. Even though Stieglitz photographed in New York City for some fifty years, his true location was his country house at Lake George (in New York State), and it was here that he produced one of the most sustained and intense series in his *œuvre*, *Equivalents*, images of clouds and skies around the lake. Small in size but intense in tonal range and contrast, they were exhibited with wide white mounts as if to emphasize the singular nature of their vision.

Equivalents are central examples of the 'art' aesthetic. The name is suggestive of their approach, for the photograph is the *equivalent* not of the literal subject, but of the spirit behind it, as in the philosophy of Wordsworth or R. W. Emerson. Indeed, one can understand why a favourite text of Stieglitz's was Kandinsky's *The Spiritual in Art*. Their subject-matter reflects process, the endless changes of the sky, and lay stress on the *moment*, for the photographer seeks both an ideal form and an ideal moment in which that form is held and found. The photograph is, in part, the reflection of a unique spot of time and space. The *Equivalents*, like Stieglitz's *Dancing Trees* (1921) and *Music* (1922), are mood poems, dense visual lyrics which retain a peculiar power over the eye (and the mind).

Reactions to Stieglitz at the time by photographers and painters established him as perhaps the leading photographer of the period. An inspirational figure he extended the act of photography into a philosophy which informed all aspects of his life, such was the strength of his individual vision. And part of this intensity was his insistence on a seriousness which bordered on the puritanical. In this he underscored the extent to which 'fine art' photography has always been associated with the professional photographer rather than the amateur, so that the creative vocabulary is subsumed into a wider language of absolute dedication to the craft matched only by a technical expertise equivalent to the artist-photographer's individual vision. When, in 1924, Paul

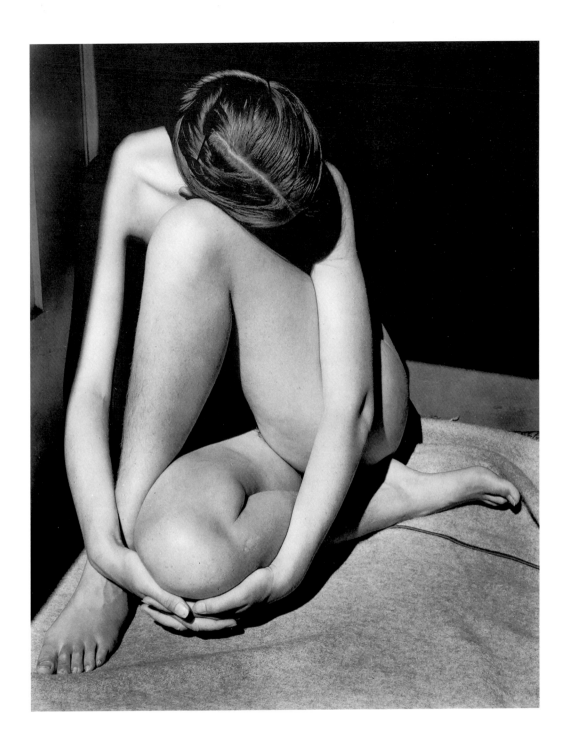

Rosenfeld called Stieglitz's images 'a profound revelation of life', he confirmed his artistic credo as a yardstick for the art-photographer which continues today.

But Stieglitz also established a secondary apparatus that fed into his vision of an art photography. His journals, *Camera Work* and *291*, for example, were part of this, as was his group of associates (including the likes of Paul Strand and Edward Steichen). But perhaps of more significance was his dedication to the gallery as an environment, a sacred place almost, where his ideal images could be viewed in an ideal context. Indeed, the gallery remains a central aspect of 'art' photography, and recalls its parallels with painting. On exhibition are the individually crafted prints of the artist-photographer, accruing a kudos according to their limited number, their personally produced (and developed) form, and the environment in which they are to be viewed. The print has an intrinsic value (the very opposite to the everyday newspaper image or the snapshot), as much as a woodcut or an etching, as an individually produced, unique reproduction from the original negative. A signature completes the analogy. Stieglitz would spend days in his darkroom producing an image before he accepted it as *equivalent* to his intentions; other photographers have scored through their negatives so that no 'fake' reproductions can be made.

The whole emphasis on the individual act and intention is basic to this view of photographic practice. Edward Weston (1886-1953) (who was much influenced by Stieglitz) referred to this as 'previsualisation'. As he declared, 'I see my finished platinum print on the ground glass in all its desired qualities, before my exposure...'[5] and 'Art is an end in itself, Technique a means to that end: one can be taught, the other cannot, for it is that quality which we bring into the world with us, and lacking it as an integral part, no amount of study will enable one to acquire it.' Such a 'pure' photography, in its essence, was to be achieved by 'few, only a handful, even less than that', and Weston was 'one of them'. Exclusive and élitist, this proclaims the photographer as inspired artist.

Weston extends the language of a 'pure' photography into a technical brilliance informed by the creative spirit. The 'pure' is part of an intuitive and inspired act of which the camera is only the medium. Significantly, Weston weds this language to his underlying philosophy which, like that of Stieglitz, is holistic and metaphysical. *Nude* (1936) [**96**] is typical of his approach. As with his landscapes, Weston's emphasis is on form. Here the body is equated with underlying natural form, seen as though it was a shell or a hill, the emphasis being on the play of light and the texture of the skin. The eye thus neutralizes the subject, and makes it part of a larger metamorphosis of form in which, as with Stieglitz, everything has its equivalent. The body is ignored as a cultural product and related to what, in the end, is an abstract pattern

97 Ansel Adams

Picket Fence, 1936

Adams was preoccupied with form, although here a picket fence is made unique in relation to its presence as an object. Adams's concern with form and light gives to the most banal of objects a magical quality which transcends their literal function. Like much 'art' photography, it wrenches the object from its context and makes it float free in relation to an assumed higher register of meaning.

of Platonic unity. In a similar manner his images of peppers and halved cabbages transcend any sense of scale and equate themselves with this assumed universality of form. Even when he photographs industrial scenes it is in relation to their geometry. Like Stieglitz, he too sees only a world of shapes.

Weston's work, moreover, is exemplary in the way it reflects the need of the art photographer to work within the studio. He seeks absolute control over his subjects, so that whether it is a nude, a shell, or a vegetable, he arranges its terms of viewing from an ideal point of view. Such a pristine environment, enclosed and intense, parallels the view he embodies in his images. Like the peppers, it is polished and pristine, and has abolished every trace of the world outside. The insistence is always on form, light, and texture; a sacred trilogy through which the object, via the photograph, will be transformed into its ideal condition as a presence, an intimation of something higher.

Like Weston, Ansel Adams (1902-84) is concerned with an underlying sense of unity and form. *Picket Fence* (1936) [**97**] is a distinctive example of his ability to transform an obvious, even ordinary, subject into something strange and unique. Adams has the ability to recover a magical sense of presence and alert us to the potential of a scene much in the way the poetry of William Carlos

Williams attempted to educate the eye in order to 'see anew'. In taking his subjects from an everyday world lost to routine, Adams illuminates the banal into something possessing an insistent *thereness*. The fence in the photograph is highlighted, but the intense use of contrast adds to the way light is used to animate each and every scene. But whereas Weston's images are so studied in their effects as to lose any sense of surprise, Adams's retains the delight and power of the eye as it celebrates an external world as a feast of continual visual significance.

Weston and Adams, along with Imogen Cunningham (1883–1976), belonged to what was known as the F.64 Group, a small body of 'art' photographers whose title emphasized its members' commitment to intense and detailed scrutiny of the world according to the highest principles of technical ability. Essentially F.64 is symbolic of the ideals of art photography, and its practitioners have in many ways a group identity. Brett Weston, John Paul Edwards, and Minor White share a common philosophy and language which, for all their stylistic differences, bind them together within a common aesthetic.[6]

The concern with intensity and surprise was as much related to the ordinary as it was to the extraordinary, and one significant strand of art photography is the way it used the camera to give significance to the ordinary and ignored. Imogen Cunningham, for example, although much concerned with the depiction of the body, was able to produce astonishing images from the barest of domestic scenes. *The Unmade Bed* (1957) [**98**] is revelatory in the way it takes one of the most common of everyday aspects (and routines) and transforms it into an image with a strange beauty. There is, of course, the play of presence and absence here, and the implied history of who was in the bed. The point is the

way that we are asked to give such invisible areas of a domestic interior especial attention. We find ourselves compelled by the way the bed is transformed into an object of supreme significance, so that each fold, each shadow has a presence quite out of proportion to what we are, in reality, looking at. In that sense Cunningham's image stresses the extent to which this kind of photography seals its terms of reference into a world impenetrable by time and history. It inhabits a visual vacuum.

This image points up the extent to which so much 'art' photography relates to domestic environments and private spaces, but it does so as part of a continuing attempt by the eye to transform the most obvious of things into their unique potential as objects. In that sense everything waits to be photographed, for it can only achieve its apotheosis, so to speak, in the image which reveals that ideal potential in visual terms. What is constant is the way the world of our experience remains available for the infusion of the photographer's eye to grant significance. If Weston and Adams found sublimity in the grandeur of the Yosemite, so Man Ray, for very different reasons, found equal mystery in the accumulating dust on Marcel Duchamp's *Large Glass*. Both perspectives have an equal claim to significance.

Such photography moves between extremes. But other art photographers occupied a middle ground where the culture remained the focus. Paul Strand (1890-1976) is one such figure and his work, certainly seen in the terms of the F.64 Group, is difficult to characterize. A one-time friend of Stieglitz, Strand has an ambivalent relationship to the tradition of art photography as represented by Adams and Weston, yet much of his underlying philosophy is similar to Stieglitz's. The difference, however, is that Strand always sought to place his concerns in an active world of human movement and meaning. The city, especially New York, is one of his primary (if early) areas of concern. In a long career Strand sustained a series of different subject areas informed by an absolute concern with the simultaneous integrity of the subject and of the art of the photograph. His images thus negotiate a mutual respect between the two and are never easy encounters. What characterizes them, be they of things, people, or scenes, is their commitment to the moment and the subject as part of a larger context. They are thus inclusive in their philosophy, but intensely focused in their effects. Neither concerned with 'effect' nor wanting to suggest a 'spiritual' dimension, Strand's images engage with the dynamics of sight and meaning. They have about them a deep and often immutable presence which resists any attempt to reduce them to paraphrase. His early period, for example, offers a series of semi-abstract patterns as well as studies of street figures, and to some extent his work remains wedded to these two extremes.

The rightly famous *Wall Street, New York* (1915) [**99**] combines these

99 Paul Strand

Wall Street, New York, 1915
Another definitive image from
the early twentieth century.
Strand's photograph hovers
between abstraction and
documentary. The figures
walking to work are dwarfed
by the monumental presence
of the bank in the background.
Wall Street is both a literal
place and a symbolic
condition. Strand's image
speaks to both the economic
terms of its significance
but equally creates a
haunting lyricism in relation
to individual lives.

differences in an image suggestive of the new relationships between
people and business. It has a compelling effect and retains its power as
an image of complexity within a simple, almost minimalist format.
Strand could find significance in anything, and like the precisionists of
the period, could as easily photograph a car or a wire wheel as a bowl or
a shoe. The modern, as it were, was part of his aesthetic. At his most
intense Strand emphasizes such qualities as shadow, pattern, and
texture to create an ambivalent presence which hints at larger contexts
and wider meanings. Such hints and guesses are carried over into his
remarkable studies of people in Mexico, Italy, and Romania which,
paradoxically, confirm his photographic connection with Lewis Hine.
And yet Strand could never be called a 'documentary' photographer.
An image like *Palladian Window, Maine* (1945) [**100**] sets him apart
from Hine and Evans. The house here retains its own substance, while
the image is concerned with presence and atmosphere; immutable
qualities hardly obvious to the eye. The camera's distance allows the
atmosphere to be sensed but not known. And yet the scene, and each
individual element within it, is alive with meaning and, potentially, a
new significance. Thus, as we continue to look at the image it changes
before our eyes. There is no static focus nor is anything privileged
above anything else. It remains true to its own terms of existence.

Strand places his images in a recognizable context, although at times he moves towards an abstract interpretation of the subject. Other photographers develop this approach, although they do so by retaining the literal image of their subject-matter. Aaron Siskind (1903–), for example, in his photographs shows a fascination with surface textures akin to those achieved through the procedures of Abstract Expressionism, especially in the work of Franz Kline. His subject-matter is the textures of walls, stones, doors, and fences, in the country and in New York. By using close-up he makes what would otherwise be part of the detritus of the urban scene yield something significant and unique. Photographs such as *Peeling Paint* (1949), *Oil Stains on Paper* (1950), and *Degraded Sign* are central examples of his work. They take the most marginal of subject-matter and turn it into a hierophany of potential meaning.

Eliot Porter (1901–) (whose career was very much guided by Stieglitz and Adams), also works at the level of close natural surfaces.

100 Paul Strand

Palladian Window, Maine, 1945

This image has a passive and almost quietist approach and represents part of a continuing interest in architecture as a subject in its own right. The camera here delights in the variety of textures and patterns.

101 Eliot Porter

Pool in a Brook . . ., 1953
A subtle use of colour creates
a semi-abstract 'pool' of visual
ambiguity. The most fragile of
objects are brought together
to create a 'mobile' of potential
change and process.

As he declared, 'My emotions, instincts, and interests are all with nature'. What distinguishes Porter is that in the 1940s he began to photograph in colour at a time when the accepted medium for art photography was still black and white. Porter's colour images are, however, distinctive in both approach and effect. *Pool in a Brook, Pond Brook, Near Whiteface, New Hampshire* (1953) [**101**] is very much in the tradition of Stieglitz (and has echoes of the *Equivalents* series). What makes it special is the way Porter's use of colour calls attention to the surface of the photograph, and does so through a remarkable play of texture and process. The separate elements of the image—leaves, water, light—are bound together in an underlying unity based on movement and reflection; an effect recently paralleled by the British photographer, Elizabeth Williams. The overall effect is almost painterly, although the surface 'sheen' creates an image that we can only observe and never, like paint, touch.

A similar effect is achieved by Ernst Haas (1921–86), an Austrian-born photographer who moved to the United States. Like Porter, Haas uses colour to produce an intensified presence of what is 'there'; the camera allows us to see it appropriately. His images are celebrations of colour and alter the terms by which it has been viewed within the 'tradition'. *Peeling Paint on Iron Bench, Kyoto* (1981) [**102**], for example, is a Kodachrome print which makes colour basic to its effect and philosophy. This could not be photographed in black and white, for it is the intense colour of the original which Haas seeks to retain, and compels us to admire. Rather than the subject, the eye here feeds on the brilliance of a world so clarified and intensified as to be super-real. The red, black, and green have, along with the reduced area of focus, produced a visual experience which is wondrous in its potential meanings.

Haas's image highlights the debate between black and white and colour, especially in the context of 'art' photography which retains something of an élitist view of black and white, still the dominant medium here, as in documentary; but in art photography it is part of a purist approach, laying stress on the photograph as a medium in its own right rather than as an attempt to reproduce the world as it 'is'. It is instructive to look at the work of Harry Callahan (1912–) in the light of this debate. Like so many 'art' photographers his work has been virtually all in black and white, but in the 1990s he began to use colour as part of a new and often radical examination of place: Atlanta, Providence, Barcelona, as well as locales outside his immediate frame of reference (Wales and Portugal, for example). In terms of their approach and point of view these colour images are typical of Callahan's work. Subtle and provocative, they are distinctive for their sense of an implied meaning always hovering on the point of definition. In his black-and-white work Callahan typically elicits a

102 Ernst Haas

Peeling Paint on Iron Bench, Kyoto, 1981

Haas uses colour to achieve a vivid and intense effect. Here a marginal subject is given an attention which makes of it something unique.

visual questioning immersed in a metaphysical strangeness. Objects, like figures, are distanced from the camera in a philosophical as well as a physical sense. In the colour work such an approach remains basic, but the presence of colour changes the atmosphere. Whereas the black-and-white images remained strangely sealed within their own world, the colour insists on the thereness of the world he photographs. Objects are boosted on to a different visual plane.[7]

New Color (Photographs 1978–1987) (4) is exceptional in its extreme use of colour. The effect is to create a hyper-presence. The colour is so intense, so vivid, that it achieves a palpable existence in its own right and, in effect, becomes *the* subject of the image. Even the colour white has about it a heightened quality which gives it a *frisson* of significance. Callahan's approach is to drench a scene with colour. It is the direct opposite of the search for tonal subtleties associated with black and white, and in a sense reflects the unnatural colour of 'ordinary' (*sic*) mass-processed prints. The point, however, is that it betokens a vibrant awareness of things, moving from a sense of the ambiguous and philosophical to a celebration of objects and their place within time and space. Callahan has, so to speak, moved towards a vision of the world in which everything is part of a hyper-reality. *Kansas City* (1981) [**103**], for example, is a celebration of colour in its own right. The eye is overwhelmed by the intensity of the red, an effect made more intense by the way Callahan refuses to turn anything here into a symbolic vocabulary. Everything is a visual feast for the eye, a spectacle in which

103 Harry Callahan

Kansas City, 1981

Callahan's images have about them a lyrical and enigmatic quality which prevents them from being reduced to paraphrase and description. They retain their own integrity. In this example, Callahan's typical style is drenched in a super-reality. The density of the colour establishes a palpable quality in its own right. Note the use of shadow, as well as details on the left- and right-hand margins. Like all of Callahan's work, this is not intended for the casual glance.

the camera indulges in its capacity to produce more than what is seen. But this is also a wonderfully dense image in the way it uses colour to establish a series of perceptual and conceptual contexts. The limited range of red and black belies its extraordinary range of reference—a point made clear by the single white patch to the left and the white cup in the middle. But equally, the image is concerned with the quizzical nature of presence. The use of shadow, the black form of the tree, and the telegraph lines are all distinctive Callahan elements. As we look at the image, shadow, in terms of its presence as a colour (rather than an object), implies a negative impression. Within the field of vision Callahan has achieved a modulated text in which the syntax of the image has been determined by colour rather than an object, and, as such, is founded upon the most immutable and the most basic of photographic contexts: light. And of course colour, in a scientific sense, is no more than the reflection of white light.

Callahan's is a long and distinguished career, and part of his achievement has been to make a body of work which not only questions its own terms of meaning, but creates a tradition in which the visual field is part of a larger philosophical concern. The oft-reproduced *Lake Michigan* (1953), one of his major images, is typical of his ability to establish a multi-layered significance from the most basic of occasions. A picture of figures in the sea, the subject could be the occasion for any number of holiday snapshots. But Callahan's approach transforms it into a brilliant essay on the tangible and

intangible; on the way we perceive space and create a frame of order. It has all the haunting lyricism so fundamental to his work. He has not so much a subject as a way of looking at things.

Callahan's work is pivotal in the way that it is dependent upon the assumptions of F.64 but moves on to its own concerns and preoccupations. And many of these underpin a pervasive philosophical concern with the nature of perception and the photograph as a means of representation. To that extent Callahan's work reflects a larger response on the part of photography, especially since the 1950s. As with so much modern art, it has made its own codes and conventions basic to its subject. Many photographers have done this while developing a heightened sense of composition. The image offers a visual conundrum for the viewer to contemplate rather than openly to question received ideas. The fine-art photograph thus continues its sense of isolation, for the questions posed are conceptual rather than cultural or political. Look at, for example, *Untitled*, by Zeke Berman (1979) [**104**]. Essentially a series of visual puns, this is also an art-object in its own right. A photograph on the nature of perception, through its use of newspapers, an actual block, and an implied cube it takes its place within a Cubist tradition which, through collage, investigates the terms of visual understanding. Marvellously conceived, it remains a

rich example of how 'art' photography moves beyond the ideal and the refined to align with wider issues concerned with the philosophical and conceptual. In that sense this is as much a poem as it is a photograph, for we read it as a series of texts, of partial and changing definitions, and as a visual (as much as a literary) puzzle. Everything is a text, everything means, but the world we perceive is not so much a mix of the flat and three-dimensional as a labyrinth of ambiguity. It is, in the true sense of the word, a *made* photograph.

Art photography, thus, can make of the most obvious of things a rich context of visual interpretation. The philosophical intention is, of course, basic, but many recent photographers in this area have expanded the questions Berman poses within recognizable environments; once again, the terms of everyday life. William Eggleston (1939–) is one such photographer. An American committed to his native Mississippi, he chooses the marginal areas of daily existence, bringing them into focus in a haunting but almost casual manner. *Black Bayou Plantation, Near Glendora, Mississippi* (1971) [**105**] is characteristic of his style. A colour image which hints at its possibility as a postcard, this offers a series of disparate elements which retain a distinct ambivalence. It is difficult to push them beyond their immediate presence in the scene. These are found objects, invested with meaning by virtue of the camera's attention. Their obvious status is deceptive, for within the context of a colour photograph they have been made significant, and distinctive. Hence, the irony of the art photograph: everything can be a photograph and, in Eggleston's terms, can be art.

105 William Eggleston

Black Bayou Plantation ...,
1971

Eggleston's approach is to give a scene of marginal interest a remarkable significance. The banal is boosted to a new frame of meaning.

The images of Eggleston, Callahan, and Berman are examples of a new kind of art photography which looks towards postmodern engagements with meaning and the nature of representation. Moving beyond a concern with the 'pure' and the aesthetic, they produce an imagery dedicated to the continuous probing of our terms of existence. As distinct, for example, from the photographed paper sculptures of Francis Bruguière (1879–1945), they return art photography to a popular forum, releasing it to deal with the terms of our existence rather than the idea of formal content divorced from the world of its meaning. Their images have an underlying ambiguity fed by a deep lyrical sense of the human context of photography's focus.

In this sense the work of Josef Sudek (1896–1976), perhaps the leading Czechoslovakian photographer of this century, is apposite. Although he began photography in the 1920s, his major work does not emerge until the 1950s. His images, often dark and dense, suggest the political climate in which he worked. The light so characteristic of the optimism to be found in Weston and Adams is here replaced by an ingrained darkness suggestive of the pessimistic and the psychological perspectives of characters from Franz Kafka. Seeing the world through a glass darkly, Sudek's images exude a distinctive ambiguity and qualified unease. Perspectives are limited, light is minimal, and the atmosphere muted.

Chair in Janáček's House (1972) [**106**] is typical of the late stage of his work. It has all the elements of the American tradition, yet modulates them through a finely interpreted series of qualifying atmospheres and contexts. The eye looks for a message, but cannot move beyond the restrictive space and subject-matter of the image. The atmosphere in the image is palpable, with a felt sense of the terms of existence within the room. Darkness again is prevalent, but related to the suggestion of candles and low-wattage bulbs rather than the sun. This is a personal space, just as the chair is named. An area of possible clarity and coherence is given intense significance. The regularities of the lace curtain are deceptive, promising a pattern and an aesthetic dimension; they are distinctive for the way in which this entire environment rests on both a delicate and ambiguous existence. Sudek both extends 'art' photography and announces its limitations. Above all, he seeks meaning in what is to hand, so that the camera is part of a constant probing and measure of one's terms of existence; the daily rhythms and objects of everyday life. In that sense he is a true European, and if we can sense the spirit of Stieglitz, we can equally see the presence of P. H. Emerson who, like Sudek, made the most subtle of images from the most basic of reference points. This remains one of the central contradictions of 'art' photography.

The Photograph Manipulated

10

'Pure' photography postulated an ideal image which transcended the everyday world. It questioned the view of photography as a literal act of recording, seeing this as limited, but nevertheless insisted on the photograph being based in the thing seen, not imagined. In this sense it is different from the terms of modernist aesthetics that, when Stieglitz was establishing *291* and *Camera Work* in New York, rejected the very world that the photographer took as a subject. What place did photography have in an aesthetic climate dominated by Cubism and abstraction, where the new terms of reference were to relativity and the subconscious rather than the recording of a surface literal reality?

From the 1900s onwards we can chart a series of photographic responses that seek to recast the photographic act in the new language of modernism. Such photography sought to manipulate the image; abandoning any commitment to a literal recording of the world as perceived by the eye, it sought a visual code suggestive of the new awareness implied by abstraction, Surrealism, Dadaism, and Futurism. Taken together, these responses form a significant tradition in their own right, and further complicate the terms by which we seek to understand the photograph's significance as a means of representation in the twentieth century.

In 1913, for example, the American-born Alvin Langdon Coburn asked 'why should not the camera artist break away from the worn-out conventions . . . and claim the freedom of expression which any art must have to be alive?'[1] The question was well put and underscores the need for a new visual vocabulary that many photographers sought to take account of in relation to the developments in other media at the time. Yet how was the camera to equate itself with these new ways of seeing? Part of Coburn's attempt had been to establish new perspectives and a new point of view, so that his images of New York are either in soft focus or reduced to a semi-abstract pattern from the vantage-point of the top of a building. But such effects hardly matched the terms of reference suggested by Cubism and the radical portraits by Picasso and Braque, as they broke up the surface of the canvas into a series of multiple planes and perspectives, reconstituting the image in relation to a new awareness of time and space. Part of Coburn's

Detail of 112

response was what his friend Ezra Pound called the *Vortograph* (1917) [**107**]. Based on a series of mirrors, Coburn photographed the subject (a person or object) cast amidst the possibility of an infinite number of reflections. The result was akin to Cubist portraiture, and broke the surface literalness of earlier photography. His portrait of Pound, in particular, seemed to speak to precisely the spirit of the modern for which Pound, with his own interest in Vorticism, was calling. For once the most modern medium of the arts could reflect the most modern of aesthetics.

In many ways, of course, the photograph had been manipulated from its inception, and certainly the combination prints of Rejlander, single prints built up from the use of several negatives, points towards the later developments of photographic collage and montage. We can find examples of both forms in the nineteenth century. Similarly, Louis Ducos du Hauron's use of what he called 'transformism' in 1889 established the use of distortion as a basic method to alter the literal appearance of the subject. Even the much-vaunted Rayographs 'discovered' by Man Ray are effectively reruns of the photogenic drawings of Talbot. We can point to other examples in the period, but perhaps what distinguishes them from their twentieth-century counterparts is precisely that they lack a radical philosophy, a persistent questioning of the means of representation that was to be basic to the modern period.

Beginning in the 1900s we see a series of photographers who begin to both question photographic practice and relate their concerns to the modernist aesthetic beginning to make itself felt in painting and literature. In this view the photograph is not concerned with mirroring

a literal world, for that is merely a surface appearance, and feeds into a larger mythology of verisimilitude. The photograph is to be seen as the site of a radical aesthetic, as much psychological as political: a critique of the dominant ideology and thus a crucial form of representation. Drawing on the same sources as Eisenstein's radical theories on cinema and film, a new view of the photograph emerged. Much of this development, as we might expect, took place in Revolutionary Russia and in 1920s Germany, where the assumptions of representational art were aligned with a discredited and corrupt bourgeois ideology. Rejecting the idea of a coherent and unified social space, such photographers sought to disrupt general assumptions as to how we structure an assumed 'natural' world, and in the photography of Constructivism and the philosophy of *ostranenie* (or 'making strange') we see some of its most dynamic and radical results.

Although international in significance, the roots of Constructivism lay in the 1917 Russian Revolution. It sought an art appropriate to the social and political ideals of the new order and, by implication, questioned realism as a mode of representation. El Lissitzky (Eliezer Markowich, 1890–1941), a Russian photographer, is central to its approach. A qualified architect, his career in Russia and Germany reflects the major concerns and achievement of the movement in the period, especially in the photograph. He knew Malevich and Tatlin, and in Berlin met Kurt Schwitters and Herbert Bayer. In 1929 he created the cover for the radical *Foto-Auge* and had examples of his

108 El Lissitzky

The Constructor, 1924
An image remarkably 'modern' in both its approach and layout. An abrasive self-portrait which, in a programmatic sense, sets out the idea of the artist-photographer within both a dynamic sense of social and individual change. We are, so to speak, the architects of our own selves.

109 Alexandr Mikhailovich
Rodchenko

Pioneer with a Horn, 1930
A horn-player blatantly
announces the contemporary
nature of the photograph's
subject. This is a celebration
of the modern and
emphasizes its affinity with
both the new and the political
as part of a modern age.
The distorted angle of vision
adds to the radical approach
and meaning.

work included in the climactic photographic exhibition *Film und Foto*, which reflected many of the 'new' photographic concerns associated with the manipulated image.

The Constructor (1924) [**108**] (a self-portrait) is a central image for an understanding of the Constructivist manifesto. The image recalls Lissitzky's knowledge of architecture (as a constructor), but equally equates the photographer with the figure of the engineer. Both figures build and design the basic structures of a new social order. But the title has larger reverberations, for this is literally a manifesto on the way we do not interpret our world so much as construct it (or have it constructed for us). It thus seeks a radical revision of our own terms of reference and, like a political poster, visually speaks out to a radical point of view. The multiple image interacts with the viewer on a number of levels and deliberately asks us to read it in an active context. Like much constructivist work, it is informed by a brash, almost aggressive, energy, appropriate to the revolutionary spirit of change it seeks to reflect and tap. The head in the image has a dominant presence; calculated and knowing, it looks directly at both the viewer and the world it seeks to construct. Equally, the eye is placed at the centre of the hand, emphasizing the relation between the intellectual and the physical and once again underlying the potent significance of the title. The unity is further suggested by the circle, the compass, and the examples of modern typology. The photograph is a superb example of a revolutionary spirit instilled into a programmatic image which reflects a multiple subject-matter. Its economy of meaning, very much a matter of design, is as much constructed as the social and political worlds at which it directs its attention.

Lissitzky's images are full of such dynamic relationships and meanings, just as they often suggest a sense of building. The emphasis is on an awareness of the terms of representation, much as we find in the theatre of Brecht. Figures fill the frame, often with a low angle which suggests the figure as dominant and in control of its environment rather than passive and receptive. Lissitzky's world is one of action, and his images establish a visual typology to reflect his philosophy.

A friend and associate of Lissitzky's was the painter and photographer Alexandr Mikhailovich Rodchenko (1891–1956). Also a Constructivist, he abandoned photography in the 1940s for abstract painting. Like his friend, however, Rodchenko made an equally radical photography capable of reflecting the social change he sought. His images have a bold and abrasive effect, and the camera distorts the angle in order to emphasize the presence of the figure. Once again the focus is on a self-conscious picturing, so that the reader is aware of the image's strategies and learns accordingly. Figures fill the frame, angle shots are distorted, with the result that the perspective on things is

seen as both radical and challenging. In Rodchenko Constructivist principles merge with Futurist values, casting human figures amidst a geometry of surrounding structures (grids, lines, patterns) as part of the larger dynamic that is the modern. *Pioneer with a Horn* (1930) [**109**] has a typical radical point of view. The pose is dominant and reflects the extent to which the title is reflected in the image. Like the photographer, the musician is seen as a 'pioneer', another example of a Constructivist making his world. But this is also about need for any revolutionary ideal to make itself heard. As much a poster as a photograph this takes its place within a radical public rendering of political philosophy.

Constructivism established a strident and highly radical style. It sought to confront rather than reassure the spectator, and its brash and bold configurations still have about them a freshness which denies their period context. Like Rodchenko, the work of Gustave Klutsis, Sergey Senkin, and Varvara Stepanova reflects an aesthetic wholly distinct from that of any nineteenth-century precursors. Their work is a vibrant and knowing manipulation of the image based on a declared political and social perspective.

Although not a communist nor a Russian, the Hungarian-born László Moholy-Nagy (1895–1946) reflects a similar concern with the photograph as part of a new means of perception.[2] His work in Berlin in the 1920s and his association with the Bauhaus are suggestive of his pedigree as a mentor for the period. An abstract painter before he became interested in photography, his book *Painting Photography Film* (1925) reflects his understanding of the image. Moholy-Nagy sought what he termed the 'creative utilization of new perceptions and principles' in which photography was to be a 'presentational art' rather than 'a copy of nature'. Whereas most people 'have a view of the world dating from the period of the most primitive steam-engine', what he wanted was a photography (and a painting) based upon 'changed compositional principles' free from traditional values. An essay from 1932 entitled 'A New Instrument of Vision' lists 'eight varieties of photographic vision' which perfectly encapsulate the conflict between a passive and active use of photographic space. For Moholy-Nagy, 'All interpretations of photography have hitherto been influenced by the aesthetic-philosophic concept that circumscribed painting'—a position reflected in the varying claims of 'abstract seeing', 'exact' seeing, as well as 'slow', 'intensified', 'penetrative', 'simultaneous', and 'distorted' seeing. The act of looking is made problematic, and the act of photographing active in its power to change the terms of perception. As a 'new instrument of vision', the camera allows access to a new awareness and programmatic of seeing. Thus Moholy-Nagy seeks a 'resolutely modern graphic structure', part of the general and radical approach which characterized Constructivism.

110 László Moholy-Nagy

Jealousy, 1928

An image which confirms Moholy-Nagy's seminal influence on a number of later photographers (for example, Callahan and Burgin). This represents a self-conscious plotting of how meaning and knowing are constructed. Thus the play of enigmatic opposites. The photograph is used as a conceptual space in which both the philosophical and perceptual are investigated.

Moholy-Nagy's style is, however, emblematic of his wider concerns. A mixture of the radical and the questioning, his images have an enigmatic quality which resists any attempt to simplify them to a message or statement of belief. *Above the Shooting Gallery* (1925) is almost postmodern in the procedures and meanings it suggests, as is *Jealousy* [**110**], which even now seems difficult to recognize as belonging to 1928. Both these establish a series of perspectives and hint at a narrative structure which confounds our attempt to read them literally and linearly. The effect is to achieve a sense of *ostranenie*, an expulsion from the text in which the image is not only made strange, but insists on its difference from an 'everyday' world and the expected conventions of photographic representation. The images work through the juxtaposition of the obvious and the unexpected, the

clichéd and the radical, to produce a series of vibrant and dynamic relationships.

Moholy-Nagy experimented with the process of picture-making as well as with picture-taking. His 'photoplastiks' of collages are one example, but his photograms—camera-lens images based on Talbot's calotype process, raise issues distinct from the socially based investigations of Constructivism. Indeed, the photograms establish a bridge between the two other dominant artistic movements of the period, Surrealism and Dada. Both had an influence on his work and were instrumental in opening up the notion of *ostranenie* to a form of photography which makes use of an imagery 'that is psychologically charged'.[3] In this context, the photographer concerned with a psychological perspective sought an imagery which pictured the subconscious. The image was to be given over to an area of free association and multiple suggestion, not the careful plotting of psychological states of mind as we saw in the work of, for example,

Diane Arbus and Robert Frank. As the Dadaist poet Tristan Tzara announced (in 1922), 'The photographer has invented a new method; he presents in space an image that goes beyond it . . .'[4]

Tzara wrote this for an introduction to the Russian-American Man Ray's (1890-1976) *Rayograms*, a version of the photogram and the calotype which continued the attempt to create an element of strangeness in the most common of objects. A Ray *Rayogram* [111] has about it a deeply enigmatic presence. It creates a discrete and enclosed space with little reference to the world of everyday sight, suggesting fragments of a dream-like interior photographed by chance. Man Ray's work in photography and painting in New York and Paris through to the 1940s is central to the 'tradition' of the manipulated image.

In many ways his work crystallizes the problematic of 'making strange'. In some of his images the concept is reduced to nothing more than a playful attempt to surprise; in others the use of the female is itself problematic in relation to his underlying attitudes and approach, the images existing as little more than the realization of Ray's sexual fantasies. Similarly the Rayograms, like the 'solarisations', suggest an element of trickery. They relate to very basic processes, but they claim for themselves enormous significance. In the end the strength of Ray's work is its humour, as in the well-known *Le Violon d'Ingres* (1924), in which a female model ('Kiki') has two 'f' curlicues superimposed upon her back. This is both a comment on the French painter Ingres (a keen amateur violinist), and on the academic tradition and values Ray attacks. However, although the intent is on the 'play' on the shape of the violin, that very aspect underlies the way Ray approaches the female form (as it does the view of women in much Surrealist photography). Like *Glass Tears* (1930) [112], the meaning of the image is based on a visual pun—the unexpected juxtaposition of disparate elements—but beneath the humour remains a woman's face, and it is this that is the object of Man's playfulness. His chosen name (i.e. Man Ray) was an appropriate choice for the kind of photography he produced.

Other images by Ray reveal how many of his preoccupations involve everyday objects. *Man* (1918), for example, is a hand-whisk. He takes common things and transforms them to the level of myth or icons of a larger human condition. The photograph assumes a metamorphosis of meaning. Ray is thus the photographer as both Dadaist and Surrealist, as much aligned with Tristan Tzara as he is with his friend Marcel Duchamp. His most radical images play into a larger vocabulary of the surreal in which the psychological is basic to their effect. Surrealist photography, in that sense, is based on an entirely different index of meaning from its literal equivalent. Its imagery is given over to an alternative inner world in which all is

infinitely expandable and changing. And yet Surrealism, as such, has an ambivalent relationship to the photograph. To make something 'surreal' demands the attempt to find that condition, so that one literally constructs an image for its effect rather than its substance. Man Ray, like Lissitzky, Rodchenko, and Moholy-Nagy openly manipulates the image and the photographic space: constructing, deconstructing, cutting-up, and fragmenting the primary terms of the photographic space in order to suggest other levels of meaning and significance. Others will merely distort in order to make their point. Bill Brandt's nude series, for example, while raising other questions about the depiction of the female body, elongates and distorts the body as if in a fairground mirror. In other contexts the surreal is established in terms of what has been directly photographed. Thus Cartier-Bresson and Atget (much celebrated by the Surrealists at the time) can be seen as surrealists, even though they do not manipulate their images; rather, they find the condition in the scene itself.

Part of the difference in their approach is the extent to which the photograph suggests a larger philosophical questioning of its subject's terms of reference. The photographs of the Italian Futurist, Anton Giulio Bragaglia (begun in 1911) of figures moving have something of this quality about them. Indeed, to compare them with the images of Muybridge is to sense how radical they are. They are close in spirit and approach to Marcel Duchamp's *Nude Descending a Staircase* (1911) which, like Fernand Léger's contemporary painting, signalled a new awareness of the figure in motion and space. Étienne Marey's chronophotographs of figures moving—blurred and semi-abstract patterns—reverse the viewpoint of much nineteenth-century photography, yet they were made in the 1880s and are akin, not to Muybridge's carefully calibrated visual studies of human movement, but to the modernism of Duchamp and Ray.

The nineteenth century saw a number of deliberate manipulations of the image, but it is the twentieth century which sees the rise of the manipulated image proper as part of a sustained aesthetic, often involving an active, even aggressive approach to the image. Like painters working with the techniques of montage and collage, photographers have cut up and rearranged basic imagery to construct a pattern of meaning. The 'invention' of photo-montage is disputed (between Raoul Hausmann and John Heartfield), but it is its effect which is significant. Hannah Hoch's *Cut with the Cake Knife* (1919) [113] is an early example.[5] A collage of disparate material, this presents a series of photographic images in a series of different perspectives bound by common themes. However, it cannot be read in literal or narrative terms; nor can it be reduced to the sum of its parts. The word DADA dominates, of course, and the mix of typeface and image increases the impression of fragmentation. Although individual

images stand out, they cannot be made to yield their meaning. We cannot, as it were, cut the image. With its fragmented structure and underlying cynicism, it reflects the mood in Europe one year after the end of the First World War.

Emerging from the extremism of Dada, John Heartfield (1891-1968) produced one of the most sustained and richest body of visual montages this century. Working from a declared left-wing position, he used his images to offer increasingly satirical critiques of Nazi Germany. Whereas Hannah Hoch and Raoul Hausmann sought to undermine meaning through the use of the irrational, Heartfield uses the absurd and the juxtaposing of different elements in order to deflate and expose. His perspective turns the photograph into a blend of the

115 Herbert Bayer

Lonely Metropolitan, 1932

Bayer's title in one sense says it all. This is as much a visual reflection of T. S. Eliot's *The Waste Land* as it is of Kafka's *The Trial*. Very much an image in the European tradition, the hands and eyes suggest an emotional intensity in which aspects of the self are 'held' within the urban environment.

political essay and the political cartoon or caricature. As much in the tradition of Hogarth and Gillray as in that of his Dadaist contemporaries, Heartfield creates a wonderfully potent visual rhetoric which always seems aware of its calculated strategies in terms of its chosen target. Like the photographer Erwin Blumenfeld and the artist George Grosz, he uses the images not just to criticize but to ridicule falsehoods and political power. But although the political message dominates it cannot be reduced to a single effect.

Hurrah, the Butter's Finished, for example (1935) [**114**] is archetypal Heartfield. The title (and the text at the bottom of the image) refers to a speech by Herman Goering and quotes him as saying that: 'Iron always makes a country strong, butter and lard only make people fat.' Against the absurdity of this claim Heartfield constructs a withering satire on its implications if believed. The montage creates its effect through the use of exaggeration, juxtaposition, the use of the unexpected, and visual hyperbole, but also through a wonderful attention to detail which gives the message a rich visual density. In the absence of any butter the patriotic family sits at the table embarking on a feast of old iron objects: chains, bike frames, nuts, bolts. The baby chews on part of an old axe; the dog, instead of a bone, has a bolt. The acute attention to detail, without reducing the essential message, is basic to Heartfield's approach. Here, for example, he compounds the effect of the meal in relation to the wallpaper (with its pattern of swastikas) and the portrait of Hitler on the wall, matched by the brilliant addition of the embroidered cushion cover which reveals none other than Hindenberg. This is a family of patriots indeed. At once blatant and subtle, this quintessential Heartfield image retains its effect. Its extreme viewpoint moves beyond rhetoric to a density which places it in a social and moral context of the kind we would associate with Jonathan Swift and Alexander Pope.

Heartfield's approach has established an important tradition of the photographic montage used as political satire. The density and economy of his approach has been followed by the British-born Peter Kennard. A consistently trenchant reader of the British scene, his *Cruise Missiles*, made in 1980, turns the wagon in Constable's *The Hay Wain* into a missile-launcher, as part of a protest to keep cruise missiles out of England. Equally, his *Defended to Death* (1982) shows the excesses of the (then) arms race between the USA and the USSR. Kennard has an incisive style, and is very much a confrontational artist, as his recent *Brittania* work reveals: a study of the myth of England and establishment power.

If the strength of such montages is their immediacy, so their weakness is the limited context in which they establish their meaning and effect. Other uses of the montage (and collage) however, move away from the overtly political and satirical in order to suggest a

philosophical underpinning to their vision, and offer definitive images of a pervasive condition associated with twentieth-century life. In Europe much of this has been influenced by such philosophical movements as Existentialism, and by the work of Kafka and Freud. Herbert Bayer's (1900–85) *Lonely Metropolitan* (1932) [**115**] is such an image. Through its play of the unexpected and the absurd this achieves a poetic density, in which dark humour gives way to a visual equivalent of a larger condition: ennui, alienation, and loneliness within an urban reality. Thus it plays upon a larger symbolic significance to create a haunting and disquieting atmosphere.

In a similar manner, although to very different ends, Richard Hamilton (1922–) in his 1956 *Just what is it that makes today's homes so different, so appealing?* [**116**] poses the question in the title as basic to the meaning of the image. An obvious satire on suburbia, this extends the irony of the American photographer Bill Owens on middle-class lifestyles. Hamilton exhausts the signifiers, taking them to the limit of their effect; an effect so over-the-top as to reinvest them with cultural significance. There is a rich play of the banal and the blatant, but all as part of a critique of a way of life, of mental attitudes, not of a political subject as such. The humour belies the concern with lonely and empty

116 Richard Hamilton

Just what is it that makes today's homes so different, so appealing?, 1956

Hamilton's images have a playfulness about them which belies their serious intention. This is a cultural montage which offers a critique of consumer society through the juxtaposition of illogical components. The image, in the end, is cluttered with consumer items, just as it is full of the language and motifs of the advert.

117 Gingo Hanawa

Object (or Complicated Imagination), 1938

A strange and at first diffident image which offers the reader no easy access to its meanings. However, look at its separate elements and a series of patterns emerges based upon an underlying critique of the modern age.

lives of the kind we would associate with the work of Lee Friedlander and Diane Arbus, for example.

Heartfield, Kennard, Bayer, and Hamilton offer examples of the photograph used to make a specific critique. The visual space is made the basis of a series of strategies devoted to putting across a satirical message. Other montages (and collages) however, create their effect from the unexpected coming together of different elements without any obvious message or reading of the image. Gingo Hanawa's *Object* [117], for example, an image much ahead of its time, is at once ambivalent and complex. It baffles the reader in search of any narrative meaning. Unconnected elements, some photographic, some not, have been assembled in a random geometry and present themselves as a *fait-accompli*; an object, both in their own terms (for they constitute, however strange, an object), and as the object of our gaze. And this is the point, for merely placing two objects or images together (as with any two words) creates the potential for meaning and a new relationship between reader and image. *Object* is thus a play on the

nature of the object and meaning, for everything, in an individual state, can be recognized, and yet in the pattern in which they are presented they demand a new form of recognition and a new kind of attention. *Object* moves us back into a three-dimensional world and recalls us to the play between image and object which is the basis of the photograph. All is calculated, echoing El Lissitzky's *The Constructor* while equally looking towards the collages of the American artist Robert Rauschenberg in the 1950s, and to the conceptual games of Jasper Johns in the same decade. Ironically, the more we look at this object, the more it gains in meaning and significance.

Victor Burgin, a British-born photographer, has played a central role in the contemporary development of this tradition. As much a critic as a photographer, his *Thinking Photography* (1981) which he edited, underscores the theoretical awareness which informs his work: the implications of linguistic theory, psychoanalysis, and semiotics for the way the image must be understood, in all its contexts. He consciously manipulates the image according to a declared critical relationship to the reader which is characteristic of the postmodern period. His references to Brecht and Benjamin suggest his frame of reference. He denounced the notion of 'moments of truth' as as 'great a mystification as the notion of autonomous creativity'. *Office at Night, No. 1* (1986) [5] reflects his critical position. This is a devious image which speaks to a postmodernist self-conscious awareness of its multiple terms of reference. The right-hand side of the photograph features the image of a female office-worker at a filing cabinet. Behind is a second figure, which we recognize as taken from Edward Hopper's painting *Office at Night*. The stylized pastiche of Hopper's painting establishes both a point of contrast and a historical and social perspective on the nature and convention of the office as a place of work and cultural institution. It also raises significant questions concerning the nature of technology and communication. The left-hand side of the image offers examples of an anonymous typology associated with the computer. The 'file', like the figure, is, in its traditional sense, now redundant; new signifiers have replaced the old, to create a new reality. And yet, the image asks, how can we represent such realities in a visual form? The image is, in short, a Brechtian essay on photographic meaning and its relation to a larger signifying process. Although Burgin has abandoned any pretence of realism, his image exposes as much about the structures and relationships of the contemporary world as any 'documentary' photograph could.

Burgin's approach is characteristic of much postmodern imagery which, in manipulating the photograph, moves beyond the strategies of political satire and caricature and uses the medium to assert its validity whilst questioning its terms of reference. Christian Boltanski (1944–) is another worker in this area. Acutely aware of the practice of

the photograph, Boltanski, like Burgin, establishes a distinct critical space between the reader and his images. *Monuments (Les Enfants de Dijon)* (1985) [**118**] is characteristic of his approach. This installation charges the image with a new and heightened significance. A number of photographs of children have been arranged next to lights so that they resemble icons; indeed, the effect suggests a cathedral, and a series of candles celebrating (and remembering) the individuals photographed. Boltanski thus creates a sense of ritual, belief, and the need to record and celebrate, whilst at the same time questioning the structures within which the very act of photography accrues status and meaning. This installation extends the critical concern of contemporary photography to a new seriousness, whilst alerting us to the presence of the image in its anthropological as well as psychological contexts. Rather than suggesting the end of the photograph as a means of representation, Burgin and Boltanski give it a new significance. The manipulation of the photograph thus continues to instruct us in the strengths of the photograph and its relation to the world in which we live. As the American Surrealist photographer, Clarence John Laughlin (1905–85) proclaimed: 'The physical object, to me, is merely a stepping stone to an inner world … of subconscious drives …' So much, then, for the mirror image.

The Cabinet of
Infinite Curiosities

11

Henri Cartier-Bresson's career (1908-) spans many of the major developments of photography in the twentieth century, and yet his *œuvre*, extensive as it is, escapes definition in terms of any single genre. His work for Magnum is exemplary, but he is not a documentary photographer. Rather, Cartier-Bresson has a style and a philosophy so distinctive and so individual that they both defy definition. His images speak simultaneously to both the complexity of the photographic act and to the mystery of the photographic message. As he has noted: 'The photographer's eye is perpetually evaluating. A photographer can bring coincidence of line simply by moving his head a fraction of a millimetre ... he composes a picture in very nearly the same amount of time it takes to click the shutter, at the speed of a reflex action.'[1]

Much has been written about Cartier-Bresson's 'decisive-moment', and it is easy to reduce it to cliché; but its efficacy remains untouched. In photographic terms it seeks *the* moment for a particular subject; not just in terms of its appearance at that moment, but in relation to its meaning within the context of an entire history. It makes any thing and any subject open to the photograph. Any moment is possible; there is no hierarchy in Cartier-Bresson's approach. He is the quintessential photographer, for his approach is to encompass and reveal the world he sees, rather than edit and restrict his frame of reference. What we experience when we look at his images is a multiple response; the comic, the sad, the banal, the tragic are all offered within the single image. Time and again he achieves this sense of balance, but he does so in terms of an almost intuitive approach to his subject.

Madrid, Spain, for example (1933) [**119**] is typical Bresson. Although the title is significant in relation to its time and place, the image escapes from its historical context. The problem with Bresson is that his images confound the critical eye. They are, in that sense, pure photographs, and speak to the act and the enigma of sight rather than the influence and presence of the photographer. This image is awash with a visual irony characteristic of his style. And we can speak of a *style* in relation to Bresson, for each of his images is recognizable as a signature of the photographer. Here the relationship between the enigmatic wall and windows in the background and the children

119 Henri Cartier-Bresson

Madrid, Spain, 1933

A quintessential Cartier-Bresson photograph. The much-lauded 'decisive moment' is here given full significance. Typically, a series of disparate elements coalesce at *just* the right moment. They create a visual geometry at once quizzical, humorous, and enigmatic. The male adult seems to float through the scene and makes the image alive with a surreal potential.

120 Henri Cartier-Bresson

Paris, Gare St Lazare, 1932

Another definitive Cartier-Bresson image which has a series of formal aspects characteristic of his style. The 'moment' is basic, but so is the use of reflection, of the incongruous, the unexpected, and the way the banal is transformed into something special and unexpected. All add to the implied rather than stated meaning of the image.

playing in the foreground is compounded by their awareness of the camera and, overwhelmingly, by the presence of the large, incongruous figure who moves across the scene in the middle area. We have, in that sense, a geometry so complex as to displace the normal codes and terms of representation. Invariably Bresson will achieve this effect; not only displacing the expected terms of response, but confounding our attempts to reduce his images to paraphrase and explanation; instead, a kind of *joi de vivre* informs the image. Perhaps this is why his photographs rise above their historical and cultural contexts. The single detail, the subtle tone, the unexpected point of view alter the scene/seen in dramatic and often extreme terms; while what we look at is filtered through a marvellously balanced sense of the image as seen through the camera.

Paris, Gare St Lazare (1932) [**120**] achieves just this effect. This is characteristic Bresson territory, not so much in terms of the subject but in terms of its treatment. Bresson turns it into a visual paradigm, a test of seeing, and a statement on the nature of the real. The image is full of humour, of irony, but also full of implied philosophical reflection both on what the moment might mean and how it is to be read. Bresson gives us clues in relation to his visual geometry, the displacement of the image, the visual puns, and so on. The point is that the image alerts us to the way the photograph escapes definition and creates its own integrity as an image.

Bresson thus *opens* the world to the camera lens, where so many photographers close what they see, confining it within a familiar frame of reference. But Bresson also alerts us to the way we need to view photographs in relation to a human context that cannot be reduced to a visual statement. Sebastião Salgado's work is characteristic of this approach. Look, for example, at his *A Child being weighed as part of a*

Salgado is best known for his monumental images of South American mine-workers which have a renaissance aspect about them. Here the plight of a single child is given a complex but direct treatment. The direct response is balanced by a subtle symbolic meaning.

supplementary food relief program, Gourma Rarhous, Mali, June 1985 [**121**]. The title insists on a specific place and time, but the subject of the photograph will not be classified, much less defined as an image. Technically, Salgado is a brilliant photographer, and his images of South American workers reflect them in almost Renaissance terms as sculptural figures. But what has he achieved here? In one sense, his style admits to both the limitations and the strengths of the camera, so that much of his work is a mixture of the polemical and the stylized. *Child being weighed...* is both emotive and calculated. How do we begin to decode and unpack an image like this? It is stark and emotional; but equally, it is calculated to establish those particular terms of reference. The child is 'hung' amidst a series of secondary pointers; but they all relate to a western viewpoint. If the child is 'weighed', then it is against a larger frame of reference which, in the end, only invests in its image as a part of a larger meaning. The photograph does not establish meaning in terms of the subject for its own sake. We can note the strategies, decode the terms of reference, and read this as a deliberate image with a specific effect in mind.

Hence the way in which the image splits between the child and the machine. The straps are so taut that they appear to form a triangle. They invoke an obvious contrast to the body below. There are, as it were, lines above and legs below, so that the tension between the two as symbols of an anonymous and human context is insistent. The geometrical imbalance creates an extraordinary resonance and a complex suggestiveness. Look at the arms; angular and malnourished. The whole play of the lines of the machine against the lines of the body reflects Barthes's distinction between denotation and connotation, with a vengeance. The child, obviously, is central. It is being weighed and photographed, and, in turn 'weighed' as a significant symbol (of hunger, weakness, poverty) for an assumed western audience. It is also naked. The camera uses the body as an extension of the official assumptions surrounding the individual; and any sense of an individual has been lost in the geometry of the image. And yet around the neck is a necklace, and in the ear is an earring; distinctive aspects of an individual existence which mitigate against the child's use by the camera as a generic symbol.

The image, then, is deceptively complex in its approach. The child is, ostensibly at least, the subject of the photograph. But we can establish a whole series of readings which move away from the child to other areas and other meanings. The emotional qualities of the image are weighed, so to speak, against the rational, so that its effect is a dense play of the subjective and the objective. Thus, to unravel the image is to play into a much larger, and seemingly endless, series of contexts and questions; such is the density of the photographic message. This might be seen as a weakness, but the capacity of the photographic image to

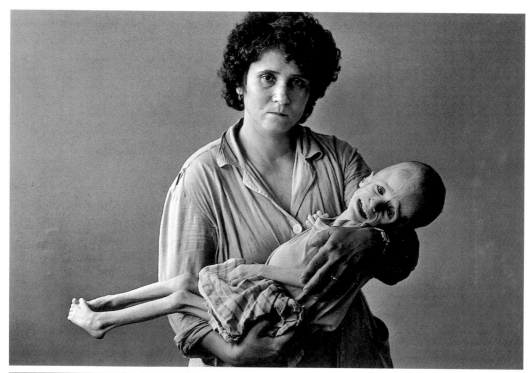

A Child in a Romanian
Institution, 1990

An everyday newspaper image
which, along with its caption,
reveals the continuing power
of the photograph in an
everyday context. The image
retains a poignancy which will
not be diluted.

'suspend' its subject within moral, political, cultural, aesthetic, emotional, and social contexts simultaneously is one of its great attributes. But this points up the temporal as well as the spatial relationship we have with any photographic image. We always look at it in terms of its spatial configuration; but we also spend time looking at that space. Indeed, we may return to an image, especially those in a personal context, again and again. Even though we sense the message of an image, it is impossible to exhaust its effect upon us. Despite the sealed and discrete nature of what it shows to us, there is always something else there. Thus, photographs move beyond a polemical statement and achieve a felt condition. They are committed to the human, just as they are, by implication, committed to an objective world.

Every detail in a photographic image resonates as part of a larger meaning. Thus, it becomes difficult to determine at what point the 'meaning' of the Salgado image is to be closed down. As we continue to read it, so every element within the photographic space begins to mean more than its literal presence. The crude scale, for example, suggests the sun, and aligns itself with the (extinguished) lamp on the wall. One foot touches the board, and there is a pad of paper and a pen to record the weight of the child. Outside the dark space of the door reveals the back half of a lamb, and the measure at the back of the child appears as if it has been plunged directly through the child's heart. Even the head of the child is caught in parallel with the scale, and sets up a triangular

pattern to match the other triangular patterns in the image. And so the meanings proliferate in terms of the symbolic codes which add to the significance of the image, and increase its density of effect. Once again, there is a distinct visual language at work here which, in its terms of reference, has no limit. Everything in the image is, in one sense, suspended, symptomatic of the condition of the child, and of the culture of which it is a part. The readings multiply. The hands of the child suggest a prayer-like posture, just as its head seems to look upwards. Its clutching of the bands also suggests a holding on to life, a desperate act; the image equally reduces the child to a position of indignity and suffering. The ruler by the child's left foot is a clear signal of a western presence; all these continue to add to the significance of the meaning of the image. John Berger states that 'photography, unlike drawing, does not possess a language'; but in relation to an image like this, I am not certain what he means. This photograph, within its established frame of reference, its assumed codes of meaning, and the declared terms in which it is to be read, possesses a highly complex and subtle language. Its movement between the denotative and the connotative allows it to transform a scene into a text of multiple meanings. Thus its capacity to surprise.

Look, for example, at [122]. This appeared on the front page of a British daily newspaper, the *Guardian*, in 1990. It was given the following caption: 'Four-year old Marian Neascu is one of 190 sick children, aged up to 18, who are kept locked up in abject conditions in a hospital known as the children's Auschwitz, 25 miles from Bucharest. Marian, held by one of six helpers who along with one nurse are the hospital's sole staff, is suffering from Hepatitis B and was abandoned by her family because they could not afford to feed her. The hospital's inmates are considered beyond recovery, and aid to Romania has so far gone to 'healthy' children. Donations can be sent to: Angel Appeal, 32 Galena Road, London W6 OLT.' This is not so much a caption as an appeal, an emotional history, and a report. The text places in context the exact nature of the circumstances and exorts (even demands) us to respond within the context of the newspaper. The child's condition is similar to that of the child in the Salgado image, but within the terms of a newspaper it takes on a different significance. The image attempts to involve directly the reader in its message. If 'a photograph simplifies', it does not necessarily reduce, much less make simplistic. The *Guardian* image simplifies, but in terms of an explicit purpose. The effect of the image is based upon its visual impact, not its nascent message.[2]

There is no background, simply two figures, a woman and a child (remember Lange's *The Migrant Mother*) who, through their despairing looks, establish the terms of the image's impact. But the photograph invokes a polemical structure which reflects its immediate

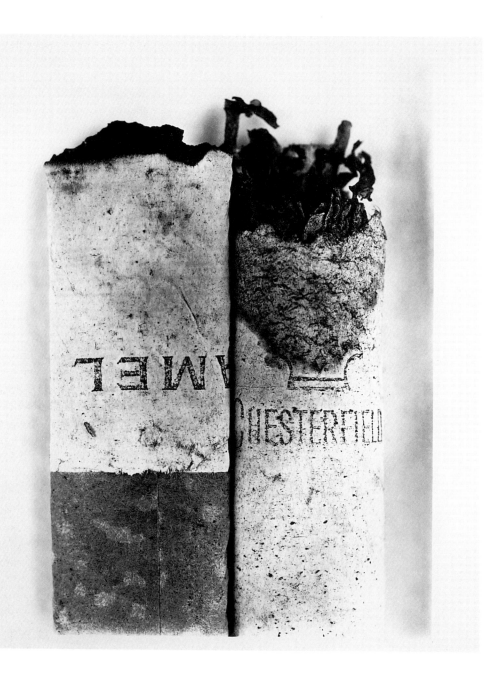

123 Irving Penn

Cigarette No. 37, 1972

This image gives monumental status to ephemera and detritus. Cigarette butts are accorded the attention usually reserved for buildings. It is, however, a significant example of the power of the photograph to transform the most banal of objects and moments into something special, even extraordinary.

context. The woman who holds the child, for example, has a distinctive bulk which merges with the simplicity of her clothes. Her hands dominate; they both reassure and are safe, just as the ring on her left hand signifies her status as a married woman (and possible mother). She also wears a watch, reflective of the fact that she and the child belong to different worlds, and that has is controlled and ordered. The child is the reverse of all of this. It wears a skirt, anachronistic in the context of the culture but telling in relation to the way the image addresses a western audience. The child almost smiles. Despite its extreme condition, the way it is photographed relates it to a whole series of conventional poses associated with the photographic tradition.

The most obvious of photographic images is fraught with complications and contradictions, and we can analyse and read it in a way that takes account of these. For all its acknowledged literalness, the photographic image retains a dense and, in many ways, wondrous capacity to *mean*. Irving Penn's (1917-) *Cigarette No. 37* [**123**], is a case in point. Taken in 1972, it rides on a number of visual and cultural conventions. It echoes, for example, Stuart Davis's painting *Lucky Strike* (1921), as much as it does Surrealist and Dadaist concerns (Brassaï's bus tickets and Schwitters's recovery of urban detritus). But equally it declares its own status as a monumental presence. Two cigarette ends are placed side by side. They are given no indication of scale other than our own sense of what constitutes an assumed size. One is American (Chesterfield), one is European (Camel). This is the world in close-up, but it is also the everyday world under scrutiny. It is the banal and the minute, as well as the throwaway, given a grand and classic status. It is a remarkable example of how the photograph has no scale in terms of its meaning or its subject. It can reduce the biggest of human disasters to cliché, and raise the most obvious of clichés to significance: hence part of its continuing enigma as a means of representation.

Merely by announcing its subject, the photograph grants both meaning and significance. The banal, the marginal, the momentary, are given status within an assumed cultural register. The photograph draws attention to and enlarges on the most minute of events. It can make anything important. It has the capacity to move between extremes—philosophical, cultural, social. The photograph is free of limits, just as its subject-matter is infinite. The 'moment' is thus its greatest asset, for the moment is always unique, and it is the *moment* that the photograph brings into focus.

To reproduce an image is, in one sense, the most obvious of activities. To interpret it is quite different, and this is one of the great assets of the photographic image as a means of representation. With the advent of the video camera and computer-generated graphics it

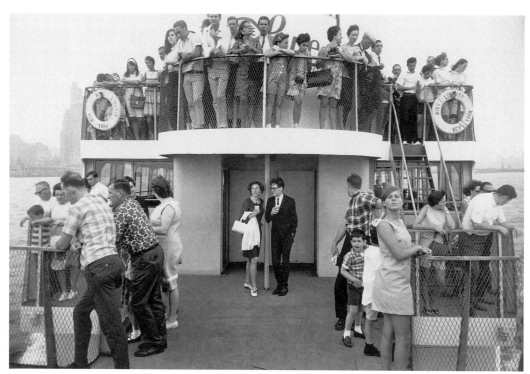

124 Garry Winogrand

Circle Line Ferry, New York, 1971

Whereas Weegee's image of people on the beach at Coney Island had them waving at the camera, in this image everyone is oblivious to its presence. A dense and subtle Winogrand image, it is a formally structured photograph, full of understatements which achieve a poetic intensity.

seems that we are moving beyond the photograph in its traditionally accepted form. And yet the holds retains its status as something unique. One could point to the continuing significance of the snapshot and the extent to which the photograph holds a central place within our everyday lives. Indeed, it is the only visual medium which is not merely open to everyone, but through which we shape our own histories and give meaning to a personal past. Thus the photograph has moved beyond its role as a recorder, to attain its iconic function as an object. We stuff our houses with photographs as signs of the past; memories of what no longer *is*. It is the closest most of us ever come to a biography, and those selected moments constitute a past that we hold up as definitive. It is our own record in time and space.

And yet the photograph remains an enigma. Photographs escape a definitive meaning because they are in themselves part of a distant and enigmatic world. They do not so much record history, as take the image out of history and leave it floating. Unless we date photographs, they have no obvious historical context. As the bearers of significance they hide their terms of reference. Gary Winogrand (1924–84), perhaps one of the finest of twentieth-century photographers, makes this sense of the enigmatic basic to his vision. Winogrand's images are both complex and subtle. They seem to announce a casual moment of caught visual intensity in which meaning is not so much reflected as suggested. His insistence that he photographed to see how things looked when they had been photographed is characteristic of his

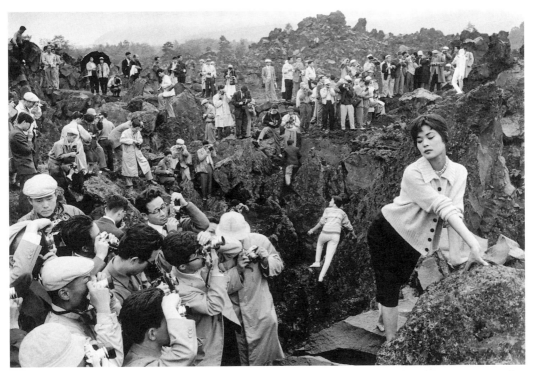

approach. And *Circle Line Ferry, New York* (1971) [**124**] is, in this context, exemplary. Winogrand has the ability to freeze rather than make still a moment, and, in so doing, turn it into a rich area of potential meaning reflected through a poetic rather than literal sense of the event. His images offer themselves as photographic essays rather than as images, and effuse the ambiguous, the ironic, and the paradoxical. In this image an everyday tourist event (the Circle Line carries tourists around the shoreline of Manhattan Island) has been transformed into a definitive image of late twentieth-century life. How different from Stieglitz's *The Steerage* or Weegee's images of Coney Island Beach. Like the photographer, everybody seems involved in the act of looking, so that we begin almost to see the world as a series of photographs. And yet what the photograph demands is a slow and deliberate accretion of meaning.

The act of looking is, then, to be balanced with the act of taking a photograph, and reminds us that every photograph reflects a conscious and deliberate act on the part of the photographer, itself the reflection of a complex cultural vocabulary and system of values. Marc Riboud's *Japanese Photo Workshop* [**125**], for example, suggests the almost desperate need to record, but it does so very much in terms of cultural stereotypes. Riboud records the act of recording, allowing us to observe the explicit relationships between photographer and subject. Where Winogrand's image is overwhelmed by stillness, so this is saturated with frenzied action. Indeed, Japan not only produces some of the

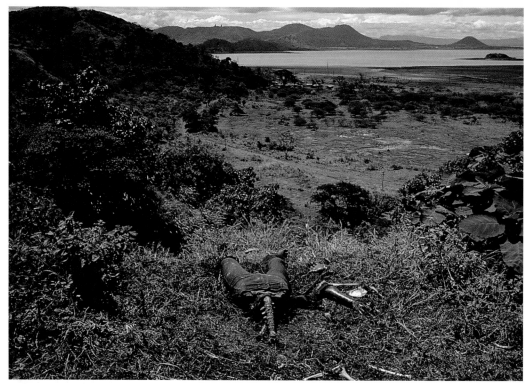

126 Susan Meiselaes

Cuesta Del Plomo ..., 1978

The lush vegetation suggests a stereotypical image appropriate to an advertisement for tourism. But this is a war photograph, and it ambushes the eye as it lazily moves over the landscape. The 'discovery' of the human remains makes them rightfully the centre of the photograph.

127 Peter Marlow

Rhodesian Refugees in a Camp, Zambia, 1978

An image which celebrates as it insists on the democratic nature of the photographic image. It is the very opposite of the stilled and stilted dagguereotypes of the nineteenth century.

most sophisticated cameras and makes the photograph central to its culture, it has even named cameras after its traditional gods, such is photography's status in Japanese society.

The snapshot[3] remains undervalued as a form of photography, lacking the distinctiveness and substance of images produced by the professional photographer. And yet the snapshot is the basis of most people's experience of the photograph; both of taking photographs and of saturating themselves within a photographic history of their own making. The snapshot has transcended its role as a photograph and answers a new set of needs, with a new kind of significance.

A myriad of recent developments—micro and macro photography, satellite images, computer-enhanced and heat-based images, and images produced by electron microscopes—have extended the range of vision at both ends of the visual spectrum and qualify the old debates about what the photograph reflects back to us. The photographs produced for astronomy, for medicine, and for physics have resulted in some of the most memorable images of the age. One recalls Buzz Aldrin's photograph of Neil Armstrong on the surface of the moon (21 July 1969)—surely a definitive image for the century.

And yet it may be that the future of the photograph, at least in the way we now understand it, is itself ambiguous. Despite the difference between a daguerreotype and a polaroid print, the photograph has always been based on a chemical process. Images are now being

generated on the basis of electronic processes which fundamentally change the terms by which we relate to the photograph, retrieve, experience, and read it. And yet the photograph continues to retain its capacity to astonish and to alert us to the way we structure and look at our world. Susan Meiselaes's image [126], for example, is deceptive. Its lush colours and ostensible subject ask us to read it as a landscape; but as we look so we see other things. Indeed, the mutilated remains of human figures in the centre foreground change the terms of reference in a second. The photograph allows itself to achieve this power, but it does so as part of its play of meaning. If it stands in for experience, it equally alerts us to our own preconceptions and expectations.

Recent developments however, have broken the continuity of the photographic experience, especially in relation to the camera. Where people once took photographs, now they make films, and the difference establishes both a different relationship to the event, and a different record. As John Berger noted, 'photographs bear witness to a human choice being exercised in a given situation. A photograph is a result of the photographer's decision that it is worth recording that this particular event or this particular object has been seen. If everything that existed were continually being photographed, every photograph would become meaningless.' Thus, a photograph 'isolates, preserves and presents a moment taken from a continuum'. The video celebrates that continuum, but the photograph privileges the moment, and in taking that moment transforms it into something other than it was.

Postmodernism has questioned the efficacy of the photograph just at the point when we have become saturated with its presence in papers, magazines, brochures, adverts; when it continues to remain basic to any proof of identification; and when more photographs are being taken than ever before. It retains its central place within the

culture as a means of representation. Like Peter Marlow's image [127], it celebrates multiplicity. It is infinite in its capacity to record and make the moment significant. It grants status to whatever it touches. It is the perfect modern medium. As Winogrand's *Woman with Ice-Cream Cone* [128] suggests, even the banal is made distinctive by a single photograph. A rich and dense image, it is quintessential Winogrand and a quintessential photograph. As Winogrand declared, 'I like to think of photographing as a two-way act of respect. Respect for the medium, by letting it do what it does best, describe. And respect for the subject, by describing it as it is. A photograph must be responsible to both. I photograph to see what things look like photographed.'

In that sense it seems appropriate to return to the first two photographic images which begin the development of such an extraordinary medium: Daguerre's *Intérieur d'un Cabinet Curiosité* and Niépce's *View from a Window at Gras*. They remain as enigmatic tokens of the varying claims of the photograph. Niépce's is an image which resists definition as it refutes measurement. A presence inert to time and space, it is not so much an image as the trace of the act of seeing. In contrast, Daguerre's image gluts the eye with its sense of a material world. It measures and celebrates the corporeal extension of things; and therein lies the difference. Niépce's image speaks to a sense of ambiguity, even mystery; Daguerre's, to a confident imaging of substance—a three-dimensional world subject to human control and knowledge. They thus hint at the extremes of the photographic process and, whether looking from a window or into a cabinet, underline the extent to which the photograph is, in the end, open to endless meanings. From its inception it has always been a cabinet of infinite curiosities.

Notes

Chapter 1

1. I use the term in relation to John Tagg's *The Burden of Representation* (London, 1988), 153–83.
2. See Beaumont Newhall's *Photography: Essays and Images* (New York, 1980), 9–14.
3. Delaroche's declaration remains part of a significant nineteenth-century debate concerning the relationship between art and the photograph, especially in the context of the photograph's literal and 'realistic' aspects. See Alan Trachtenberg's *Classic Essays on Photography* (New Haven, 1980), pp. viii–ix, and the essays by Baudelaire and Robinson, 83–99.
4. Ibid. 71–82 and 37–48 for the response of Oliver Wendell Holmes and Edgar Allan Poe. Their reactions are further reflected in the use of photography by the American poet Walt Whitman—see Graham Clarke's *Walt Whitman: The Poem as Private History* (New York and London, 1991)—and its central place in Nathaniel Hawthorne's *The House of the Seven Gables* (1851). The relationship between painting and photography is central to the culture's use of the medium.
5. See Walter Benjamin's 'The Work of Art in the Age of Mechanical Reproduction', in *Illuminations* (London, 1973). See also 'A Short History of Photography', in *Artforum*, 15 (Feb. 1977), repr. in *Classic Essays on Photography*, 199–216.
6. John Berger, 'Understanding a Photograph', in *The Look of Things* (New York, 1974), repr. in *Classic Essays on Photography*, 291–4. See also the more recent *Another Way of Telling*, by Berger and Jean Mohr (Harmondsworth, 1992).
7. *Classic Essays on Photography*, 287–90.
8. See Roland Barthes's *Camera Lucida* (Toronto, 1981). See also Barthes's discussion of the photograph in *Image—Music—Text*, trans. Stephen Heath (London, 1977).

Chapter 2

1. See Victor Burgin (ed.), *Thinking Photography* (London, 1982), 144. The entire volume is of significance.

2. The denotative and connotative levels of 'meaning' are basic to any reading of the photographic image and underpin its status as a *text*. See Frank Webster, *The New Photography* (London, 1980) and the last section of Barthes's *Mythologies* (London, 1973).
3. The distinction between 'punctum' and 'studium' is made by Roland Barthes in *Camera Lucida*, ch. 10.
4. One of the most significant analyses of the American Civil War and the photograph is to be found in Alan Trachtenberg's *Reading American Photographs* (New York, 1991), especially in relation to their ideological context. See, for example, the excellent volume on the photographer Alexander Gardener, *Witness to an Era* (New York, 1991) by D. Mark Catz. See also Matthew Brady's *History of the Civil War* (New York, 1866) by Benson J. Lossing.
5. See Umberto Eco's 'Critique of the Image', in Burgin's *Thinking Photography*, 32–8, where he discusses the meaning of iconic codes.

Chapter 3

1. See Henry Fox Talbot, *The Pencil of Nature* (London, 1844–6).
2. See Mike Weaver's discussion of Talbot in *The Photographic Art: Pictorial Traditions in Britain and America* (London and New York, 1985).
3. See, for example, Carolyn Bloore and Grace Seiberling, *A Vision Exchanged* (London, 1985).
4. See Beaumont Newhall, *Photography: Essays and Images* (New York, 1980), 115.
5. The work of Roger Fenton remains a significant example of the nineteenth-century approach in the way it shows how Fenton excelled in so many areas of the photograph, especially those associated with painting. He photographed still-lifes, landscapes, portraits, and cityscapes according to the dominant principles of the time and of his audience. See, for example, *Roger Fenton, Photographer of the 1850s* (South Bank Board, London, 1988).

6. Lady Eastlake's writing is reproduced in Beaumont Newhall's *Photography: Essays and Images* and in *Classic Essays in Photography*, 39–61. See also the discussion in Beaumont Newhall's *The History of Photography* (New York, 1964).

7. Peter Henry Emerson's books of photography include *Life and Landscape on the Norfolk Broads* (1886), *Pictures of East Anglian Life* (1888), and *Naturalistic Photography* (1890). His theories on the photograph and his astonishing images established him as a forerunner of photography as an art in its own right. See, for example, Ian Jeffrey's excellent essay on Emerson in Mike Weaver's *Nineteenth-Century Photography* (Cambridge, 1989). Emerson's work might also be compared with the writing of Thomas Hardy and, of course, the *plein-air* painting of nineteenth-century French art.

Chapter 4

1. The complex relationship between landscape and the picturesque, as well as the aesthetics of the tourist, are covered in Malcolm Andrew's *The Search for the Picturesque* (London, 1989), but see also the much earlier study by Christopher Hussey, *The Picturesque: Studies in a Point of View* (1927).

2. Roger Fenton's response to landscape was very much within the picturesque tradition, although it equally suggests parallels with the work of Constable and Wordsworth.

3. For this sense of the American scene, see the two seminal studies by Barbara Novak: *American Painting of the Nineteenth Century* (New York, 1969), and *Nature and Culture* (New York, 1980). See also John Wilmerding (ed.), *American Light* (Washington DC, 1989).

4. 'Transcendentalism' is a complex but pervasive aspect of much nineteenth-century American thought. It remains basic to the American sense of landscape. Photographers such as Weston and Adams continue to interpret the American scene through the same terms of reference.

5. Chris Killip's *In Flagrante* (London, 1988) is a significant interpretation of the English landscape as a cultural symbol of an assumed 'Englishness'. His images counter the dominant pastoral tradition as represented by Fenton. Killip offers images which reflect the painful realities of North-East England in the 1980s. As he notes in the introduction to his book: 'THE OBJECTIVE HISTORY OF ENGLAND doesn't amount to much if you don't believe in it, and I don't, and I don't believe that anyone in these photographs does either as they face the reality of de-industrialization in a system which regards their lives as disposable.' The photographs of Graham Sykes which accompany Tony Harrison's poem *V* (Bloodaxe Books, 1985) are in a similar vein.

Chapter 5

1. The panorama is placed in its historical context in Ralph Hyde's *Panoramania* (London, 1988).

2. Ibid. 41.

3. William Wordsworth's 'Sonnet Upon Westminster Bridge' looks upon the city of London from an assumed vantage-point which celebrates the scene in terms of a photograph. The scene he describes is both silent and still.

4. See, for example, Stephen White, *John Thomson* (London, 1985).

5. Stieglitz's response has to be placed in the context of such other photographers as Alvin Langdon Coburn, Edward Steichen, and Berenice Abbott. See, for example, my 'The City as Ideal Text: Manhattan and the Photography of Alfred Stieglitz, 1890–1940', in C. Mulvey and J. Simons (eds.), *New York City as Text* (London, 1990), 12–27.

6. New York as a symbol of modernity has remained basic to the photographer, painter, and writer alike. A valuable text remains Waldo Frank, Lewis Mumford, *et al.* (eds.), *America and Alfred Stieglitz: A Collective Portrait* (New York, 1934; reissued 1979). See also Paul Goldberger, *The City Observed: New York* (New York, 1979) and Peter Conrad, *The Art of the City* (Oxford, 1989).

7. The relationship between Arbus and New York remains ambivalent. See, for example, Patricia Bosworth's biography *Diane Arbus* (New York, 1985), which includes significant detail on the photographer's relationship with the city. Her interest in the work of Lisette Model and Weegee confirms the terms of her photographs of city life.

8. Thomson's photographs of figures form part of a larger tradition of the street figure as a subject in itself. See White, *John Thomson*. Photographs of individuals in the 'street' are basic to such photographers as Strand, Abbott, and Davidson. See, for example, John Berger's excellent essay on Strand's *Blind* in *About Looking*.

9. Atget's influence on both city photography and the Surrealists is both complex and extensive. The essential study of Atget remains that of John Szarkowski, and Maria Morris Hambourg's four-volume edition of Atget's *œuvre*: *Old France*, *The Art of Old Paris*, *The Ancien Régime*, and *Modern Times* (London, 1989). See also *Atget Paris* (Paris, 1992). The

work of Brassaï and of Charles Marville is, in its own way, basic to Atget's significance.

10. See S. S. Phillips, David Travis, and Weston J. Naef, *André Kertesz of Paris and New York* (New York, 1985).

Chapter 6

1. See the introduction to Graham Clarke (ed.), *The Portrait in Photography* (London and Seattle, 1992).

2. John Tagg, *The Burden of Representation* (London, 1988), 37.

3. Ibid. 35. This does, of course, raise enormous questions as to the difference between portraits in the professional and public sense and those associated with snapshots and private space.

4. The 'rise' of portraiture in the USA is of especial significance. See, for example, Renato Danese (ed.), *American Images* (New York, 1979).

5. In many ways the rise of the photograph as a means of representation runs counter to the development of painting and literature in the critical period between 1900 and 1920. 'Modernism' at the time appeared to question the very terms on which the photograph was based, and the portrait, as such, was basic to its status.

6. This might be related to 'official' images of the British monarchy as well as to images of other heads of state.

7. See, for example, my essay on August Sander in *The Portrait in Photography*, 71–93.

Chapter 7

1. The 'entwined questions' of the relationship between the representation of the body and sexuality go far beyond the space I have for my overview here. The reference is from Abigail Solomon-Godeau, *Photography at the Dock* (Minnesota, 1991), 220.

2. John Berger uses the term 'mystification' in relation to his critique of Kenneth Clark's *The Nude*. See *Ways of Seeing* (Harmondsworth, 1972), 105–9.

3. See, for example, pp. 11–15 of the introduction to *1,000 Nudes: Uwe Scheid Collection* (Germany, 1994).

4. Stieglitz's studies of O'Keeffe relate to a larger 'body' of reference which as much underlines the relationship between Stieglitz and O'Keeffe as it does the larger aesthetic questions. See, for example, the excellent *O'Keeffe, Stieglitz and the Critics, 1916–1929* by Barbara Buhler Lynes (Chicago, 1989).

5. Eadweard Muybridge's images of the moving body remain very much cast between an assumed objectivity and the stereotyping of the subject in relation to fixed ideas of male and female poses.

6. 'Scopophilia', or the 'pleasures of the eye', is most obviously related to the cinema. It remains, however, central to the way in which the 'eye' looks at and enjoys the photograph, most obviously in a sexual context. See, for example, Laura Mulvey, *Visual and Other Pleasures* (Bloomington, 1989) and Annette Kuhn, *The Power of the Image Essays on Representation and Sexuality* (London, 1985).

7. The film *Klute* (USA, 1971, directed by Alan J. Pakula) is basic to this sense of the voyeuristic and threatening aspect of the unseen spectator. It underlies a basic aspect of the male gaze and of an assumed sexual power. In Brassaï, for example, the camera is present in a series of brothel scenes, seemingly unnoticed and insignificant.

8. The work of Helmut Newton is important as an example of the way in which fashion photography overlaps with the issue of the body. See, for example, Carol Squirs (ed.), *The Critical Image: Essays on Contemporary Photography* (Seattle, 1990).

9. I refer here to John Berger's still-valid argument about the position of women that he outlines in *Ways of Seeing*. In a more sustained academic context, see Lynda Nead's excellent studies, *The Female Nude: Art, Obscenity, and Sexuality* (London, 1992) and *Myths of Sexuality: Representations of Women in Victorian Art* (Oxford, 1988).

10. Women photographers have increasingly questioned male codes of representation. Look, for example, at Val Williams *Women Photographers on Women* (London, 1989), and Abigail Solomon-Godeau, *Photography at the Dock* (Minnesota, 1991). See also the excellent *Photography and the Body*, by John Pultz (London, 1995).

11. The question of the representation of death and Aids has given, ironically, a new impetus to the representation of the dead body. For critical considerations of this very difficult area of photographic practice see Jay Ruby, *Secure the Shadow: Death and Photography in America* (Massachusetts, 1995).

Chapter 8

1. See Abigail Solomon-Godeau, *Photography at the Dock*, 169.

2. See William Stott, *Documentary Expression and Thirties America* (Oxford and New York, 1973); and Alan Trachtenburg, *America and Lewis Hine: Photographs 1904–1940* (New York, 1977) and *Reading American Photographs* (New York, 1989).

3. See, for example, Beaumont Newhall's *Photography: Essays and Images* (New York, 1980).

4. For example, the most famous of literary and photographic collaborations, *Let Us Now Praise Famous Men* (1941) by James Agee, with photographs by Walker Evans.

5. See the 'essay' by Dorothea Lange in *Photography: Essays and Images*, 263–6: 'The Assignment I'll Never Forget.'

6. *American Photographs* (1936) by Walker Evans remains a central text, especially in relation to later 'interpretations' of the American scene, for example, the ground-breaking *The Americans* (1956) by Robert Frank.

7. Susan Moeller, *Shooting War: Photography and the American Experience of Combat* (New York, 1989). See also John Taylor, *War Photography* (London, 1991).

8. Neidich's *American History Reinvented* (New York, 1989) is both a powerful and apposite text of its time. It establishes a distinctive critical perspective in relation to the photograph as both witness and evidence of the past.

Chapter 9

1. See Marius De Zayas, 'Photography and Artistic Photography', in *Classic Essays in Photography*, 125–32.

2. See Sarah Greenough and Juan Hamilton (eds.), *Alfred Stieglitz: Photographs and Writings* (Washington DC, 1983).

3. 'Straight photography', as associated with Alfred Stieglitz, was a reaction against the way much nineteenth-century photography attempted to 'look' like painting. Stieglitz argued for a photography which achieved its 'look' by means 'strictly photographic'. See William Innes Homer, *Alfred Stieglitz and the American Avant-Garde* (Boston, 1979) and the biography of Stieglitz by his niece, Sue Davidson-Lowe, *Stieglitz: A Memoir/Biography* (New York, 1983). The British equivalent, at the time, was P. H. Emerson.

4. The full statement can be found in Homer, *Alfred Stieglitz*, 70. For a further discussion of the image, see Allan Sekula's 'On the Invention of Photographic Meaning', in *Thinking Photography*, 84–109.

5. Edward Weston, 'Random Notes on Photography', in *Photography: Essays and Images*, 104.

6. The F.64 Group was founded by Edward Weston, Ansel Adams, and Willard Van Dyke in 1932. As its title suggests, it was committed to a 'pure' photography akin to the ideas and aesthetic of Alfred Stieglitz. Its dominant subject-matter was the nude and the landscape. Its 'spirit', as it were, is reflected in the publications associated with *Aperture*.

7. Harry Callahan's career as both a photographer and a teacher is both long and distinguished. The black-and-white work is as much an enigma as it is technically brilliant. In an image such as *Lake Michigan* (1953) he captures a subtle sense of loneliness and separation which achieves the status of a general condition of human feeling. Very much a photographer of atmosphere, his images establish a mood which renders an underlying philosophical meaning as basic to their effect.

Chapter 10

1. See Mike Weaver, *Alvin Langdon Coburn Symbolist Photographer* (New York, 1986), esp. 6–10 and 33–47.

2. See Mike Weaver (ed.), *The Art of Photography* (London, 1989), 228–31.

3. See the article 'Photography' by László Moholy-Nagy, in *Classic Essays on Photography*, 165–6.

4. *The Art of Photography*, 230.

5. See Dawn Ades, *Photomontage* (London, 1986), for a full account of the significance of montage and collage within the context of photography. Such approaches had their parallels in both art and film. Kurt Schwitters used the ephemeral as basic to his entire *œuvre* in the way that Brassaï could make the marginal detail central to the eye's attention as it was symbolic of the mind's understanding.

Chapter 11

1. See Brooks Johnson, *Photography Speaks* (Norfolk, Va., 1989), 52.

2. The significance and status of photographs in newspapers is both complex and ambiguous and demands a study in its own right. See, however, Roland Barthes's discussion in *Image—Music—Text*. See also John Taylor's discussion of the press and the context of war photography in *War Photography*.

3. The 'snapshot' remains very much outside the professional 'canon'. However, it is central to the practice of photography and to its significance in a larger social and cultural context. Many of its meanings can be traced to the influence of the original 'Kodak' Brownie camera and the assumptions underlying its influence. See, for example, Robert Kee (ed.), *Picture Post* (London, 1989).

List of Illustrations

The Publishers would like to thank the following individuals and institutions who have kindly given permission to reproduce the illustrations listed below

1 Joseph Nicéphore Niépce: *View from a Window at Gras*, 1826. Heliograph. Gernsheim Collection, Harry Ransom Research Center, University of Texas at Austin.

2 Louis-Jacques-Mandé Daguerre: *Intérieur d'un Cabinet Curiosité*, 1837. Daguerreotype. © Collection Société Française de Photographie, Paris.

3 William Henry Fox Talbot: *Photogenic Drawing*. National Museum of Photography, Film and Television, Bradford/photo Science and Society Picture Library, London.

4 William Henry Fox Talbot: *Latticed Window*, 1835. Science Museum, London/photo Science and Society Picture Library, London.

5 Victor Burgin: *Office at Night No.1*, 1986. © Victor Burgin/John Weber Gallery, New York.

6 Olivia Parker: *Bosc*, 1977. Olivia Parker © 1977.

7 Diane Arbus: *Identical Twins*, 1967. Gelatin-silver print. 37.5 × 36.8 cm. © Estate of Diane Arbus, 1971/Museum of Modern Art, New York, Richard Avedon Fund. Copy Print © 1997 Museum of Modern Art, New York.

8 Diane Arbus: *A Family on Their Lawn One Sunday in Westchester, New York*, 1969. Gelatin-silver print, 37.4 × 37.4 cm. © Estate of Diane Arbus, 1968/Museum of Modern Art, New York, Purchase. Copy Print © 1997 Museum of Modern Art, New York.

9 Matthew Brady: *General Robert Potter and Staff. Matthew Brady Standing by Tree*, 1865. Library of Congress, Washington, DC.

10 Matthew Brady: *John Henry, A Well-Remembered Servant*, 1865. Library of Congress, Washington, DC.

11 Lee Friedlander: *Route 9W New York*, 1969. Fraenkel Gallery, San Francisco.

12 Lee Friedlander: *Albuquerque*, 1972. Gelatin-silver print. Fraenkel Gallery, San Francisco.

13 William Henry Fox Talbot: *The Open Door*, 1843. Royal Photographic Society, Bath.

14 Gustave O. Rejlander: *The Two Ways of Life*, 1857. Brown carbon print from 1925 printed from the original 32 wet collodion negatives. Royal Photographic Society, Bath.

15 Henry Peach Robinson: *Fading Away*, 1858. Albumen print made from 5 separate wet collodion negatives. Royal Photographic Society, Bath.

16 Louis-Jacques-Mandé Daguerre: *Shells and Fossils*, 1839. © Musée National de Techniques, Paris/Studio Photo C.N.A.M.

17 William Henry Fox Talbot: *The Library*, 1845. Science Museum (Talbot Collection), London/Science and Society Picture Library.

18 Roger Fenton: *Fruit*, 1860. Royal Photographic Society, Bath.

19 Calvert Richard Jones: *Garden Implements*, 1847? Board of Trustees of the Victoria and Albert Museum, London.

20 Francis Frith: *Entrance to the Grand Temple, Luxor*, 1857. Albumen print. Museum of Modern Art, New York. Copy print © 1997 Museum of Modern Art, New York; from Francis Frith, *Egypt and Palestine* (London: James S. Virtue, 1858-9).

21 Lady Hawarden: *Clementina Maude*, 1863-4. Board of Trustees of the Victoria and Albert Museum, London.

22 Peter Henry Emerson: *Gathering Water Lilies*, 1886. Board of Trustees of the Victoria and Albert Museum, London.

23 Roger Fenton: *Mill at Hurst Green*, 1859. Albumen print. Royal Photographic Society, Bath.

24 Roger Fenton: *The Terrace and Park at Harewood House*, 1860. Albumen print. Royal Photographic Society, Bath.

25 Timothy O'Sullivan: *Inscription Rock, New Mexico*, 1873. International Museum of Photography, George Eastman House, Rochester, NY.

26 Timothy O'Sullivan: *Desert Sand Hills Near Sink of Carson, Nevada*, 1867. Albumen print. 22.3 × 29.1 cm. Collection of the J. Paul Getty Museum, Malibu, CA.

27 William Henry Jackson: *Grand Canyon of the Colorado*, 1883. Albumen print. 53.3 × 43.2 cm. Collection of the J. Paul Getty Museum, Malibu, CA.

28 Carleton Watkins: *Panorama of Yosemite Valley from Sentinel Dome*, 1866. Three albumen prints. 39.4 × 52.3; 39.8 × 52.3; 39.7 × 52 cm. Collection of the J. Paul Getty Museum, Malibu, CA.

29 Carleton Watkins: *Cape Horn near Celilo, Oregon*, 1867. Albumen print. Collection of the J. Paul Getty Museum, Malibu, CA.

30 Edward Weston: *Dunes, Oceano*, 1936. Gelatin-silver print. © 1981 Center for Creative Photography, Arizona Board of Regents.

31 Edward Weston: *Point Lobos*, 1946. Gelatin-silver print (1948). © 1981 Center for Creative Photography, Arizona Board of Regents/ Museum of Modern Art, New York. Copy Print © 1997 Museum of Modern Art, New York.

32 Ansel Adams: *Moon and Mount McKinley*, 1984. © 1995 Ansel Adams Publishing Rights Trust. All rights reserved.

33 Robert Adams: *Los Angeles, Spring*, 1984. Fraenkel Gallery, San Francisco.

34 Fay Godwin: *Reedy Loch above Strathan, Sutherland*, 1984. © Fay Godwin/Collections, London.

35 John Davies: *Agecroft Power Station, Pendlebury, Salford, Greater Manchester*, 1983. Gelatin-silver print. © John Davies.

36 Raymond Moore: *Dumfriesshire*, 1985. © Raymond Moore/Sotheby's, London.

37 Martin Parr: *New Brighton*, 1984. © Martin Parr/Magnum.

38 Alfred Stieglitz: *The Flatiron*, 1903. Gravure on vellum, 32.7 × 16.8, from *Camera Work*, iv (October, 1903). Museum of Modern Art, New York. Purchase. Copy Print © 1997 Museum of Modern Art, New York.

39 Alfred Stieglitz: *From the Shelton, Looking West*, c.1935. Gelatin-silver print. © Board of Trustees of the National Gallery of Art (Alfred Stieglitz Collection), Washington, DC.

40 Lewis Hine: *Bowery Mission Breadline*, 1906. Museum of Modern Art, New York. Purchase. Copy Print © 1997 Museum of Modern Art, New York.

41 Weegee (Arthur Fellig): *Murder in Hell's Kitchen*, 1940. © 1994, International Center of Photography, New York, Bequest of Wilma Wilcox.

42 John Thompson: *The Independent Shoe Black*, 1876. Library of Congress, Washington, DC.

43 Walker Evans: *Many are Called*, 1938. Woodburytype. International Museum of Photography, George Eastman house, Rochester, NY.

44 Berenice Abbott: *Columbus Circle*, 1933. © Berenice Abbott/Commerce Graphics Ltd., Inc., East Rutherford, NJ.

45 Joel Meyerovitz: *Broadway and West 46th Street, New York*, 1976. © Joel Meyerovitz/Bonni Benrubi Gallery, New York.

46 Eugène Atget: *Cour 41 Rue Broca, Paris 5*, 1912. Musée Carnavalet, Paris/Photothèque des Musées de la Ville de Paris/© DACS 1997.

47 Brassaï: *No 27 of Paris After Dark*, 1933. © Gilbert Brassaï, Paris.

48 André Kertész: *Overhead Crosswalk with Clock*, 1947. © Estate of André Kertész, New York.

49 André Kertész: *Meudon*, 1928. © Estate of André Kertész, New York.

50 Louis Faurer: *Goggle-Eyed Man*, 1947. © Louis Faurer/Howard Greenburg Gallery, New York.

51 Michael Spano: *Street Scene*, 1980. © Michael Spano/Laurence Miller Gallery, New York.

52 Helen Levitt: *Untitled*, 1942. Fraenkel Gallery, San Francisco.

53 Robert Mapplethorpe: *Apollo*, 1988. Art and Commerce Anthology/The Robert Mapplethorpe Foundation Inc., New York.

54 Charles Richard Meade: *Portrait of Daguerre*, 1846. Hand-coloured daguerreotype. Image 16.0 × 12.0 cm. Collection of the J. Paul Getty Museum, Malibu, CA.

55 Margaret Cameron: *Sir John Herschel*, 1867. Royal Photographic Society, Bath.

56 Margaret Cameron: *Mary Hillier*, 1872. Royal Photographic Society, Bath.

57 David Octavius Hill and Robert Adamson: *Baiting the Line*, 1845. National Portrait Gallery, London.

58 Bill Brandt: *René Magritte with His Picture 'The Great War'*, 1966. © Bill Brandt (1966).

59 Vandyk: *The Prince of Wales and Lloyd George*, 1919. © August Sander Archiv/SK-Stiftung Kultur; VG Bild-Kunst, Bonn, 1996.

60 Paul Strand: *Blind Woman*, 1916. © 1971 Aperture Foundation Inc., Paul Strand Archive/Philadelphia Museum of Art. Purchased with funds given by Mr and Mrs Robert A. Hauslohner.

61 August Sander: *Smalltown Man and Wife*, 1928. National Portrait Gallery, London.

62 Yousuf Karsh: *Georgia O'Keeffe*, 1965. © Karsh of Ottawa/Camera Press Ltd., London.

63 Robert Mapplethorpe: *Self-Portrait*, 1971. Three polaroids with spray paint on paper bag. Art and Commerce Anthology/The Robert Mapplethorpe Foundation Inc., New York.

64 Cindy Sherman: *Untitled No. 122*, 1983. Metro Pictures, New York/Saatchi Collection, London.

65 Diane Arbus: *A Naked Man Being a Woman NYC*, 1968. Gelatin-silver print. © Estate of Diane Arbus, 1972/Robert Miller Gallery, New York.

66 Richard Avedon: *Self-Portrait*, 1964. Richard Avedon Studio, New York.

67 Clarence White: *The Chiffonier*, 1904. Metropolitan Museum of Art, New York. Gift of Mrs Alma Werheim, 1928 (28.130.2).

68 Alfred Stieglitz: *Georgia O'Keeffe–Torso*, 1919. Albright-Knox Art Gallery, Buffalo, New York. Consolidated Purchase Funds, 1911.

69 Barbara Kruger: *My Face is Your Fortune*, 1982. Collotype. 48.2 × 61 cm. © Barbara Kruger/Mary Boone Gallery, New York/Cincinnati Art Museum. Gift of RSM Co.

70 Eadweard Muybridge: *Nude Men, Motion Study*, 1877. Gelatin-silver print. Museum of Modern Art, New York. Gift of Philadelphia Commercial Museum. Copy Print © 1997 Museum of Modern Art, New York; from Eadweard Muybridge, *Animal Location* (Philadelphia: University of Pennsylvania, 1877).

71 Cindy Sherman: *Untitled*, 1992. Colour print. Metro Pictures, New York

72 Anonymous: *Nineteenth-Century Nude*, 1850. Private Collection.

73 David Seymour: *Bernard Berenson at the Borghese, Rome*, 1955. © David Seymour/Magnum.

74 E. J. Bellocq: *Prostitute, New Orleans, c.1912.* Untitled, *Storyville Portrait, c. 1912.* Printing-out paper, gold toned. Fraenkel Gallery, San Francisco.

75 Anonymous: *Untitled Illustration from Picture Post*, 1950s. Hulton Getty Picture Collection Ltd., London; from *Picture Post*, Vol. 44, no. 8 (20 August 1949), photo Bill Brandt.

76 Hans Bellmer: *La Poupée (The Doll)*, 1935. Silver print. 11.5 × 7.7 cm. Spencer Museum of Art, University of Kansas. © Editions Filipacchi, Paris.

77 Minor White: *Portland*, 1940. Minor White Archive, Princeton University, NJ. © 1989 by Trustees of Princeton University.

78 Jo Spence and Terry Dennett: *Industrialization*, 1982. Jo Spence Memorial Archive, London.

79 Annette Messager: *Mes Vœux (My Wishes)*, 1989. © Musée National d'Arte Moderne, Centre Georges Pompidou, Paris/ © ADAGP, Paris and DACS, London, 1997.

80 Judith Joy Ross: *Untitled*, 1988. Gelatin-silver print. 24.5 × 19.6 cm. Untitled from *Easton Portraits* (1988). © Judith Joy Ross/Museum of Modern Art, New York. E. T. Harmax Foundation Fund. Copy Print © 1997 Museum of Modern Art, New York.

81 William Edward Kilburn: *The Great Chartist Meeting on Kennington Common*, 1848. Daguerreotype. Royal Archives, Windsor Castle (The Royal Collection Trust)/ © Her Majesty Queen Elizabeth II

82 Margaret Bourke-White: *Sharecropper's Home*, 1937. Library of Congress, Washington, DC.

83 Russell Lee: *Interior of a Black Farmer's House*, 1939. Library of Congress, Washington, DC.

84 Dorothea Lange: *Migrant Mother*, 1936. Library of Congress, Washington, DC.

85 Walker Evans: *Graveyard, Houses, and Steel Mill, Bethlehem, Pennsylvania*, 1935. Library of Congress, Washington, DC.

86 Robert Frank: *Parade—Hoboken, New Jersey*, 1958. Gelatin-silver print. 20.6 × 31.2 cm. © Robert Frank, courtesy of PaceWildensteinMacGill, New York/ Museum of Modern Art, New York. Purchase. Copy Print © 1997 Museum of Modern Art, New York.

87 Bruno Barbey: *Left-Wing Riot Protesting the Building of Narito Airport, Tokyo*, 1972. © Bruno Barbey/Magnum.

88 George Rodger: *Bergen-Belsen Concentration Camp*, April 1945. George Rodger, *Life* Magazine/© Time Inc./Katz Pictures Ltd., London

89 Hung Cong ('Nick') Ut: *Accidental Napalm Attack*, 1972. Hung Cong/Associated Press/Wide World Photos, New York.

90 Robert Haeberle: *People about to be Shot*, 1969. Robert Haeberle, *Life* Magazine © Time Warner Inc./Katz Pictures Ltd., London.

91 Don McCullin: *Shell-Shocked Soldier*, 1968. © Don McCullin/Magnum.

92 Warren Neidich: *Contra-Curtis; Early American Cover-Ups. Number 7*, 1989. © Warren Neidich/Aperture, New York.

93 Bill Brandt: *Northumberland Miner at His Evening Meal*, 1937. © Bill Brandt, 1937.

94 Birney Imes: *Blume and Mary Will Thomas, New Year's Eve*, 1984. © Birney Imes.

95 Alfred Stieglitz: *The Steerage*, 1907. Royal Photographic Society, Bath.

96 Edward Weston: *Nude*, 1936. Gelatin-silver print. © 1981 Center for Creative Photography. Arizona Board of Regents/International Museum of Photography, George Eastman House, Rochester, NY.

97 Ansel Adams: *Picket Fence*, 1936. The Ansel Adams Publishing Rights Trust. All rights reserved.

98 Imogen Cunningham: *The Unmade Bed*, 1957. © 1970, 1996 The Imogen Cunningham Trust, Berkeley, CA.

99 Paul Strand: *Wall Street, New York*, 1915.

Bibliographic Essay

The number of texts on the photograph is enormous and there are, of course, individual texts by and on photographers, many of which are identified in the preceding chapters. However, in a general context the following might be considered as basic studies (most of them also include bibliographies for further reading).

Cecil Beaton and Gail Buckland, *The Magic Image: The Genius of Photography from 1839 to the Present Day* (London, 1979), is an excellent source-book and contains entries on a wide range of photographers. Peter Bunnell's *A Photographic Vision: Pictorial Photography 1889–1923* (Salt Lake City, 1980) is more specific in approach and area, and focuses upon a central period. Helmut and Alison Gernsheim's *The History of Photography from the Camera Obscura to the Beginning of the Modern Era* (London and New York, 1969) and their *The Origins of Photography* (London, 1982) are excellent surveys, whilst Jonathan Green's *American Photography: A Critical History, 1945 to the Present* (New York, 1984) covers the critical post-war period in the USA. Margaret Harker's *The Linked Ring: The Secession Movement in Photography in Britain, 1892–1910* (London, 1979) covers similar areas to Bunnell's but from the British perspective, whilst Mark Haworth-Booth (ed.), *The Golden Age of British Photography, 1839–1900* (London and New York, 1984) offers a distinctive study of the nineteenth-century tradition.

Manfred Heiting (ed.), in *50 Years/Modern Color Photography* (Frankfurt, 1986), celebrates colour rather than the dominance of black and white. William Innes Homer's *Alfred Stieglitz and the American Avant Garde* (Boston, 1977) is a standard study of the significance of Stieglitz in relation to the New York scene of the 1900s.

Of the many general surveys and histories, Ian Jeffrey's *Photography: A Concise History* (London and New York, 1981) remains a standard text. Volker Kahmen, in *Photography as Art* (London, 1974), offers an approach to an underlying critical question. Other histories include Jean-Claude Lemagny and Andre Rouille (eds.), *A History of Photography* (New York, 1987), although the classic history remains Beaumont Newhall's *The History of Photography from 1839 to the Present* (New York and London, 1982). Newhall's pioneering work is part of an exemplary career in the subject. Naomi Rosenblum's *A World History of Photography* (New York, 1984) is excellent in its scope. See also her *Photographers at Work* (New York, 1978). John Szarkowski's *Photography Until Now* (New York, 1989) is incisive, with excellent illustrations. Other histories and general studies include Peter Tausk, *Photography in the Twentieth Century* (London, 1980) and Peter Turner, *American Images, Photography 1945–1980* (London and New York, 1985), the catalogue for a major exhibition. See also his *History of Photography* (London, 1987).

On similar lines, Mike Weaver (ed.), *The Art of Photography 1839–1989* (London, 1989), is a profusely illustrated catalogue of the celebratory Royal Academy exhibition in 1989. His *The Photographic Art: Pictorial Traditions in Britain and America* (London and New York, 1985) and (ed.), *British Photography in the Nineteenth Century* (New York and Cambridge, 1989) confirm him as one of the major historians of the subject. From a different perspective, see Val Williams's *Women Photographers: The Other Observers: 1900 to the Present* (London, 1986).

Critical studies of the photograph, including anthologies of early essays and debates, include the following: Robert Adams's *Beauty in Photography: Essays in Defence of Traditional Values* (New York, 1981) establishes its own terms of reference. Dawn Ades's *Photomontage* (London, 1976) is a sympathetic overview of one area of significant avant-garde

photography. In critical terms, however, especially in relation to semiotics, the work of Roland Barthes remains central. See, for example, *Camera Lucida, Reflections on Photography* (New York, 1981; London, 1982). See also his *Image—Music—Text*, trans. Stephen Heath (London, 1977), *Mythologies* (London, 1973), and *Elements of Semiology* (London, 1967).

The sense of reading rather than just looking is implicit in Jonathan Bayer (ed.), *Reading Photographs: Understanding the Aesthetics of Photography* (New York, 1977). Other central critical writings are Walter Benjamin's *Illuminations* (London, 1970), as well as his important essay 'A Short History of Photography' (1931), repr. in Alan Trachtenberg (ed.), *Classic Essays on Photography* (New Haven, 1980). Another central critic of the medium is John Berger, whose *Ways of Seeing* (London, 1972) and (with Jean Mohr) *Another Way of Telling* (Cambridge, 1989) offer individual critical perspectives.

A different approach is found in Richard Bolton (ed.), *The Contest of Meaning: Critical Histories of Photography* (Cambridge, Mass., 1989) and Michael Braive's *The Era of the Photograph: A Social History* (London, 1966), but a text which holds a central position in the critical theory on the photograph is Victor Burgin (ed.), *Thinking Photography* (London, 1982). Other useful interpretations are Gisele Freund, *Photography and Society* (London, 1980), and Vicki Goldberg (ed.), *Photography in Print: Writings from 1916 to the Present* (New York, 1981).

Paul Hill and Thomas Cooper, *Dialogue with Photography* (Manchester, 1979), and Brooks Johnson, *Photography Speaks* (Norfolk, Va., 1989) offer very useful statements by major photographers. Rosalind Krauss and Jane Livingston, *L'Amour Fou: Photography and Surrealism* (New York, 1985) is a veritable source-book on photography and surrealism, while Jean-Claude Lemagny, Alain Sayag, and Agnes de Gouvion St Cyr's *Art and Nature: Twentieth-Century French Photography* (New York, 1988) offers an important study of one of the central traditions. Nathan Lyons (ed.), *Photographers on Photography: A Critical Anthology* (Englewood Cliffs, NJ, 1956) and Beaumont Newhall (ed.), *Photography: Essays and Images* (New York, 1980) reproduce seminal documents on the subject.

R. Rudishill's *Mirror Image: The Influence of the Daguerreotype on American Society*, (Albuquerque, 1972) is a basic study of early photography in the context of its influence on the USA. In a different context Aaron Scharf's *Art and Photography* (Baltimore, 1969) is an excellent study of the underlying relationship between many aspects of photography and painting. Susan Sontag's *On Photography* (New York, 1973) is one of the seminal interpretations of the medium, whilst Carol Squirs (ed.), *The Critical Image: Essays on Contemporary Photography* (Seattle, 1990), offers significant essays on a number of contemporary issues. John Szarkowski's *Mirrors and Windows: American Photography Since 1960* (New York, 1978) is a significant study of the period in a critical context, but see also his *Looking at Photographs* (New York, 1973) and *The Photographer's Eye* (New York, 1966).

Other significant critical studies include John Tagg's excellent *The Burden of Representation* (London, 1988) and Alan Thomas's *Time in a Frame: Photography and the Nineteenth-Century Mind* (New York, 1977). Alan Trachtenberg (ed.), *Classic Essays on Photography* (New Haven, 1980) is an excellent anthology of primary sources, whilst his *Reading American Photographs* (New York, 1989) is a series of central essays on the American photographic tradition, very much in the context of history and ideology. But see also George Walsh *et al.* (eds.), *Contemporary Photographers* (London and New York, 1982) and Frank Webster, *The New Photography* (London, 1980), which look at the social and cultural meaning of recent photography very much within the domain of semiotics.

Amongst studies on specific areas are Graham Clarke (ed.), *The Portrait in Photography* (London, 1993) and Sally Eauclair, *The New Colour Photography* (New York, 1981). Other texts on specific areas are Rainer Fabian and Hans-Christian Adam, *Masters of Early Travel Photography 1839–1919* (London, 1980); Estelle Jussim and Elizabeth Linguist-Cook, *Landscape as Photography* (New Haven and London, 1985); Susan Moeller, *Shooting War* (New York, 1989); and John Taylor, *War Photography* (London, 1991).

For individual traditions the following are useful: Arthur D. Bensusan *Silver Images: A History of Photography in Africa* (Cape Town, 1966); G. Chudakov, *Pioneers of Russian Soviet Photography* (London, 1983); Ralph Greenhill, *Early Photography in Canada* (Toronto, 1965); Japan Photographers Association, *A Century of Japanese Photography* (New York, 1980);

Hardwicke Knight, *Photography in New Zealand: A Social and Technical History* (Dunedin, 1971); David Mellor (ed.), *Germany: The New Photography 1927–37* (London, 1978); The Walker Art Center, *The Frozen Image: Scandinavian Photography* (Minneapolis, 1982); and Alkis X. Xanthakis, *History of Greek Photography 1839–1960* (Athens, 1988). All stress the plurality and richness of the international tradition.

For texts which emphasize visual images over critical discussion, see, for example, Bryan Campbell, *Exploring Photography* (London, 1978); Robert Doty, *Photography in America* (New York and London, 1974); Tom Hopkinson, *Treasures of the Royal Photographic Society 1839–1919* (London, 1980); Ian Jeffrey and David Mellor, *The Real Thing: An Anthology of British Photography 1840–1950* (London, 1975); Claude Nori, *French Photography from its Origins to the Present* (Paris, 1978); and Aaron Scharf, *Pioneers of Photography: An Album of Pictures and Words* (London, 1975). To confirm the importance of the photograph one might look at Vicki Goldberg's *The Power of Photography: How Photographs Changed Our Lives* (New York, 1993).

Timeline

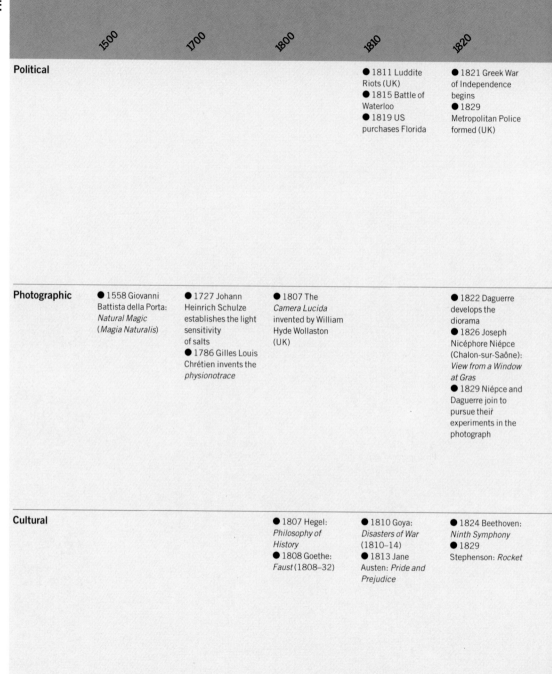

	1500	1700	1800	1810	1820
Political				● 1811 Luddite Riots (UK) ● 1815 Battle of Waterloo ● 1819 US purchases Florida	● 1821 Greek War of Independence begins ● 1829 Metropolitan Police formed (UK)
Photographic	● 1558 Giovanni Battista della Porta: *Natural Magic* (*Magia Naturalis*)	● 1727 Johann Heinrich Schulze establishes the light sensitivity of salts ● 1786 Gilles Louis Chrétien invents the *physionotrace*	● 1807 The *Camera Lucida* invented by William Hyde Wollaston (UK)		● 1822 Daguerre develops the diorama ● 1826 Joseph Nicéphore Niépce (Chalon-sur-Saône): *View from a Window at Gras* ● 1829 Niépce and Daguerre join to pursue their experiments in the photograph
Cultural			● 1807 Hegel: *Philosophy of History* ● 1808 Goethe: *Faust* (1808–32)	● 1810 Goya: *Disasters of War* (1810–14) ● 1813 Jane Austen: *Pride and Prejudice*	● 1824 Beethoven: *Ninth Symphony* ● 1829 Stephenson: *Rocket*

1830	1840	1850	1860	1870	1880
● 1832 First Reform Act (UK) ● 1833 Abolition of slavery in British Empire ● 1835 Railway Boom (UK) begins ● 1837 Accession of Victoria (UK)	● 1840 Penny post (UK) ● 1842 US/Canadian border agreed ● 1845 US annexes Texas	● 1854 Crimean War starts – US forces Japan to end isolation	● 1860 Lincoln elected president of USA ● 1861 American Civil War (1861–5) ● 1863 Emancipation of US slaves ● 1867 Second Reform Act (UK)	● 1870 Franco-Prussian War ● 1876 Battle of Little Bighorn (death of Custer)	● 1887 Victoria's Golden Jubilee (UK)
● 1833 Niépce dies ● 1837 Daguerre produces the first dageurreotype ● 1839 Hippolyte Bayard makes positive images on paper – Invention of the daguerreotype announced – Talbot: photogenic drawings announced	● 1840 Voigtländer: Petzval lens ● 1841 Talbot: the calotype – Hunt: *A Popular Treatise on the Art of Photography* ● 1844 Talbot: *The Pencil of Nature* ● 1846 Zeiss establishes lens factory ● 1847 Photographic Club established in London	● 1850 Albumen paper introduced by Blanquart Evrard ● 1851 Frederick Scott Archer: wet collodion process – Société Heliographique, Paris ● 1852 Society of Arts in London exhibits 779 photographs ● 1853 Photographic Society (London)	● 1861 Oliver Wendell Holmes invents the hand-held stereoscope – James Clerk Maxwell: three-colour photography – Celluloid invented ● 1864 J. W. Swann: carbon process ● 1866 Gardner: *Photographic Sketchbook of the American Civil War*	● 1878 Gelatin dry plates ● 1879 Klic: photogravure	● 1884 Flexible negative film produced by Eastman – *Amateur Photographer* (UK) ● 1885 Half-tone developed ● 1888 Eastman: the first Kodak produced with a film of 100 pictures
● 1830 Stendhal: *Le Rouge et le noir* – Berlioz: *Symphonie fantastique* ● 1831 Delacroix: *La Liberté guidant le peuple* ● 1835 De Tocqueville: *Democracy in America* ● 1837 Electric telegraph invented ● 1839 Faraday: theory of electromagnetism	● 1842 Gogol: *Dead Souls* – Tennyson: *Morte d'Arthur* ● 1848 Marx and Engels: *Communist Manifesto* ● 1849 California gold-rush	● 1851 Great Exhibition in Crystal Palace – Melville: *Moby-Dick* ● 1852 Livingstone crosses Africa (1852–6) ● 1853 Verdi: *La traviata* ● 1857 Baudelaire: *Fleurs du mal* – Flaubert: *Madame Bovary* ● 1859 Darwin: *Origin of Species* – First American oil-wells	● 1860 Hans Bessemer: mass-production of steel ● 1863 Hugo: *Les Misérables* ● 1865 Wagner: *Tristan und Isolde* ● 1867 Marx: *Das Kapital*	● 1871 Eliot: *Middlemarch* ● 1874 First Impressionist exhibition (Paris) ● 1875 Bell patents telephone – Tolstoy: *Anna Karenina* – Bizet: *Carmen* ● 1876 Brahms: *First Symphony* ● 1877 Edison: the phonograph ● 1879 First tramways (Berlin)	● 1882 First generating station (New York) ● 1885 First motor-car (Benz) ● 1887 Hertz: radio waves ● 1889 Verdi: *Falstaff* (1889–93)

	1890	1900	1910	1920	1930
Political	● 1894 Sino-Japanese War (1894–5) ● 1896 Herzl founds Zionism ● 1899 Second Boer War (1899–1902)	● 1901 Victoria dies ● 1903 Suffragette movement begins (WSPU)	● 1912 Balkan Wars (1912–13) ● 1914 First World War (1914–18) ● 1917 US enters First World War – Russian Revolution ● 1919 Prohibition (US)	● 1922 USSR formed ● 1926 General Strike (UK)	● 1934 Third Reich formed – Stalin purges begin ● 1936 Spanish Civil War (1936–9) ● 1939 Second World War (1939–45)
Photographic	● 1891 Telephoto lenses ● 1892 The Linked Ring established in London ● 1897 First edition of *Camera Notes*, edited by Stieglitz	● 1900 Kodak produces first Brownie cameras ● 1904 First colour process ('Autochrome') ● 1907 *Daily Mail* (London) first paper to be illustrated completely with photographic images		● 1924 The Leica Camera: between 1924 and 1936 180,000 manufactured	● 1932 F.64 Group founded ● 1935 Farm Security Administration begins photographing rural conditions in USA: over 270,000 images produced ● 1936 *Life* magazine first published – Kodachrome film ● 1938 *Picture Post* established
Cultural	● 1890 Van Gogh dies ● 1893 Tchaikovsky: *Sixth Symphony* ● 1894 First escalator lifts (US) ● 1895 Röntgen discovers X-rays – Marconi: the radio ● 1898 Zola: *J'accuse*	● 1900 Planck: quantum theory – Freud: *Interpretation of Dreams* – Puccini: *Tosca* ● 1903 Wright brothers: first aeroplane flight ● 1905 Einstein: *Special Theory of Relativity* – Debussy: *La Mer*	● 1911 Amundsen reaches South Pole – Stravinsky: *Le Sacre du printemps* ● 1912 Jung: *Psychology of the Unconscious* – Stainless steel invented ● 1913 Proust: *À la recherche du temps perdu* (1913–27) ● 1916 Dada movement	● 1921 Chaplin: *The Kid* ● 1922 Joyce: *Ulysses* Eliot: *The Waste Land* ● 1923 Le Corbusier: *Vers une architecture* – First talkie ● 1925 Hitler: *Mein Kampf* ● 1928 Penicillin discovered – First Walt Disney cartoon ● 1929 Wall Street Crash	● 1930 Whittle patents turbo-jet engine (UK) – Empire State Building (1930–1) ● 1932 Cockcroft and Walton split the atom ● 1936 Ayer: *Language, Truth and Logic* ● 1937 Picasso: *Guernica* ● 1938 Nuclear fusion discovered – Marx Brothers films (1929–46)

1940	1950	1960	1970	1980	1990
● 1946 Cold War begins ● 1947 Independence of India	● 1950 Korean War (1950–3) ● 1953 Stalin dies – McCarthy era begins (US) ● 1957 Soviet Sputnik space flight	● 1960 Vietnam War (1960–75) ● 1961 Berlin Wall erected ● 1962 Cuban Missile Crisis ● 1963 J. F. Kennedy assassinated (president of the USA, 1961–3) ● 1966 Cultural Revolution (China) ● 1967 Six-Day War (Israel against Egypt)	● 1973 US withdraws from Vietnam War ● 1974 Watergate scandal, Nixon resigns ● 1975 Vietnam War ends ● 1979 Iran hostage crisis	● 1989 Berlin Wall dismantled	● 1990 Reunification of East and West Germany ● 1991 Conflict begins in Yugoslavia – Gulf War
● 1941 *Let Us Now Praise Famous Men* (Agee and Evans) ● 1942 Kodacolor negative film ● 1945 Weegee: *The Naked City* ● 1947 Magnum founded – Polaroid camera first marketed ● 1949 Beamont Newhall: *The History of Photography*	● 1952 *Aperture* founded, with Minor White as its editor ● 1955 'Family of Man' exhibition, MOMA ● 1958 Frank: *The Americans*	● 1966 International Center of Photography, New York	● 1971 Photographers' Gallery, London, opens ● 1975 Centre for Creative Photography; Tuscon, Arizona	● 1983 National Museum of Photography, Film, and Television, Bradford (UK)	
● 1943 Sartre: *Being and Nothingness* ● 1945 Abstract Expressionistic painting introduced by Jackson Pollock (US) ● 1949 Simone de Beauvoir: *The Second Sex*	● 1951 Stravinsky: *The Rake's Progress* ● 1953 Colour television service (US) ● 1958 Silicon chip invented by Texas Instruments (US)	● 1961 First manned space-flight (USSR) ● 1962 The Beatles ● 1968 Student protests throughout Europe and USA ● 1969 First manned moon landing (US)	● 1973 OPEC raises oil prices	● 1982 Laser discs (CDs) invented ● 1986 Chernobyl disaster	

Glossary

Albumen print: invented by Louis Blanquart-Evrard in the 1850s, the albumen print became the most popular form of photographic paper in the nineteenth century. The paper was coated in a solution of egg albumen and sodium chloride. It was sensitized in a solution of silver nitrate.

Ambrotype: a form of *collodion* print which made a positive image without any need to print from a negative.

Autochrome: the first colour process developed by the Lumière brothers in France in 1907. Based on panchromatic solutions, this was the most advanced form of colour photography available until the Kodachrome process in the 1930s.

Calotype: the basic process invented by Talbot in 1840, it consisted of a paper sensitized with a salt solution and silver nitrate. This was the basis of his photogenic drawings in 1834 but the calotype allowed a negative/positive process and is therefore the basis of photography proper. An earlier but different version was the *salt print* which Talbot used in 1834.

Camera lucida: invented by Thomas Woolaston in 1806, this was an optical instrument to aid the artist in the accurate depiction of a landscape scene. Its principle was based on the refraction of light through a prism. It was instrumental in the development of Talbot's ideas about the photograph.

Camera obscura: a 'dark chamber' which constituted the earliest form of camera, although it did not record a permanent image. Developed in 1569 by Battista Parta for use by artists, it consisted of a hole in a tent or box which allowed the entry of light on to a flat surface. The projected image appeared as inverted, but with the use of a mirror the artist was able to trace what he saw.

Carte-de-visite: a very popular form of photograph in the 1860s, especially in France. It consisted of a multiple image of the sitter (usually full-length) which was then used as a calling card. André Disdéri was a major figure in this field.

Combination printing: the process of creating a single print by combining a series of negatives. Most notably used in the nineteenth century by H. P. Robinson and O. G. Rejlander.

Daguerreotype: the first published photographic process, in France (1839), developed by Louis-Jacques-Mandé Daguerre. Based on experiments he had made (with Nièpce) since the 1820s, this consisted of a silvered copper plate made sensitive by iodine vapour. It was easily damaged and, once developed, had to be protected by glass to prevent the surface being scratched. To begin with, exposure times were up to twenty minutes, although they were rapidly reduced to seconds. There was no negative, thus each daguerreotype was unique. Despite its popularity it was rapidly superseded by Talbot's negative/positive process.

Heliography: the process invented by Nièpce, it is the earliest form of photographic image, used to produce the famous 'first' photograph from 1826. It was based on a copper plate covered in a solution of bitumen. Its obvious drawback was the number of hours required for each exposure.

Kodak: George Eastman's simple camera which entered production in 1888; it was replaced by the pocket Kodak with a film of twelve exposures. It sold for one guinea. In 1900 the Brownie camera, at five shillings, was to make the camera available on a general basis, and may be seen as the beginnings of popular photography.

Leica: a German camera, considered to be the first 35 mm. Invented by Oscar Barnack. The first design dates from as early as 1905, although it was not marketed until 1925. Its mobility, rapid action, and lightness radically changed the way photographs could be taken. It was especially significant in the development of documentary and photo-journalism.

Linked Ring: founded in May 1892 in London in response to what its founders considered to be the paucity of photography at the time, it was dedicated to promoting what it took to be the highest form of art of which photography was capable. By 1907 its members included Evans, Coburn, Stieglitz, Steichen, Demachy, and Puyo.

Magnum: established in May 1947 by Henri Cartier-Bresson, Robert Capa, George Rodger, and David Seymour (Chim) as an independent photographic agency which, as the name suggested, would allow them to 'live in pursuit of great pictures'. A co-operative, it continues to have an enormous influence on photography and photo-journalism.

Petzval lens: Joseph Petzval, the Hungarian mathematician, was the first person to design a lens which was not 'fixed' in the way Talbot's lenses were. It was the first 'modern' lens.

Photogram: a basic photographic image made without the use of the camera and the earliest form used by Fox Talbot. Objects are placed on a light-sensitive paper and exposed to the light. It is also the basis of, for example, Man Ray's 'Rayographs'.

Photogravure: a process invented by Karl Klin in 1879, this involved a copper plate covered with resin which was contact-printed on to paper. A printing rather than a photographic process, it is capable of producing intense contrast and a dense area of black.

Platinotype: a process much favoured in the 1880s and 1890s. It was noted for its permanence and subtlety of tonal difference. A solution of platinum and iron salts was added to a sheet of paper.

Polaroid: a camera capable of producing an 'instant' photograph which was developed by Edwin Land in America in 1940, and first marketed in 1947. A colour version was available in 1963.

Stereograph: an image based on the stereoscopic camera which had two lenses, set apart in relation to the eyes. Each 'print' had two exposures and, when placed in a stereoscope (a viewing machine) produced the illusion of a three-dimensional image. Especially popular in the 1850s, particularly for travel photography.

Wet-plate or Collodion process: invented by Frederick Scott-Archer in 1851, this became the most popular form of photography until the 'dry plate' in the 1880s. A sheet of glass coated in a solution of collodion, it was named 'wet-plate' because the plate had to be developed as soon as the image had been taken by the camera.

Index

Oxford History of Art

Titles in the Oxford History of Art series are up-to-date, fully-illustrated introductions to a wide variety of subjects written by leading experts in their field. They will appear regularly, building into an interlocking and comprehensive series.